2nd Edition

Photoshop®
for Lightroom Users

Scott Kelby

Editor of Photoshop User magazine

***The Photoshop Book for
Lightroom Users***, 2nd Edition Team

MANAGING EDITOR
Kim Doty

COPY EDITOR
Cindy Snyder

ART DIRECTOR
Jessica Maldonado

PHOTOGRAPHY BY
Scott Kelby
(unless otherwise noted)

Published by New Riders

Composed in Univers LT and Quatro Slab by Kelby Media Group, Inc.

Trademarks

All terms mentioned in this book that are known to be trademarks or service marks have been appropriately capitalized. New Riders cannot attest to the accuracy of this information. Use of a term in the book should not be regarded as affecting the validity of any trademark or service mark.

Photoshop, Photoshop Lightroom, and Photoshop Elements are registered trademarks of Adobe Systems, Inc.

Macintosh and Mac are registered trademarks of Apple Inc.

Windows is a registered trademark of Microsoft Corporation.

Warning and Disclaimer

This book is designed to provide information about Adobe Photoshop Lightroom and Adobe Photoshop for digital photographers. Every effort has been made to make this book as complete and as accurate as possible, but no warranty of fitness is implied.

ISBN13: 978-0-13-465788-2

ISBN10: 0-13-465788-8

1 18

http://kelbyone.com
www.newriders.com

This book is dedicated to my dear friend, and colleague, Rick Sammon—one of the very best guys in our entire industry, and I'm honored to call him my friend.

ACKNOWLEDGMENTS

I start the acknowledgments for every book I've ever written the same way—by thanking my amazing wife, Kalebra. If you knew what an incredible woman she is, you'd totally understand why.

This is going to sound silly, but if we go grocery shopping together and she sends me off to a different aisle to get milk, when I return with the milk and she sees me coming back down the aisle, she gives me the warmest, most wonderful smile. It's not because she's happy that I found the milk; I get that same smile every time I see her, even if we've only been apart for 60 seconds. It's a smile that says, "There's the man I love."

If you got that smile, dozens of times a day, for nearly 30 years of marriage, you'd feel like the luckiest guy in the world, and believe me—I do. To this day, just seeing her puts a song in my heart and makes it skip a beat. When you go through life like this, it makes you one incredibly happy and grateful guy, and I truly am.

So, thank you, my love. Thanks for your kindness, your hugs, your understanding, your advice, your patience, your generosity, and for being such a caring and compassionate mother and wife. I love you.

Secondly, a big thanks to my son, Jordan. I wrote my first book when my wife was pregnant with him (21+ years ago), and he has literally grown up around my writing, so you can imagine how incredibly proud I was when he completed his first book, a 243-page fantasy novel, last year. It has been a blast watching him grow up into such a wonderful young man, with his mother's tender and loving heart, and compassion way beyond his years. As he wraps up his senior year of college (#rolltide), he knows that his dad just could not be prouder of, or more excited for, him. Throughout his life, he has touched so many people in so many different ways, and even though he's still a young man, he's already inspired so many people. I just cannot wait to see the amazing adventures, love, and laughter this life has in store for him. Hey, little buddy, this world needs more "yous!"

Thanks to our wonderful daughter, Kira, for being the answer to our prayers, for being such a blessing to your older brother, for being such a strong little girl, and for proving once again that miracles happen every day. You are a little clone of your mother, and believe me, there is no greater compliment I could give you. It is such a blessing to get to see such a happy, hilarious, clever, creative, and just awesome little force of nature running around the house each day—she just has no idea how happy and proud she makes us. She's what happens when a magical unicorn, a leprechaun, and a fairy princess cosmically collide, and the result gets covered in chocolate sprinkles and cherries. It doesn't get much better than that.

A special thanks to my big brother, Jeff. I have so much to be thankful for in my life, and having you as such a positive role model while I was growing up is one thing I'm particularly thankful for. You're the best brother any guy could ever have, and I've said it a million times before, but one more surely wouldn't hurt—I love you, man!

Thanks to my friend and business partner, Jean A. Kendra, for her support and friendship all these years. You mean a lot to me, to Kalebra, and to our company.

A warm word of thanks goes to my in-house editor, Kim Doty. It's her amazing attitude, passion, poise, and attention to detail that has kept me writing books. When you're writing a book like this, sometimes you can really feel like you're all alone, but she really makes me feel that I'm not alone—that we're a team. It often is her encouraging words or helpful ideas that keep me going when I've hit a wall, and I just can't thank her enough. Kim, you are the best!

ACKNOWLEDGMENTS

I'm equally as lucky to have the immensely talented Jessica Maldonado (a.k.a. The Photoshop Girl) working on the design of my books. I just love the way Jessica designs, and all the clever little things she adds to her layouts and cover designs. She's not just incredibly talented and a joy to work with, she's a very smart designer and thinks five steps ahead in every layout she builds. I feel very, very fortunate to have her on my team.

Also, a big thanks to our copy editor, Cindy Snyder, who helps by reading all the techniques in the book (and makes sure I didn't leave out that one little step that would take the train off the tracks)—she catches lots of little things others would have missed.

A big thanks to my dear friend, rocket photographer, Professor of Tesla studies, unofficial but still official Disney Cruise Guide, and Amazon Prime Aficionado, Mr. Erik Kuna. You are one of the reasons I love coming to work each day. You're always uncovering cool new things, thinking outside the box, and making sure we always do the right thing for the right reasons. Thanks for your friendship, all your hard work, and your invaluable advice.

My heartfelt thanks go to my entire team at Kelby Media Group. I know everybody thinks their team is really special, but this one time—I'm right. I'm so proud to get to work with you all, and I'm still amazed at what you're able to accomplish day in, day out, and I'm constantly impressed with how much passion and pride you put into everything you do.

Thanks to Jeanne Jilleba, my Executive Assistant, for constantly putting my wheels back on the track. I know even finding where I'm at in the building is a challenge, but you just seem to take it all in stride. I'm very grateful to have your help, and your talent, and immeasurable patience every day.

High five to all the crew at Peachpit Press/New Riders, and to my Editor, Laura Norman, for taking over the helm, and guiding my books safely to their birth. Gone but not forgotten: Nancy Aldrich-Ruenzel, Sara Jane Todd, Ted Waitt, Nancy Davis, Lisa Brazieal, Scott Cowlin, and Gary-Paul Prince.

Thanks to Kleber Stephenson for making sure all sorts of awesome things happen, and doors open, and opportunities appear. I particularly enjoy our business trips together where we laugh too much, eat way too much, and have more fun on a business trip than was previously scheduled.

Thanks to my friends at Adobe Systems: Terry White, Mala Sharma, Bryan Lamkin, Sharad Mangalick, Tom Hogarty, Kathy Scibetta, Julieanne Kost, and Russell Preston Brown. Gone but not forgotten: Barbara Rice, Cari Gushiken, Rye Livingston, John Loiacono, Kevin Connor, Addy Roff, and Karen Gauthier.

Thanks to Manny Steigman for always believing in me, and for his support and friendship all these years. Thanks to Gabe, Rebecca, Steve, Joseph, and all the wonderful folks at B&H Photo. It is the greatest camera store in the world, but it's so much more.

I want to thank all the talented and gifted photographers who've taught me so much over the years, including: Moose Peterson, Joe McNally, Anne Cahill, David Ziser, Peter Hurley, Lindsay Adler, Tim Wallace, Jim DiVitale, Dave Black, Frank Doorhof, and Helene Glassman.

Thanks to my mentors John Graden, Jack Lee, Dave Gales, Judy Farmer, and Douglas Poole, whose wisdom and whip-cracking have helped me immeasurably throughout my life.

Most importantly, I want to thank God, and His Son Jesus Christ, for leading me to the woman of my dreams, for blessing us with two amazing children, for allowing me to make a living doing something I truly love, for always being there when I need Him, for blessing me with a wonderful, fulfilling, and happy life, and such a warm, loving family to share it with.

OTHER BOOKS BY SCOTT KELBY

The Adobe Photoshop Lightroom Classic Book for Digital Photographers

How Do I Do That In Photoshop?

Professional Portrait Retouching Techniques for Photographers Using Photoshop

The Digital Photography Book, parts 1, 2, 3, 4 & 5

Light It, Shoot It, Retouch It: Learn Step by Step How to Go from Empty Studio to Finished Image

The Adobe Photoshop CC Book for Digital Photographers

How Do I Do That In Lightroom Classic?

The Flash Book

The Lightroom Mobile Book

Professional Sports Photography Workflow

ABOUT THE AUTHOR

Scott Kelby

Scott is Editor and Publisher of *Lightroom Magazine*; producer of LightroomKillerTips.com, Editor and co-founder of *Photoshop User* magazine; host of *The Grid*, the influential, live, weekly talk show for photographers; and is founder of the annual Scott Kelby's Worldwide Photo Walk.™

He is President and CEO of KelbyOne, an online educational community for learning Lightroom, Photoshop, and photography.

Scott is a photographer, designer, and award-winning author of more than 90 books, including *Light It, Shoot It, Retouch It: Learn Step by Step How to Go from Empty Studio to Finished Image*; *The Adobe Photoshop CC Book for Digital Photographers*; *Professional Portrait Retouching Techniques for Photographers Using Photoshop*; *How Do I Do That In Lightroom?*; and *The Digital Photography Book* series. The first book in this series, *The Digital Photography Book*, part 1, has become the top-selling book on digital photography in history.

For six years in a row, Scott has been honored with the distinction of being the world's #1 best-selling author of photography techniques books. His books have been translated into dozens of different languages, including Chinese, Russian, Spanish, Korean, Polish, Taiwanese, French, German, Italian, Japanese, Hebrew, Dutch, Swedish, Turkish, and Portuguese, among many others. He is a recipient of the prestigious ASP International Award, presented annually by the American Society of Photographers for "…contributions in a special or significant way to the ideals of Professional Photography as an art and a science," and the HIPA Special Award, presented for his worldwide contributions to photography education.

Scott is Conference Technical Chair for the annual Photoshop World Conference and a frequent speaker at conferences and trade shows around the world. He is featured in a series of online learning courses at KelbyOne.com and has been training Photoshop users and photographers since 1993.

For more information on Scott, visit him at:

His daily Lightroom blog: **lightroomkillertips.com**

His personal blog: **scottkelby.com**

Twitter: **@scottkelby**

Facebook: **facebook.com/skelby**

Instagram: **@scottkelby**

TABLE OF CONTENTS

TABLE OF CONTENTS

SIX THINGS YOU'LL WISH YOU HAD KNOWN BEFORE READING THIS BOOK

I really want to make sure you get the absolute most out of reading this book, and if you take two minutes to read these six things now, I promise it will make a big difference in your success with Photoshop, and with this book (plus, it will keep you from sending me an email asking something that everyone who skips this part will wind up doing). By the way, the images shown below are just for looks. Hey, we're photographers—how things look matters to us.

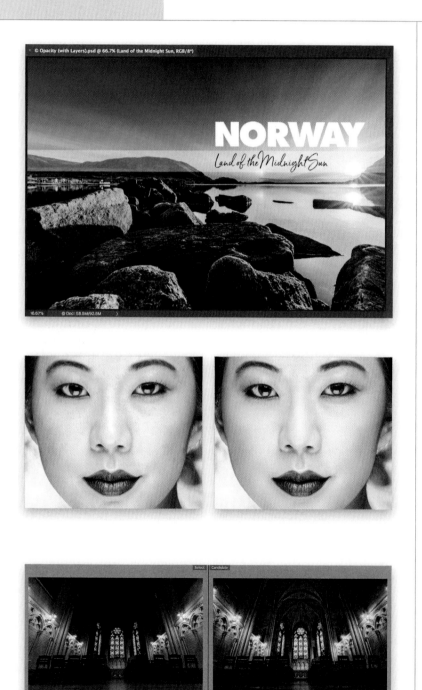

(1) You can download many of the key photos used here in the book (and the video I mention in Chapter 1, and the one in #6 on the next page), so you can follow along using many of the same images that I used, at **http://kelbyone.com/books/PSforLR2**. See, this is one of those things I was talking about that you'd miss if you skipped over this and jumped right to Chapter 1. Then you'd send me an angry email about how I didn't tell you where to download the photos or watch the videos. You wouldn't be the first.

(2) If you've read my other books, you know they're usually "jump in anywhere" books, but since you're new to Photoshop, I would really recommend you start with Chapters 1 and 2 first, then you can jump to anywhere else in the book and you'll be fine. But, hey, it's your book—if you decide to just hollow out the insides and store your valuables in there, I'll never know. Also, make sure you read the opening to each project, up at the top of the page. Those actually have information you'll want to know, so don't skip over them.

(3) The official name of the software is "Adobe Photoshop CC." But, if every time I referred to it throughout the book, I called it "Adobe Photoshop CC," you'd eventually want to strangle me, so from here on out, I usually just refer to it as "Photoshop." Same thing with "Adobe Photoshop Lightroom Classic." I just refer to it as "Lightroom." Just so you know.

(4) The intro page at the beginning of each chapter is designed to give you a quick mental break, and honestly, they have little to do with the chapter. In fact, they have little to do with anything, but writing these quirky chapter intros is kind of a tradition of mine (I do this in all my books), but if you're one of those really "serious" types, I'm begging you, please skip over them, because they'll just get you really irritated. I'm not kidding.

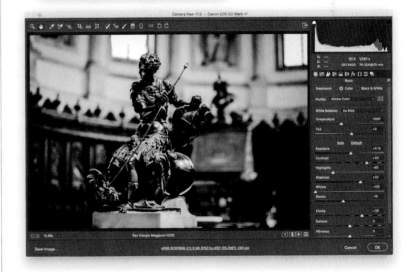

(5) What if this book makes me fall deeply in love with Photoshop? That wouldn't be a bad thing, ya know, and if that happens, I got ya covered with one of those big 300+-page books that covers everything you'd ever want to do (as a photographer) in Photoshop. It's called *The Adobe Photoshop CC Book for Digital Photographers* (I know, the name is kinda, well, direct), but don't worry about that right now—we've got plenty of work to do here first.

(6) I created a short bonus video for you. It shows you step by step how to use Photoshop to edit videos. I didn't include this in the book, because there's no direct link between Lightroom and Photoshop for editing your videos. It's basically an all-Photoshop kind of thing. When you're done with your video, you can import the final completed video back into Lightroom just so you can watch it there, but this is really a standalone Photoshop production. Anyway, I still thought you might dig it, so I made a video especially for you. See? I care.

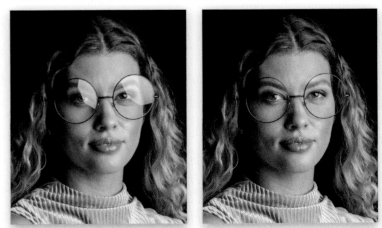

Chapter 1

ESSENTIAL TECHNIQUES

THE BASIC STUFF YA GOTTA KNOW FIRST

It's a tradition in many of my books to use song, TV show, or movie titles for the names of the book chapters. In this case, it's a song title because I found a song that is actually named "Technique." It's a rap tune from a band named Def Shepard, which seems like a wink and nod to the big hair '80s band Def Leppard (either that or it's a shout-out to all those hearing-impaired sheep herders out there). Anyway, I have to say, that whole idea of taking part of an existing band's name and just changing a letter or two is brilliant! Not only is it much easier than coming up with a new name from scratch, but when people hear the name, they think, "Hey, I think I've heard of them before" and—boom—you've got instant name recognition and that translates into more record sales (well, it would if they actually still sold records). For years now, I wanted to be a rapper (they always look like they're having so much fun in those beer commercials), and I even had my rapper name all picked out: I was going to be "Plain White Rapper." But, now I'm thinking I should do what Def Shepard did and use a derivative of an existing band name. So, how about if I named my band Bed Zepplin? Or maybe AC/BC? I thought The Rolling Jones might be nice, or how 'bout Elton Johnny, and I could do a song called "Goodbye Mellow Brick Toad"? Now, if you're a teen, you might be so young that you've never heard of these bands, so if my East Coast hip-hop style was aimed at this highly sought-after teen demographic, then I would go with a name like Mr. Gaga or Justin Timberpond. Or, if I wanted to go the rap route, I could be 51 Cent or Dr. Drayage, M&Ms, or my favorite, Snoop Scotty Scott (oh yeah, Snoop Scotty in da hiz-zay!). Now, if you're wondering, "What in the world does this have to do with Photoshop?" then you must have skipped over #4 in the "Six Things You'll Wish You Had Known Before Reading This Book" back in the book's introduction. Peace out. Fo shizzle!

1

PHOTOSHOP IS ABOUT FIVE MAIN THINGS

When we jump from Lightroom to Photoshop, it's most likely to use one of the five major things that Lightroom either can't do at all or if it can do it, it's pretty painful. Here are the five features you'll be jumping over to Photoshop for:

#1: LAYERS

A lot of Photoshop's power is in its ability to add things on top of a photo, while keeping them separate, so you can reposition, move, and blend them separately. This can be anything from adding professional type to your image, to painting on it with a brush, or even stacking parts of other photos to create collages or composites. You're going to be a shark at using layers in no time, and it's probably this incredibly powerful feature that has us coming over to Photoshop more than any other, with the exception of…

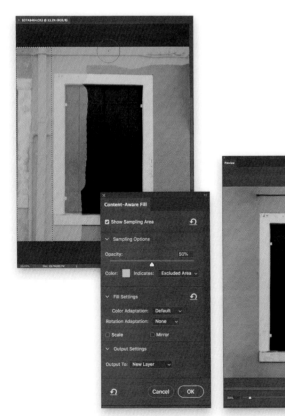

#2: REMOVING DISTRACTING STUFF

If you didn't come to Photoshop to use layers, then you're probably here because there's something in your image you don't want. Maybe it's a sign in the background, or a soda can on the ground ruining your sunset shot on the beach, or maybe it's a big branch encroaching on your image. Whatever it is, you want it gone, and while Lightroom has the Spot Removal tool, that tool is well-named—it's for removing specks, dust, and spots, but not much more. However, this is one area where Photoshop shines—it has tools and features to remove just about anything and to make it look like it was never really there. It's the king of making things or people go away (it's kinda like the Nickelback of image editing applications).

#3: FILTERS

There are 121 different filters (well, last time I counted anyway) that do everything from special effects, to fixing problems, to making things look awesome, to making things look awful, and you can use them in combinations to create amazing, wonderful, fascinating things. There are filters that can make wheels on a car look like they're spinning and filters that create smoke or fire. There are filters that create picture frames, there are filters that make a photo look like an oil painting, and everything in between, and most give you lots of control over how they look.

#4: BRUSHES

Lightroom has the Adjustment Brush, and you can paint with a hard-edged brush or a soft-edged brush. But, Photoshop is brush paradise—there are hundreds of different types of brushes, shapes of brushes, settings, and options galore. There's just an amazing amount of power there. You'll be using these brushes a lot and you don't even have to know how to draw (I can't even draw a stick man). These are powerful tools in the hands of a photographer.

#5: TOOLS

Lightroom has six tools (and three of them do the exact same thing, but with a different shape). Photoshop has nearly 70 tools (though, there are tools we, as photographers, won't use at all), and the ones we will use are incredibly helpful, handy, and easy to learn. Do you see where this is all going? Lightroom has a limited number of tools and features, and the ones it does have do very specific things. Photoshop has tons of tools and features, and brushes and power, and it opens up a whole new world to us Lightroom users. If you're working in Lightroom and there's something you want to do, but you know Lightroom can't do it, don't worry—Photoshop can. I'll show you how.

HOW LAYERS WORK

If you laid an 8x10" photo on a table, then took a 4x6" photo and laid it on top, you could move the 4x6 around, reposition it on top of the original photo, or you could even cut a hole in that 4x6 and see through that part of it. If you changed your mind, you could take that smaller photo away, so you'd just be left with the original 8x10. Well, that's how layers work in Photoshop. That 8x10" photo is your "Background layer" (that's its official name), and you can add stuff on top of it (like other photos), move them around, make parts of them transparent, or remove them altogether, all without messing up your original image. But, it's not just photos you can stack on top of your background photo—you can add type (on its own layer), shapes, paint strokes, and more.

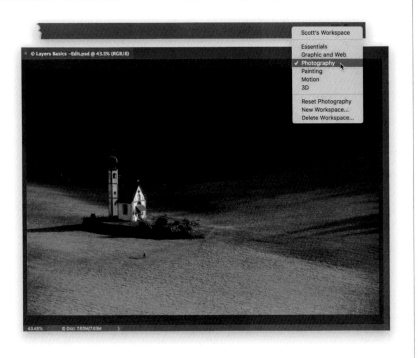

STEP ONE:

Let's do a quick, easy project, so you'll have a better idea of how layers work, and then we'll do another project to help you start using layers like a pro. Start in Lightroom by clicking on a photo, pressing **Command-E (PC: Ctrl-E)**, and the image will open in Photoshop (if it's a RAW photo; if it's a JPEG or TIFF, choose Edit a Copy with Lightroom Adjustments in the Edit Photo with Adobe Photoshop dialog). When the image opens in Photoshop, you can switch to the Photography workspace, so the Layers panel is right where you need it, along with only the tools that you'll need. In the right side of the Options Bar across the top of Photoshop, click-and-hold on the little rectangular icon with three dots and choose **Photography** (as shown here). *Note:* I've made some adjustments to my Photography workspace. You can see how I did this in the short video I created, which you can find on the book's companion webpage, mentioned in the book's introduction.

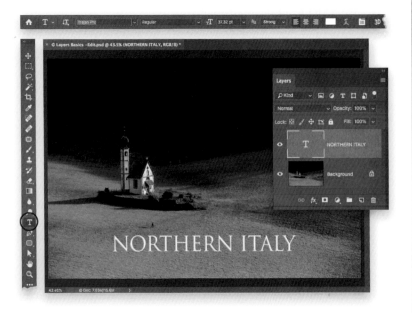

STEP TWO:

First, look over in the Layers panel on the right and you'll see your image is on a layer called "Background." Everything we add will float above that Background layer. So, let's add a Type layer by getting the Horizontal Type tool (**T**) from the Toolbar on the left, then click once anywhere on your image, and start typing (to replace the placeholder text the tool automatically adds for you). Change your font, style, size, etc., by highlighting the type and making these changes in the Options Bar. Here, I chose the Trajan Pro font. Just to the right of that, you can change the size and alignment (left, centered, right), and there's a color swatch for choosing your font's color (I chose white).

STEP THREE:

Look at the Layers panel, again. Notice that your Type layer appears above your Background layer? Layers stack in order from bottom to top, so the bottom image is the Background layer, then the Type layer is on top of that, and if we add more layers, we'll add them on top of what we already have, stacking bottom to top. By the way, Type layers automatically have a "T" as their thumbnail, so you can recognize them instantly. Since this new Type layer is floating, we can move it anywhere using the top tool in the Toolbar, the Move tool—just click on it to choose it and it becomes your active tool. Now, click directly on your type and drag it around your image, so you can see how it floats above the background. When you're done, drag it about where I have mine in the example shown here.

STEP FOUR:

Let's add another Type layer, so get the Horizontal Type tool again. Here, I added "photography by scott kelby" (all lowercase), and then I changed the font to Minion Pro Italic (you can choose any font you'd like). I then switched to the Move tool and dragged this new Type layer under the right side of my headline type. Okay, so how do you delete a layer? First, in the Layers panel, click on the layer you want to delete (to make it active), then simply press the **Delete (PC: Backspace) key** and it deletes the layer (you can also click-and-drag it down onto the Trash icon at the bottom of the Layers panel). Also, if you have a lot of layers in your Layers panel, to see more of them, move your cursor to the bottom of the panel and a double-headed arrow will appear (as shown circled here). Just click-and-drag down to expand the panel, so you can see more layers. Once you get more layers stacked up, a scroll bar will appear on the right side of the panel, so you can scroll through the layers to see them. Okay, let's look at resizing stuff on layers (on the next page), but we're going to keep using the same project for a few more minutes.

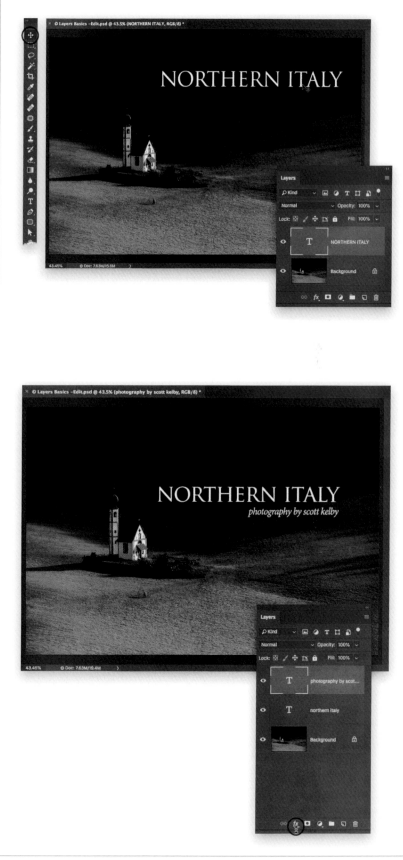

HOW TO RESIZE STUFF ON A LAYER

When you add something to a layer—whether it's another photo, or type, or something else—you'll want to know how to resize it (because stuff never seems to be the right size from the start). Luckily, Photoshop makes this really easy, and you can go beyond just resizing—you can rotate, add perspective, skew, all sorts of stuff. Here's how:

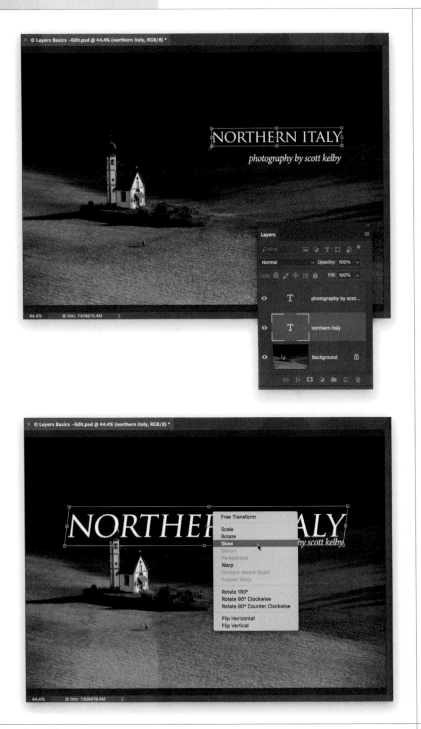

STEP ONE:

We resize things on layers (well, any layer but the Background layer) using a feature called "Free Transform." To use Free Transform, first click on the layer you want to transform (here, I clicked on the Northern Italy Type layer), then press **Command-T (PC: Ctrl-T)**. This puts a bounding box around your type (or image or whatever is on the layer you clicked on). To resize this layer, just click on one of the corner points and drag inward to make it smaller (as I did here) or outward to make it larger. Once it's at the size you want, just click anywhere outside the bounding box (or press **Return [PC: Enter]**) to confirm your transformation (you can also click the checkmark icon up in the Options Bar). If you change your mind about the resize before you confirm it, just hit the **Esc key** to cancel.

STEP TWO:

To see all the things you can do with Free Transform, after you press Command-T (PC: Ctrl-T), Right-click inside the bounding box and a pop-up menu will appear with all the things you can do to this layer. Because this is a Type layer, some things are grayed-out (Type layers, by default, are editable so once you do something to it in Free Transform, you can still highlight the type and change the word, the font, or whatever. To keep it editable, there are certain things you can't do). Here, I first chose Scale, then I clicked on a corner point and dragged outward to make my type much larger. Then, I Right-clicked again and chose Skew. Now you get to use the center points, so I clicked on the top one and dragged a little to the right to make the text look italic (this font didn't have an italic version).

STEP THREE:

So far so good. Now let's add another image to our project. Head back over to Lightroom, click on another image, and then press Command-E (PC: Ctrl-E) to bring it over to Photoshop. Once it's open in Photoshop, we want to copy-and-paste this image over onto the project we are working on (the Northern Italy project). To do that, first we have to select the image, so press **Command-A (PC: Ctrl-A)**, which puts a selection around the entire image (as seen here at the bottom; a selection looks like a Hollywood lighting marquee), then press **Command-C (PC: Ctrl-C)** to Copy that image into memory. Click back on the original image (tabs for each image appear across the top, if you have this default preference set, like I do here, so just click on the image's tab), then press **Command-V (PC: Ctrl-V)** to Paste this image into your Northern Italy document. When you paste an image, it automatically appears on its own layer, and it may be so large that it covers your entire original image (as seen here at the top). That's simply because the image we pasted is literally larger in size (taken with a higher megapixel camera) than the image on the Background layer. Easy fix, though: press Command-T (PC: Ctrl-T) to bring up Free Transform and we'll scale it down.

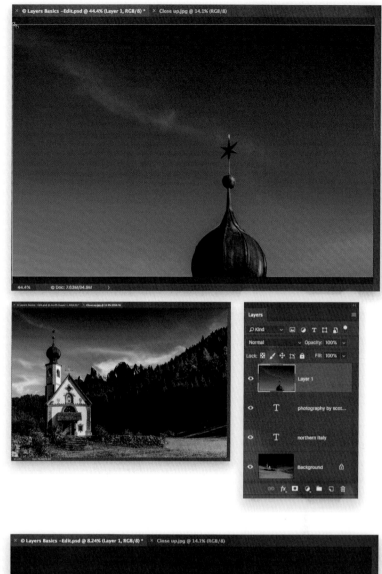

STEP FOUR:

If you look at the image in the previous step, you can see that there was only one corner point visible when I chose Free Transform on this new image layer. But, there's kind of a hidden trick for how to reach all four corner points: press **Command-0** (that's a zero; **PC: Ctrl-0**) and the window instantly resizes (shrinks the image area down), so you can see the corner points.

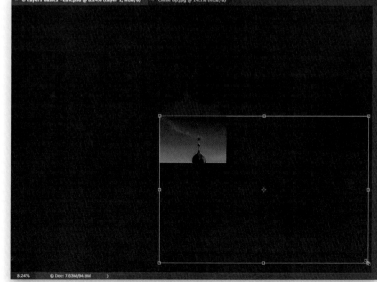

Continued

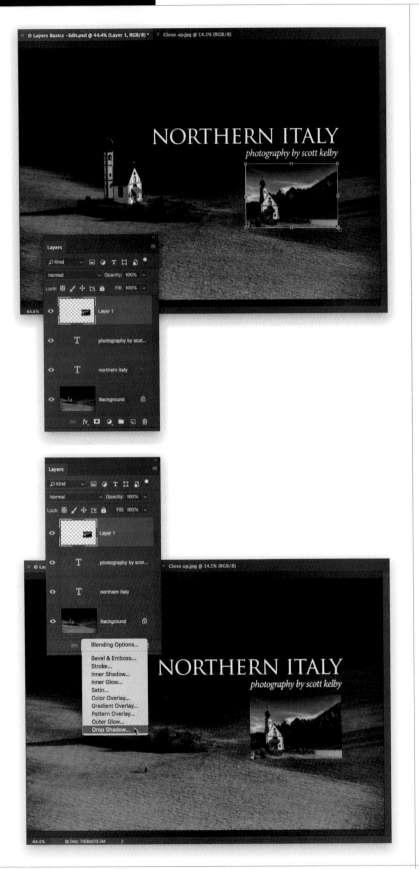

STEP FIVE:

Now that you can see all four corner points, click on one and drag inward to resize the image down and move it under the right side of the type (as seen here). You can reposition the image you're resizing without committing to the resize by just moving your cursor inside the bounding box and clicking-and-dragging it. When it's at the size and location you want, just click anywhere outside the bounding box to confirm your resize. Now, look at the layer stack (that's what we call layers stacked above the background) in the Layers panel. At the bottom, our Background layer is the first image we brought over from Lightroom; floating above that is the Northern Italy Type layer (thankfully, Type layers are automatically named with their first few words, making it easy to see which is which); then the "photography by scott kelby" layer; and lastly, this new smaller image layer. If you took the Move tool (**V**) and dragged that smaller image up higher, it would cover "photography by scott kelby," and if you went even higher, part of Northern Italy, too. That's because it's on the top layer in the stack. Try doing that yourself, so you see what I mean. Then, in the Layers panel, click-and-drag the "photography by scott kelby" layer above the small-image layer, and that type now appears over the small image. That's right—you can change the order of the layers in a stack by clicking-and-dragging them up/down.

STEP SIX:

Okay, drag that Type layer back where it was, then move your small image back where it belongs (and make sure its layer is active in the Layers panel by clicking on it once). Now we're going to add a drop shadow effect to our small-image layer. Effects like this are called "layer styles" and they apply the effect to whatever is on the layer (so, if you painted a red brush stroke on this layer, it would also have its own drop shadow). Click on the Add a Layer Style icon (the fx) at the bottom of the Layers panel and choose **Drop Shadow** from the pop-up menu of effects.

STEP SEVEN:
This brings up the Drop Shadow options in the Layer Style dialog. Use the Opacity slider to choose how dark your shadow will appear (I don't choose 100% because then it's solid, and without it being at least a little transparent, it looks unrealistic). You can also change the angle and distance of the shadow, but here's a killer little tip: move your cursor outside that dialog, right onto your image, and just click-and-drag the shadow right where you want it—much easier than messing with the Angle and Distance controls. The Size slider determines how soft the shadow will be—drag it to the left for a very hard, defined shadow or to the right for a very soft shadow, like you see here. Don't click OK yet, because while we're here, let's add a stroke around our small image to help it stand out from the background image. Under Styles, on the left, click on Stroke. Choose 3 px for your Size, click on the Color swatch and choose white, and set the Position to Inside, so the stroke appears inside the edges of the image. Now click OK to apply the shadow and stroke.

STEP EIGHT:
One more thing you'll want to know in this basics project is how to hide a layer (say you want to see what your image looks like without a particular layer, or perhaps you don't like the way one looks, but you're not ready to delete it—you just want to hide it while you're working things out). In the Layers panel, click the little Eye icon to the left of a layer's thumbnail and it hides that layer. Try hiding the small-image layer (click its Eye icon), then hide the "photography by scott kelby" layer, too (as shown here). Notice there are "eyes" beside Drop Shadow and Stroke, too? Make the small-image layer visible again (click where its Eye icon used to be), then hide the stroke effect, then the shadow effect by clicking on their "eyes." Okay, that's the basics, but it's important that you "level up," as they say, for the rest of the book to work for you. So, let's start a new project and take things up a notch, shall we?

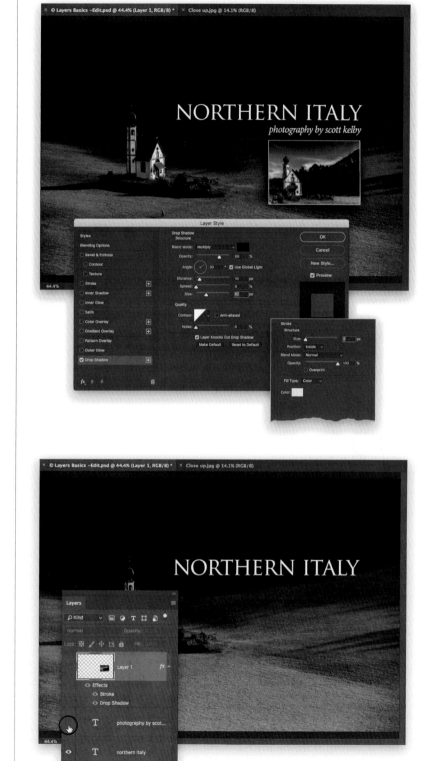

BLANK LAYERS AND USING OPACITY

Besides just dropping another photo on top as a layer or creating a Type layer (like we did in the previous project), sometimes you might want to use a color-filled rectangle to create a back-screen, or paint on a layer with a brush, or add an icon or a graphic, or one of a hundred things you might want to do on an empty layer. Here's how to create a new blank layer and fill an area of it with a color, along with how to change the opacity of your layers (and why you might want to):

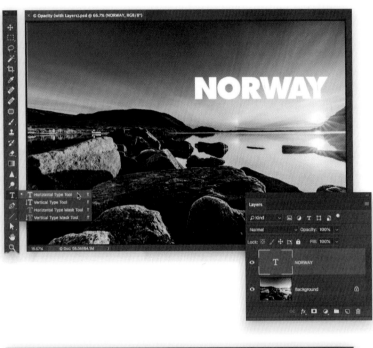

STEP ONE:

In Lightroom, press **Command-E (PC: Ctrl-E)** to open the image you want to edit in Photoshop and it will appear as the Background layer. We'll start by adding some text above the image, so get the Horizontal Type tool **(T)** from the Toolbar. First, set your Foreground color to white by pressing **D** on your keyboard (which makes your Foreground color black), then press **X** which swaps it to white. Click on your image, start typing, and it will reflect whatever font and size you have selected up in the Options Bar (I chose Futura Extra Bold here at 115 pt, but you can use any big, bold font you've got, in all caps). Once your type is in place, click on the Move tool (it's the first tool at the top of the Toolbar), and then click-and-drag your type, positioning it like you see here.

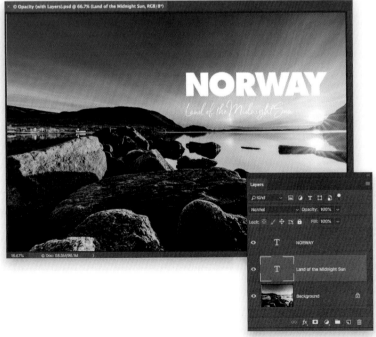

STEP TWO:

Let's create another line of type below our "Norway" headline, so get the Horizontal Type tool again, click somewhere on the image, and type "Land of the Midnight Sun" in a script font (I used Serendipity at 52 pt). Get the Move tool again, and click-and-drag this Type layer under the word "Norway," like I have here. Also, in the Layers panel, I would click-and-drag this new Type layer below the Norway layer (as seen here) because, visually, the Norway layer is higher up the image than the Land of the Midnight Sun layer (this will make more sense later on). Now that we've added this second Type layer, there is a problem: the area behind our Land of the Midnight Sun type is so bright that it's kind of hard to see the type. So, in the next step, we'll put something behind it to make it easier to see.

STEP THREE:

We're going to put a black bar behind the type, so it's easier to read, and we'll create this on a new blank layer. To create one, click on the Create a New Layer icon (it's the second one from the right) at the bottom of the Layers panel. Now, get the Rectangular Marquee tool **(M)** from the Toolbar and click-and-drag out a wide rectangle from side to side (as seen here). You'll see a moving marquee around that area. Press the letter D on your keyboard to set your Foreground color to black, and then press **Option-Delete (PC: Alt-Backspace)** to fill this selection with black. Now press **Command-D (PC: Ctrl-D)** to Deselect. This black bar is covering our Land of the Midnight Sun layer (because new layers are added above the active layer), so go to the Layers panel and click-and-drag that black bar layer down below your Type layers, and now it appears behind your type.

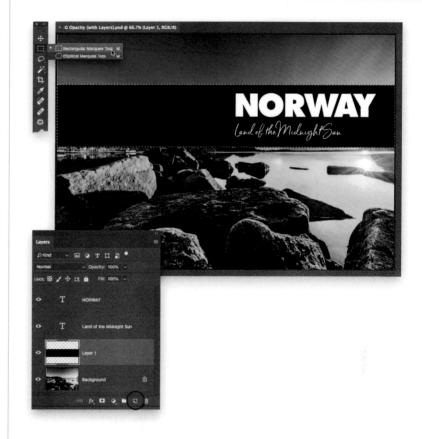

STEP FOUR:

Let's take a quick look at the Layers panel. We have the image on the Background layer (at the bottom of the layer stack), and then on top of that we have the black bar layer, and then the two Type layers. Now, if you look at the image in Step Three, you can see that the solid black bar covers up part of the image behind it. That's because it's a solid object and solid objects cover up what's below them in the Layers panel. However, you can change the opacity of these layers (except for the Background layer). So, if you want your solid object (the black bar, in this case) to be a little see-through, or even a lot see-through, you can simply lower the Opacity amount for that layer. With the black bar layer still active, go up to the Opacity field, near the top right of the Layers panel (where it says 100%), click on the little down-facing arrow to its right, and the Opacity slider appears. Drag it down to around 40% (as shown here), and now you can see through the black bar to the image on the Background layer.

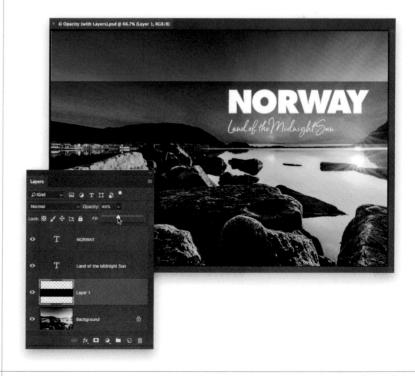

Continued

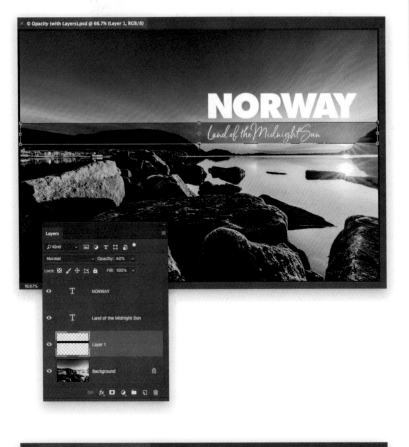

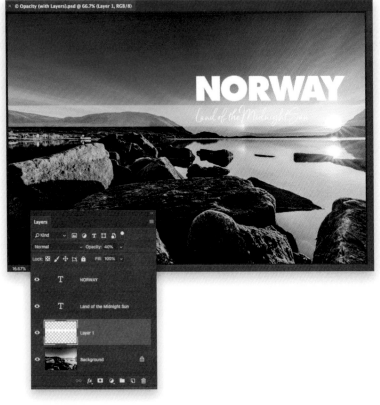

STEP FIVE:

That looks better, but the size of the bar is probably bigger than we need. It's easy to read the big Norway type, so we just need the black transparent bar to be behind our Land of the Midnight Sun layer. This gives us a chance to use Free Transform, again (we looked at this feature in the previous project). In the Layers panel, make sure your black bar layer is still active (just click on it if you're not sure—it should be highlighted), then press **Command-T (PC: Ctrl-T)** to put a bounding box around the black bar. To shrink its size, click on the top-center point and drag it downward until it's just a little higher than your Land of the Midnight Sun layer. Then, click on the bottom-center point and drag it up until the bar is just behind your second Type layer (as seen here). When it looks good to you, just click anywhere outside the bounding box to lock in your transformation (you can also press **Return [PC: Enter]** or click the checkmark icon up in the Options Bar. To cancel it, press the **Esc key** on your keyboard).

STEP SIX:

I'm not thrilled with how that back-screened black bar looks ("backscreening" is the term we use for a darkened area behind our type), so let's change its color from black to white. Since our Foreground color is currently set to black, all you have to do is press X to set it to white, so go ahead and do that now. Now, even though we don't have a selection around our black bar, we can still fill just the black bar with white by using a special keyboard shortcut: press **Option-Shift-Delete (PC: Alt-Shift-Backspace)**. That fills whatever is on your active layer with your Foreground color, which in our case, fills it with white (as seen here). The text is still kinda hard to read (white type on a white transparent bar), but we can fix that easily.

STEP SEVEN:

Our fix is to simply change the second line of type to black, so we'll have black type over a white backscreened bar. Press D, again, to set your Foreground color to black, and then we're going to use that same keyboard shortcut you just learned—the one that fills anything on a layer with your Foreground color. But, first, you have to tell Photoshop which layer you want to work on, so in the Layers panel, click on the Land of the Midnight Sun layer, then press Option-Shift-Delete (PC: Alt-Shift-Backspace) to fill this Type layer with black.

TIP: HIDING THE PLACEHOLDER TEXT

If you'd rather not have that placeholder text added when you click with the Horizontal Type tool, just go to Photoshop's Preferences under the Photoshop (PC: Edit) menu. In the dialog, click on Type on the left, then turn off the Fill New Type Layers with Placeholder Text checkbox, in the Type Options section.

STEP EIGHT:

Lastly, it's not just blank layers that have an Opacity adjustment—it's any layer (besides the Background layer, of course, because there's nothing below it to see through to). So, let's make our type less obtrusive by lowering the opacity of the Land of the Midnight Sun layer to 60%, then in the Layers panel, click on the Norway layer and lower its Opacity amount to 50% (as shown here). You'll probably wind up using the layer Opacity setting quite a bit in Photoshop, so I wanted to make sure you knew what it was and how to use it, as well as what we use blank layers for. This is handy stuff to know up front.

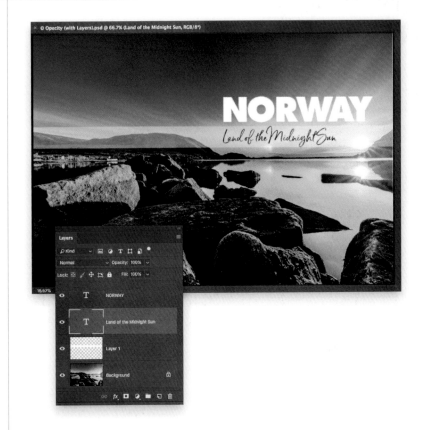

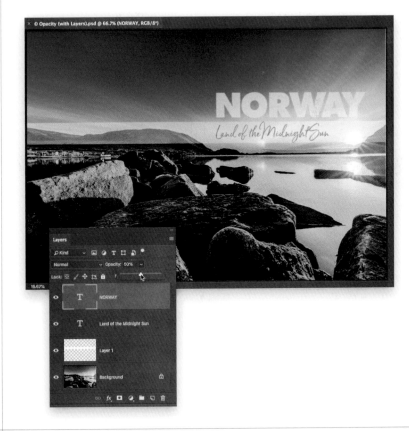

USING PHOTOSHOP'S TOOLBAR

You'll find all of Photoshop's tools in the vertical Toolbar on the left side of the screen. Now, while there are quite a number of tools in the Toolbar (compared to Lightroom's six tools), don't sweat it because there are a whole bunch of them we never ever use. Plus, once you see how Photoshop handles working with tools, you'll realize that it's much easier than it appears at first glance. Here are the most important things to know about Photoshop's Toolbar:

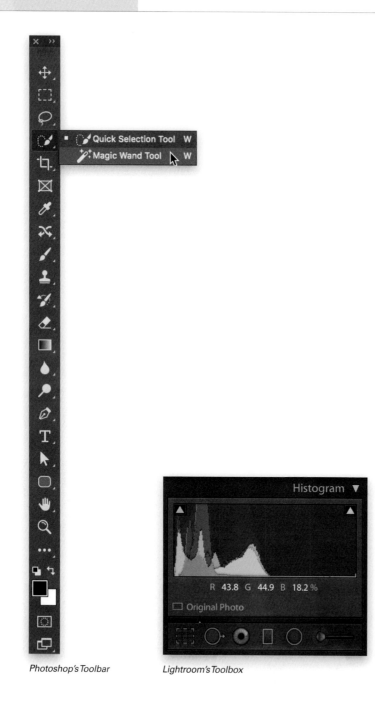

Photoshop's Toolbar Lightroom's Toolbox

THE TOOLBAR:
You're probably familiar with using tools, since Lightroom has a horizontal tool-box in the Develop module, right below the histogram (shown here below, on the right). Of course, it only has six tools, whereas Photoshop has 71 (don't worry, you don't have to learn them all. As photographers, we actually only use a few of these tools. By the way, I switched back to the Essentials workspace here; see page 4 for more about workspaces). Photoshop's Toolbar is vertical (seen here, on the left) and runs along the left edge of the screen (although, if you want it somewhere else, you can click-and-hold right on the little tab at the top of it, drag it right off the edge, and it becomes a floating Toolbar you can put wherever you want).

ACCESSING OTHER TOOLS:
The tools you see in Photoshop's Toolbar are the ones that Adobe figured you'd use the most. But, if you see a little triangle in the bottom-right corner of a tool's button, this means there are other tools nested (hidden) beneath that tool. Click-and-hold on one of those tools, and a little menu pops up displaying other tools (the "nested" tools). For example, if you click-and-hold on the Dodge tool, the Burn tool and Sponge tool (for de-saturating) appear. In the example shown here, if you click-and-hold on the Quick Selection tool, its cousin, the Magic Wand tool, appears.

MOST TOOLS HAVE OPTIONS:

When you click on a tool, any features or controls for that tool appear up at the top of the screen in the Options Bar (here are some of the Magic Wand tool's options). To return these options to their default settings, Right-click on the tool's icon on the left side of the Options Bar and choose **Reset Tool** from the pop-up menu.

KEYBOARD SHORTCUTS:

Most tools have a one-key keyboard shortcut assigned to them. Some are obvious, like you'd press L to get the Lasso tool or B to get the Brush tool, but then there are some that are not so obvious, like pressing V will get you the Move tool. This one-key shortcut thing is great, but the problem is there are 71 tools, but only 26 letters in the alphabet. So, nested tools have to share shortcuts. For example, pressing the letter I will get you the Eyedropper tool, but there are two other eyedropper tools, plus a few other tools, all nested under the Eyedropper tool, and they all share the same shortcut. To toggle through any nested tools, just add the Shift key. For example, each time you press Shift-I, it brings the next nested tool to the front as the active tool.

FOREGROUND & BACKGROUND COLORS:

There are two large color swatches at the bottom of the Toolbar: the top one is your Foreground color and the bottom one is your Background color. If you're painting with a brush, the Foreground color swatch will show you the color you'll be painting with (here on the left, our current Foreground color is black). The Background color swatch is used with other tools, like the Gradient tool (here, it's white). To change colors, click once on a swatch to bring up Photoshop's Color Picker. Click in the gradient bar in the center to choose your color, then click in the large square on the left to choose how vibrant the color will be. To reset the color swatches to their defaults (black/white), press the letter **D**. To swap the Foreground and Background colors, press the letter **X**.

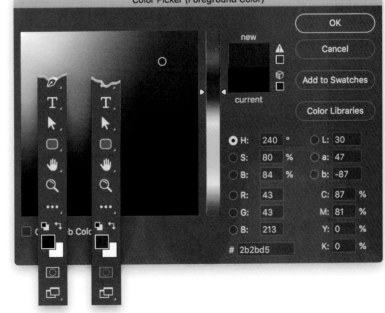

NAVIGATING PHOTOSHOP'S INTERFACE

Unlike Lightroom, by default, Photoshop's panels are all on the right side of the screen (there are no panels on the left side, just the Toolbar). But also, unlike Lightroom, most of Photoshop's 26 panels are hidden from view (you can find them all by going under the Window menu). Again, like with the tools, there are only a few photographers actually use. Also, some of the shortcuts for viewing and making your way around your images will be very familiar to Lightroom users. (*Note:* I'm working in Application Frame here, so you can see the full Photoshop window. You can turn this off on a Mac by selecting it under the Window menu.)

HIDING PANELS:
To hide all the panels (including the Toolbar on the left and Options Bar at the top), press the **Tab key** and you'll get the view you see here—just your image—no panels or Toolbar. If you only want the panels hidden, and to keep the Toolbar and Options Bar still visible, then press **Shift-Tab**.

TIP: PHOTOSHOP'S NAVIGATOR PANEL
If you like Lightroom's Navigator panel, there's one here in Photoshop, too. Go under the Window menu and choose **Navigator**. Use the slider beneath the image thumbnail to zoom in/out (drag to the right to zoom in tighter; to the left to zoom out). Once you've zoomed in, you can click-and-drag the red rectangle to where you want the zoom focus to be.

ZOOMING IN/OUT:
You zoom in/out in Photoshop using the same keyboard shortcuts that you use in Lightroom: **Command-+** (plus sign; **PC: Ctrl-+**) to zoom in and **Command-–** (minus sign; **PC: Ctrl-–**) to zoom out. To fit your image onscreen as large as it can fully be viewed, double-click on the Hand tool (its icon is a hand) in the Toolbar. To jump right to a 100% (1:1) view, double-click on the Zoom tool (its icon is a magnifying glass). To zoom right in to a particular area, get the Zoom tool (**Z**) and click-and-drag it in the area you want to zoom in tight on. Lastly, once you are zoomed in tight, you can use the scroll bars on the right and bottom of the image window to move around, but it's easier to just press-and-hold the **Spacebar** on your keyboard, which temporarily switches you to the Hand tool, so you can click-and-drag around the image.

COLLAPSING PANELS:

To give yourself more room to view your images, you have three ways to view your panels: (1) the regular full-panel view; (2) double-click directly on a tab and it collapses down to just show its name (here, I collapsed the Layers and Adjustments panels, along with all the other panels nested with them); (3) to tuck all the panels off to the right, so just their icons are showing, click on the two, tiny, right-facing arrows at the top-right of a panel. To see any panel (along with those nested with it) full size again, click on its icon. To see all the panels again, click on the two, tiny, left-facing arrows at the top right of the panel group.

REORDERING & CLOSING PANELS:

To change the order of nested panels, just click-and-drag a panel tab into the order you want (here, I'm dragging the History panel from the fourth position to the second). To move a panel from one group to another, just click-and-drag its tab onto the other group's tab. If you want to close a panel altogether and remove it from a group, click-and-drag the panel out of its group and release it over your image area. Now, click the little X in its top-left corner to close it.

OPENING & ADDING MORE PANELS:

All of Photoshop's panels can be found under the Window menu, so to open any panel, choose it from there, and it will appear floating over your image area. To add it to a panel group, click-and-drag its tab right over the tabs in the group where you want it to appear (here, I'm adding the Character panel to a group). That entire group of nested panels will have a blue highlight around it (seen here), letting you know you've targeted that group. Let go of the tab and the panel is added to that group. If, instead, you see a thin, blue horizontal bar, that means you're creating a new horizontal row of panels. If, as you're dragging a panel, you see a blue vertical bar, you're creating a new column of panels.

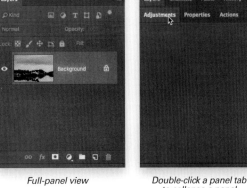

Full-panel view *Double-click a panel tab to collapse a panel* *Click the arrows at the top right to hide/show panels*

Click-and-drag tabs to reorder nested panels *To close a panel, click-and-drag its tab out of its group, and then click the X in the top-left corner*

ROTATING, FLIPPING & OTHER IMPORTANT STUFF

You already learned earlier in this chapter that we use the Free Transform feature to resize things on a layer. However, this feature is like a Swiss Army knife of transformations because it will do so much more. Let's do a quick project that will introduce you to some of the other important things you'll be using Free Transform for, besides just resizing.

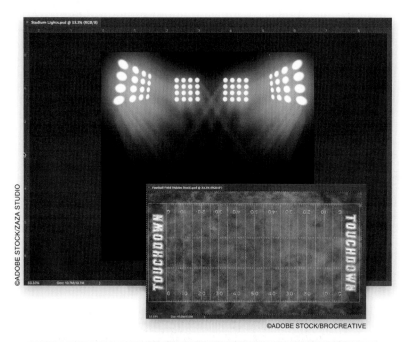

©ADOBE STOCK/ZAZA STUDIO

©ADOBE STOCK/BROCREATIVE

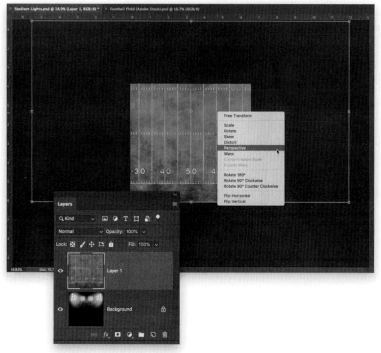

STEP ONE:
We'll start by opening the background image (this is an image I downloaded from Adobe Stock of stadium lights—we're going to build a Fantasy Football party invite graphic). Since this is just a generic stadium lighting background, I want to add an American-style football field to the bottom of it, so I also downloaded a field image. To get the field photo onto our stadium lights background image, open it, then press **Command-A (PC: Ctrl-A)** to select it. Now, press **Command-C (PC: Ctrl-C)** to Copy the field image into memory.

STEP TWO:
Switch back to the stadium lights background image and press **Command-V (PC: Ctrl-V)** to Paste the field image you just copied onto its own layer (as seen in the Layers panel here below). As you can see, it's a little big (another reason why we need to know how to resize stuff within Photoshop, but that's not what we're going to do here). So, we're going to use Free Transform's Perspective option to make the field look flat. Press **Command-T (PC: Ctrl-T)** to bring up Free Transform, then Right-click anywhere inside its bounding box, and a pop-up menu will appear with a list of all the transformations you can do. Choose **Perspective** (as shown here).

TIP: ANOTHER WAY TO COPY AN IMAGE
Go back to the field image, then go under the Layer menu and choose **Duplicate Layer**. In the dialog that appears, from the Destination pop-up menu, choose the stadium lights image, click OK, and it will appear there on its own layer.

STEP THREE:

To add the Perspective effect, click and-drag one of the bottom corner points out to the right (or left), and it flattens out the perspective of the image (as seen here). If you can't reach the bottom corner points, press **Command-0** (zero; **PC: Ctrl-0**) and your document window will automatically scale down (zoom out), so you can reach them all. As you drag them out farther and farther (like I've done here), you might have to do that "zoom out" trick more than once. Make sure you get it pretty flat looking (you can drag the top-left and top-right corner points in if you need to, as well). When you're done, just click anywhere outside the bounding box to lock in your transformation. By the way, there's a keyboard shortcut for Perspective (in case you don't feel like choosing it from the pop-up menu): after you bring up Free Transform, just press-and-hold **Command-Option (PC: Ctrl-Alt)**, and then click-and-drag a corner point.

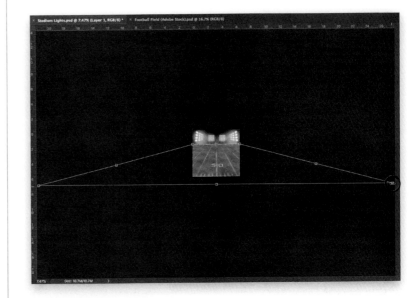

STEP FOUR:

Now that we've added our perspective, let's fade the back edge of the field to black. We do this using a layer mask, and you'll learn more about them, and why we use them, later on, but for now, your introduction will be using one to fade the back of this field to black. First, click the Add Layer Mask icon (the third icon from the left; it looks like a rectangle with a black circle in the center) at the bottom of the Layers panel. Now, get the Gradient tool **(G)** from the Toolbar, then go up to the Options Bar and click on the little down-facing arrow to the right of the Gradient thumbnail to bring up the Gradient Picker, and click on the third gradient from the left in the top row—the Black, White gradient. Take the Gradient tool, click it just inside the back of the field (where you want the field to be black), and then drag it to the front of the field where you want to see solid field. That does it—now your field fades to black. If you don't like how it looks, press **Command-Z (PC: Ctrl-Z)** to Undo and try dragging the tool again, starting in a slightly different place.

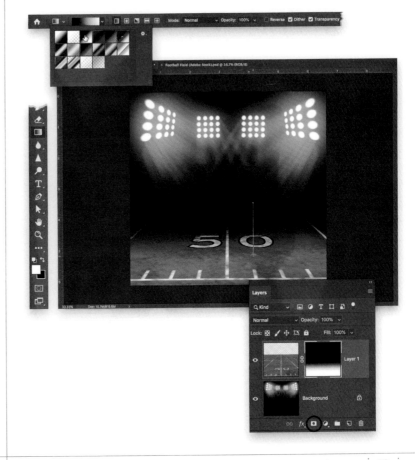

Continued

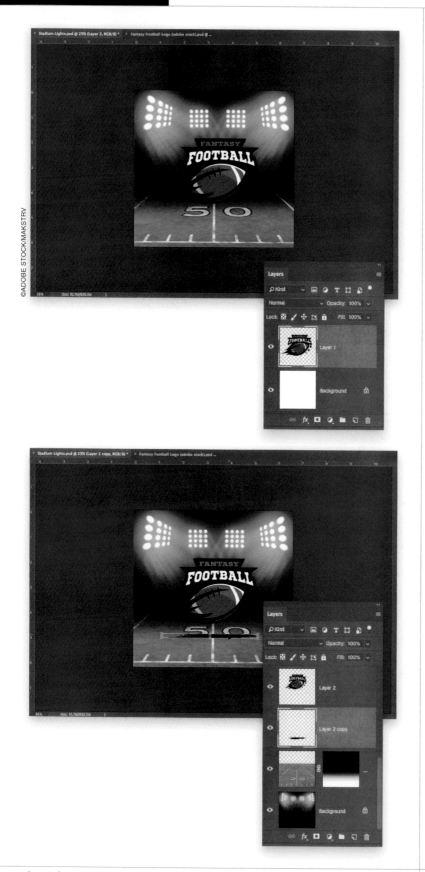

©ADOBE STOCK/MAKSTRV

STEP FIVE:

Next, let's bring in our logo—bringing it in will be a breeze because I already have it on its own separate layer, and now you know that you can copy-and-paste layers between documents. So, open the logo image, click on the logo layer in the Layers panel (seen here), and then press Command-C (PC: Ctrl-C) to Copy it. Switch back to your stadium light document, press Command-V (PC: Ctrl-V), and the logo appears on its own layer. Get the Move tool **(V)** from the Toolbar and click-and-drag the logo into position (as seen here).

STEP SIX:

Now we're going to use Free Transform to help us create a drop shadow of the logo on the field. (*Note:* We looked at Photoshop's built-in Drop Shadow effect for layers earlier in this chapter, but that would put the shadow behind the logo, not down on the ground below it, so we'll have to do this manually. It's okay; it's easy.) First, let's make a duplicate of our logo layer, and the quickest way to duplicate a layer is to use the keyboard shortcut **Command-J (PC: Ctrl-J)**. Now, press **D** to set your Foreground color to black and let's fill this duplicate logo layer with black by pressing **Option-Shift-Delete (PC: Alt-Shift-Backspace)**. By the way, if we didn't include the Shift key in that keyboard shortcut, Option-Delete would just fill our entire layer with black. By holding Shift, it just fills whatever is already on that layer—in this case, it covers over our logo in black. Now, in the Layers panel, click-and-drag this black-filled, duplicate logo layer beneath the original logo layer in the layer stack. Press Command-T (PC: Ctrl-T) to bring up Free Transform, and you'll see the control points appear around our black-filled logo. Click on the top control point and drag straight downward to squish the logo so it's very short, and then click inside it and drag it so it's positioned on the field, under the logo (as shown here). When you're done, just click anywhere outside the bounding box to lock in your transformation.

STEP SEVEN:

We now have a hard-edged shadow, but we want a soft one, so we'll use a filter to soften and blur the edges. Go under the Filter menu up top, under Blur, and choose **Gaussian Blur** (this is the main filter we use to blur things). When the filter dialog appears, you'll see a Radius slider. The higher the Radius, the blurrier things get, so choose something around 24, and then click OK to soften the shadow. Now, to make it a bit more realistic, let's go near the top-right corner of the Layers panel and lower the Opacity amount of this drop shadow to around 65%. Okay, next let's open the image of a football player. He's on his own separate layer, as well, so we can copy-and-paste that layer of him into our main image document. Once it appears, click-and-drag this layer to the top of the layer stack in the Layers panel and use Free Transform to scale him down to size. Remember, if you can't reach the control points, press Command-0 (zero; PC: Ctrl-0) to shrink the window down so you can reach them. Then, click inside the bounding box and drag him over to the left side, positioning him so his left side extends out of the document (like you see here), then just click anywhere outside the bounding box to lock in your resize.

STEP EIGHT:

Next, let's make a copy of our player layer, flip him horizontally, and move this copy to the other side. Press Command-J (PC: Ctrl-J) to make a duplicate of our player layer then, using the Move tool, drag this copy layer over toward the center, just so it's easy to see there are two different layers of the same player. Now bring up Free Transform (by now you know the shortcut), Right-click anywhere inside the bounding box and, from the pop-up menu that appears, choose **Flip Horizontal** (as shown here).

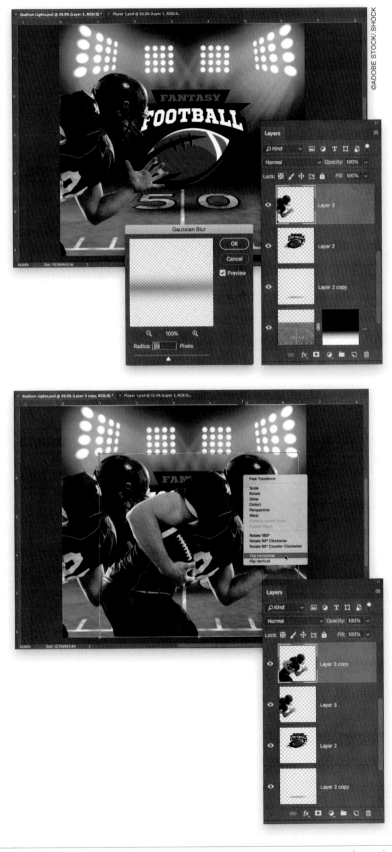

Continued

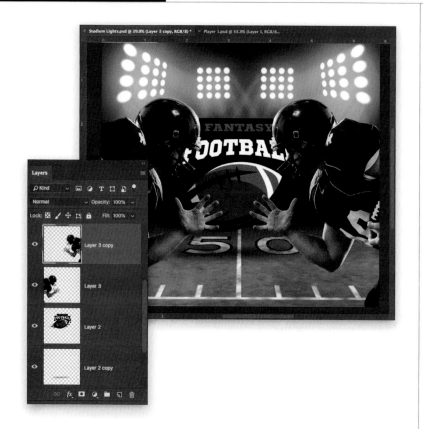

STEP NINE:
This flips the duplicate player so they are now facing one another, but you'll have to click inside the bounding box and drag him over to the right, so his right side extends off the screen, like the left side does. Position him so there's a gap between the two players and you can see most of the logo behind them, and then click anywhere outside the bounding box to lock in your transformation. If you need to, using the Move tool, click on the logo layer, and drag it to where it looks right between the two players (that's what I kinda had to do here).

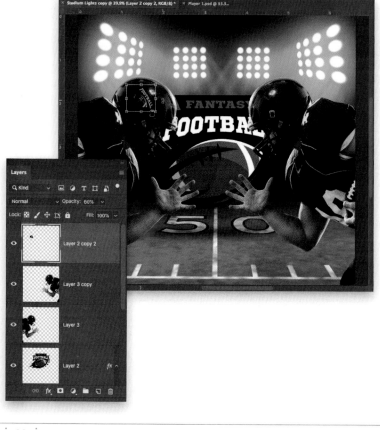

STEP 10:
Now we're going to add small versions of the Fantasy Football logo to the players' helmets. In the Layers panel, click on the logo layer, press Command-J (PC: Ctrl-J) to duplicate it, and then drag this duplicate layer all the way to the top of the layer stack, so it appears in front of the players. Now, bring up Free Transform and scale the logo down until it's small enough to fit on the player's helmet on the left. Once the size is right, move your cursor just outside the bounding box, and it will turn into a two-headed arrow. Click-and-drag up/down to rotate the logo until it looks right on the helmet (as seen here, where it's "kinda" right), then lock in your transformation.

STEP 11:

To make the logo look a bit more like it's really on his helmet, lower its layer's opacity a bit—to around 60%. Now, make a duplicate of this small logo layer (you know the shortcut), click-and-drag it over to the other helmet, and use Free Transform to rotate it a bit. Since you had already lowered the opacity before you made the duplicate, it has already been lowered to 60%. Next, we're going to add a glow around the big logo that matches the blue tint in the stadium lights to kind of unify them color-wise.

STEP 12:

In the Layers panel, click on the big logo layer to make it active, then click on the Add a Layer Style icon (the fx) at the bottom of the Layers panel, and choose **Outer Glow** (this applies a glow to whatever is on this layer). When the Layer Style dialog appears (seen below on the right), click on the color swatch to bring up the Color Picker and we'll steal a color that's already in our document. While the Color Picker is open onscreen, move your cursor out onto your image, and click on that blue color coming off the lights, and that becomes the color of your glow (how easy was that?). To increase the size of your glow, drag the Size slider to the right, and if your glow isn't visible enough, drag the Opacity slider to the right, as well. When it looks good to you, click OK. Lastly, using the Move tool, drag your logo a little higher in the frame so the players don't block quite as much of it (as seen here), and your project is complete. Note: At the very end, I didn't like the two shots of the same player in the same pose, so I downloaded another shot of the same player, but in a different pose (I had to flip him horizontally). Also, if you struggled a little with this project, don't sweat it—this was a more advanced one, but it got you more familiar with Free Transform, and you got a good foundation in using layers and opacity, and again, that's all good stuff to know up front.

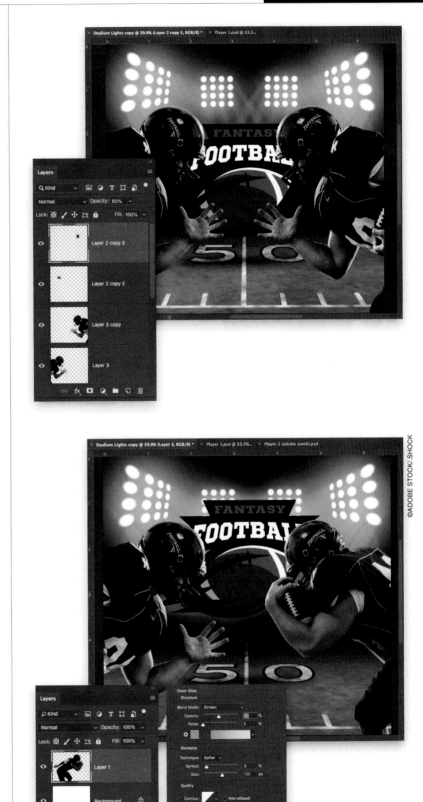

BASIC SELECTIONS (HOW TO WORK ON JUST PART OF YOUR IMAGE)

All of Lightroom's Develop module sliders pretty much affect the entire image. So, if you wanted to adjust only part of an image, you'd get the Adjustment Brush and paint over just that area. You can also do this in Photoshop (using a different method), but generally, if you want to edit just one part of your image, you use Photoshop's selection tools to tell it: "When I make an adjustment, only affect this area." There is a tool for every type of selection imaginable, which is one of the things that make Photoshop so powerful. Here are the selection tools you'll use the most, but we'll cover more advanced ones later in the book:

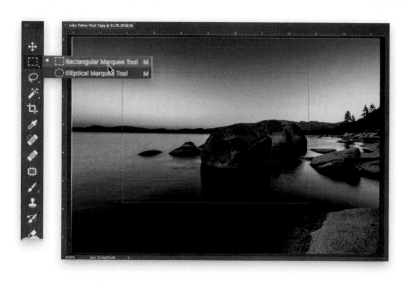

MAKING RECTANGULAR SELECTIONS:

If the area you want to select is either square or rectangular, there's one tool that does both: the Rectangular Marquee tool (I think they call it "marquee" because the animation that shows where the selection boundary is looks like a Hollywood movie marquee with chasing lights, but most folks just call it "the marching ants"). Choose this tool (it's the second one from the top in the Toolbar, or press **M**) and select an area by clicking-and-dragging out a rectangle (as seen here, where I drew a rectangular selection over the rocks). *Note:* To make a perfectly square selection, just press-and-hold the Shift key while you click-and-drag.

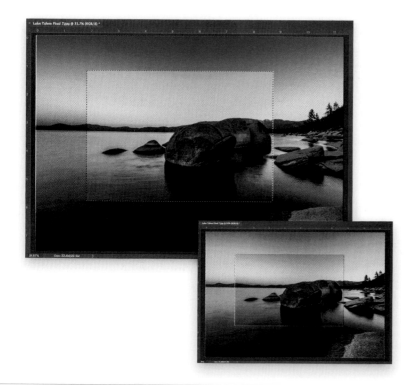

ADJUSTING THAT SELECTED AREA:

Now, if you make any adjustments to the image, only the area inside that rectangle will be affected. Let's give it a try. There's a feature that completely removes color called, "Desaturate," so go ahead and use its keyboard shortcut, **Command-Shift-U (PC: Ctrl-Shift-U)**, and you'll see it only removes the color from inside your selected area (as seen here). By the way, you can also use a selection to do the opposite of this—drag out a selection over a part of the photo you don't want affected, then go under the Select menu and choose **Inverse**. Now, when you remove the color, it removes it from everything outside your originally selected area (as seen here in the inset). Okay, hit **Command-Z (PC: Ctrl-Z)**, which is the keyboard shortcut for Undo, a few times to get the image back to how it looked before you removed the color from parts of it.

ADDING OTHER AREAS TO YOUR SELECTED AREA:

Once you have a selection in place, if you want to add more areas to it, just press-and-hold the **Shift key** and drag out more rectangles. That's what I did here, where I dragged out two more smaller rectangles on the right side of the big rectangle, and now those two areas are added to my original rectangular selection.

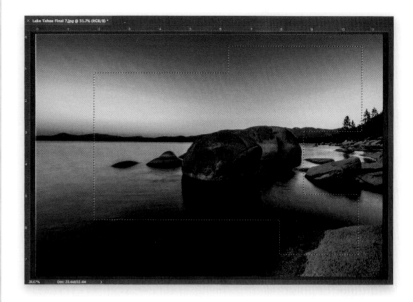

SUBTRACTING FROM YOUR SELECTED AREA:

If instead of adding, you want to subtract an area from your selection, press-and-hold the **Option (PC: Alt) key** and click-and-drag over that area (which is what I did here where I removed most of the left side of my selection—I pressed-and-held the Option key and dragged out a rectangle over the area on the left I wanted to remove from my selection). Now, if you were to desaturate (remove the color), it would only affect those areas that are still selected (as seen here). *Note:* You can use these same keys (Shift and Option) to add/subtract from selections made with any of Photoshop's selection tools. Let's hit Command-Z (PC: Ctrl-Z), again, to Undo our color removal from that selected area.

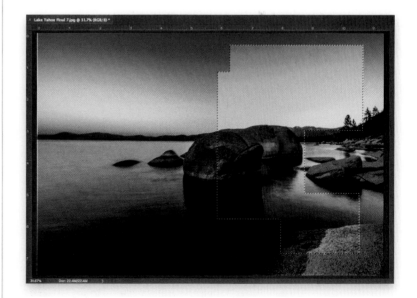

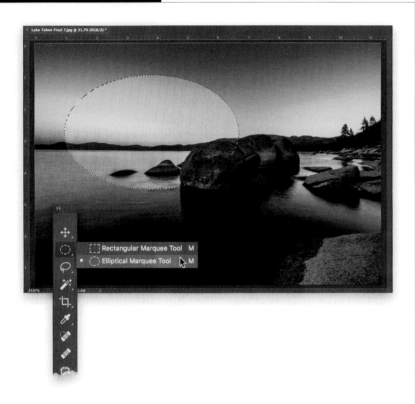

MAKING CIRCULAR SELECTIONS:

Let's move on from rectangular and square selections to oval or circular ones. They work the same way, but you just use a different tool—the Elliptical Marquee tool (it's nested beneath the Rectangular Marquee tool in the Tool-bar, or press **Shift-M**). Click-and-drag to make oval-shaped selections; press-and-hold the Shift key while clicking-and-dragging to make perfect circles.

TIP: DESELECTING & MOVING SELECTIONS

If you want to remove your selection altogether (called "deselecting"), just press **Command-D (PC: Ctrl-D)**. To move or reposition a selection, click inside it (while you still have the selection tool) and drag it. To reposition your selection while you're dragging it out, press-and-hold the **Spacebar** and you can move it as you drag it out. Lastly, if you want to move what's inside a selected area (not just the selection itself), then switch to the Move tool **(V)**.

DRAWING FREEHAND SELECTIONS:

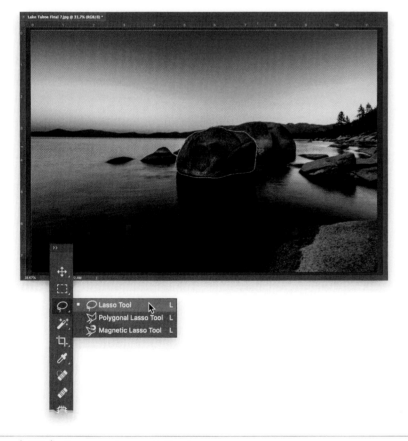

The Lasso tool (**L**; the third tool down in the Toolbar) lets you draw a free-form selection (here, I traced around the big rock in the foreground). Just click-and-hold and start drawing, like you're tracing around the edges with a pencil or pen. When you get back near to where you started, release the mouse button and it connects to where you started and makes the selection. If what you want to select has straight lines, but it's not a square or rectangle (like a stop sign), then you can use the Lasso tool's cousin, the Polygonal Lasso tool (it's nested beneath the Lasso tool; press **Shift-L** until you have it). This tool lets you draw a selection made up of straight lines and kind of works like a connect-the-dots tool: click at the point where you want to start, move your cursor to the next corner and click, it draws a straight selection line between the two points, and then you continue on to the next point. When you get back to where you started, click on the first point and it creates the selection.

THE QUICK SELECTION TOOL:

If you want to select a large object, or more than that, try using the Quick Selection tool (**W**; the fourth tool down in the Toolbar) to paint over what you want to select (like I did here, where I painted over the rocks), and it selects it by sensing where the edges are (similar to Lightroom's Adjustment Brush with Auto Mask turned on). If it selects too much, press-and-hold the **Option (PC: Alt) key** and paint over the areas you didn't want it to select and it will subtract those areas from your selection (it does a pretty good job once you tell it where you messed up). So, once these rocks are selected, any changes I make (brightening, darkening, sharpening, etc.) will only effect those rocks.

THE MAGIC WAND TOOL:

This tool is handy when you have a solid color or similar colors in an area you want to select—say you had a solid yellow wall and you wanted to select it so you could change its color. The Magic Wand tool will usually select that entire wall in just one or two clicks. Here, we want to select the sky, so get the Magic Wand tool (it's nested beneath the Quick Selection tool; or press **Shift-W**) and click it once in the sky. It selects some of the sky, but not all of it, so press-and-hold the **Shift key** (to add to your selection) and click it again over any areas it missed—you might have to do this a few times. Also, the Tolerance amount (up in the Options Bar) determines how many colors out it selects—the higher the number, the more colors it includes. So, if it selects way too much, just enter in a lower number (the default number is 32. I usually try 20, and then 10, if it's selecting too much, but in this case, it's not selecting enough. So, you can either increase the number a lot, or keep Shift-clicking over areas that didn't get selected, which is usually what I do). I went ahead and desaturated the sky here—not what I would actually do, but I wanted you to clearly see we were fully able to select the sky. Okay, now you should have a handle on the essential selection tools.

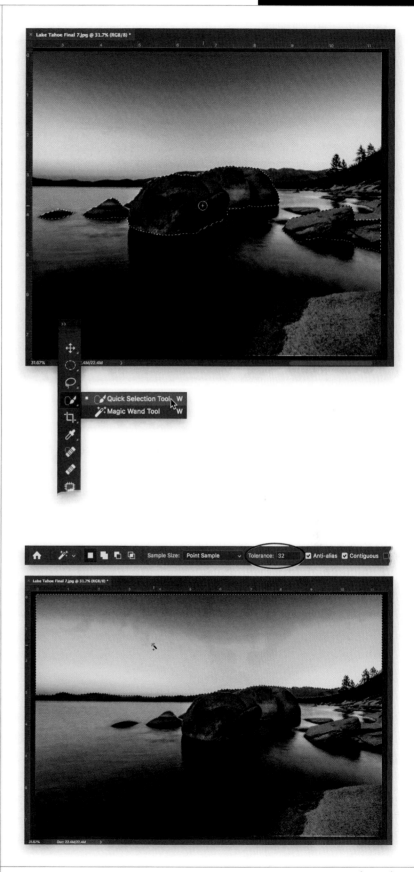

CAMERA RAW: IT'S LIKE LIGHTROOM ON A LAYER

When Adobe created Lightroom, they took their Camera Raw plug-in from Photoshop and added it to Lightroom (it has the same sliders, in the same order, that do the exact same things). But, in Lightroom, they call it the Develop module. Luckily, you don't have to jump back to Lightroom to make edits like you would in the Develop module, because you can use the Camera Raw filter right within Photoshop. Here's how:

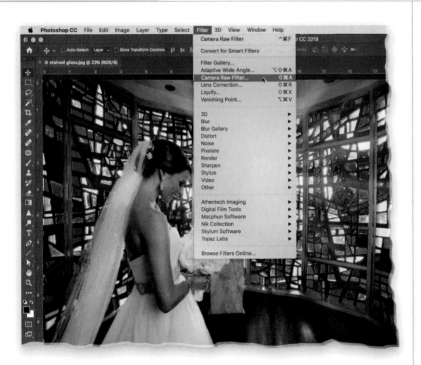

STEP ONE:
In Lightroom, press **Command-E (PC: Ctrl-E)** to open the image you want to edit in Photoshop. If you come to a point where you want to add a Develop module edit, but you're not ready to head back to Lightroom quite yet, just go under the Filter menu and, right near the top, you'll find **Camera Raw Filter** (as seen here).

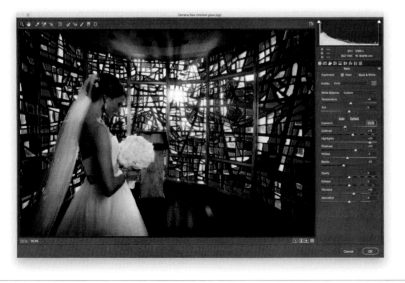

STEP TWO:
This brings up the Camera Raw window (it's generally just called "ACR," for short), and if you look on the right side of the window, you'll see all the same sliders, with the same names, that do the same thing as in Lightroom's Develop module, so this should all be familiar to ya. The functionality is the same, but things appear a little differently: for example, the toolbar (that includes the White Balance eyedropper tool) is in the top left, and instead of scrolling down to get to the other panels, they're in a row of horizontal icons near the top right—just hover your cursor over each icon to find what you're looking for. Anyway, you make your Develop module edits here, then click OK, and you're instantly back in regular Photoshop to pick up right where you left off. Easy enough.

Layer blend modes open up a whole new world of effects and blending between layers, and they are super-easy to use (which is why they are so popular). Basically, they determine how a layer interacts with the layers below it. When a layer is set to the default Normal blend mode, it doesn't interact with the layers below—anything on this layer covers up whatever is below it. It's a solid thing. However, if you change a layer's blend mode from Normal to anything else, now it can affect what's below it, making it darker, lighter, more contrasty, artsy, weird, all kinds of looks—it just depends on which one you choose. Here, I'm going to introduce you to a few of the most popular ones:

INTRO TO LAYER BLEND MODES

STEP ONE:

When you have a background image, with another layer above it, when the layer blend mode for the top layer is set to Normal (as it is here), that layer covers whatever is on the layer below—you can't see through it. It doesn't blend with the image below, it simply covers it. By changing the blend mode, the image on top can blend in with the image below. You choose blend modes from the pop-up menu above the word "Lock" in the Layers panel. Click-and-hold on it and 27 different blend modes appear. The most popular are: Multiply, which darkens the top image as it blends with the image(s) below; Screen does the opposite—it brightens as it blends; Soft Light blends and adds contrast; and Overlay blends with more contrast.

STEP TWO:

Here, I chose one that's not as popular: Hard Light. Why? I thought it looked best. How did I know? I quickly tried all 27. How? By pressing **Shift-+ (plus sign)**. Each time you press this, it auditions another blend mode (well, it toggles through them one-by-one, but "audition" sounds much more regal. You can also hover your cursor over each blend mode in the pop-up menu to see how each one will look). Anyway, while I was "auditioning" different ones, I just liked the way Hard Light looked. However, a few of my favorites looked good too, including Multiply (shown bottom left), and Overlay (bottom right). What's interesting is that if you put the chocolate boxes on the top layer, and the cups and beans on the lower layer, and use the same blend modes, you get entirely different looks—I love that. Don't forget that Shift-+ trick. That'll make you start to fall in love with layer blend modes, too.

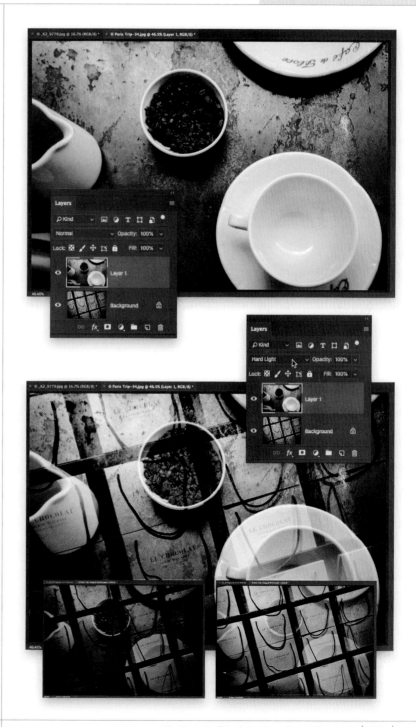

LAYERS CHEAT SHEET

Here's a quick cheat sheet of 10 layer moves you'll wind up doing a lot. I thought I'd put 'em all in one place to keep you from digging through all the projects we just did, in case you need to refer back to this chapter later (and, I hope you will, but now you can just jump right here).

#1

#2

#3

#4

#5

#5

1. TO DELETE A LAYER:
In the Layers panel, click on the layer you want to delete, and then hit the **Delete (PC: Backspace) key** on your keyboard, or just click-and-drag the layer onto the Trash icon at the bottom of the panel (as shown here on the left).

2. TO HIGHLIGHT ALL THE TYPE ON A TYPE LAYER:
In the Layers panel, double-click directly on the T icon for the Type layer you want to select (as shown here on the right) or, using the Move tool **(V)**, double-click right on the type itself.

3. TO CREATE A NEW LAYER:
Click on the Create a New Layer icon (the rectangular icon just to the left of the Trash icon) at the bottom of the Layers panel (as shown here on the left).

4. TO TRY OUT DIFFERENT BLEND MODES TO SEE WHICH ONE YOU LIKE:
Press **Shift-+ (plus sign)** to toggle through the different layer blend modes until you see one you like (as seen here on the right), or just hover your cursor over each one in the blend mode pop-up menu.

5. TO CHANGE THE ORDER OF YOUR LAYERS:
Click-and-drag them up/down in the Layers panel. To move the current layer up one level, press **Command-] (PC: Ctrl-])**. To move it down one level, press **Command-[(PC: Ctrl-[)**.

6. TO CHANGE THE BACKGROUND LAYER INTO A REGULAR LAYER:

In the Layers panel, click on the lock icon to the far right of the word "Background."

#6 *#6*

7. TO HIDE A LAYER FROM VIEW:

Click on the Eye icon to the left of the Layer you want to hide. Click where it used to be to bring it back. To see just one particular layer and hide all the rest, Option-click (PC: Alt-click) on the layer's Eye icon. All the other layers will be hidden, and only that layer will be visible. To bring them all back, Option-click on that Eye icon again.

#7 *#7*

8. TO RENAME A LAYER:

In the Layers panel, double-click directly on the layer's name to highlight it, then type in a new name, and hit the **Return (PC: Enter) key**.

9. TO DUPLICATE A LAYER:

Press **Command-J (PC: Ctrl-J)**.

#8 *#9*

10. TO SELECT MULTIPLE LAYERS:

Press-and-hold the Command (PC: Ctrl) key, and then click on the layers you want to select. If the layers are contiguous, press-and-hold the Shift key, click on the first layer, and then click on the last one to select them. While selected, they'll now move as a group.

#10 *#10*

JUMP

As soon I thought of jumping back and forth between Lightroom and Photoshop, I knew this chapter's title had to be "Jump" by Van Halen. And, by Van Halen, of course, I mean the "real" Van Halen with lead singer David Lee Roth, which to many of us is the only incarnation of Van Halen that will ever be "real," because when they replaced David Lee Roth with Sammy Hagar, they became something else—a great band with a really good guitar player…and Sammy Hagar singing. But, that my friends is not Van Halen. Honestly, at that point, I think they should have changed the band's name to Van Heusen. That way, fans would instantly know that: (a) this is not really Van Halen, and (b) this would make a great name for the world's best-selling dress shirt brand. By the way, since I mentioned Van Heusen, did you know that "Van Heusen has been associated with stylish, affordable, and high-quality shirts since introducing the patented soft-folding collar in 1921?" Well, it's true because I read it on the Internet, and as you know, the International Council That Ensures Everything You Read on the Internet Must Be True (or the ICTEEYROTIMBT, for short) stands 100% behind this assertion. Now, if you're thinking that mentioning Van Heusen is a sneaky way for me to somehow introduce paid product placements into my chapter openers, well that is just absurd (by the way, did you know that "Today, Van Heusen has grown into a 24/7 lifestyle brand known not only for dress shirts but for both men's and women's dresswear, sportswear and accessories"?). This is clearly just another baseless charge probably concocted by marketing folks at Calvin Klein or Kenneth Cole or One Direction, who feel threatened by Van Heusen's "fit, fabric, finish and innovative fashion—at a fraction of the cost of luxury brands." Just preposterous! I would never stoop to such levels (www.vanheusen .com), and frankly I'm a bit taken aback by such baseless allegations. So much so, in fact, that I've done a bit of research, and I've uncovered an astonishing conflict of interest, which I believe is the real reason Sammy Hagar was kicked out of Van Halen and replaced by the original, and only true, lead singer of Van Halen, David Lee Roth. It seems that Mr. Hagar just happens to own a rather large company that makes men's slacks (www .haggar.com). Shocking! Well, at least finally, now, the truth is out!

GOING FROM LIGHTROOM TO PHOTOSHOP (AND BACK)

When you're in Lightroom and you get to a point where there's something you need to jump over to Photoshop for, the process is really simple, and having that "edited in Photoshop" file come right back to Lightroom is just as easy. Here's how to make the round trip:

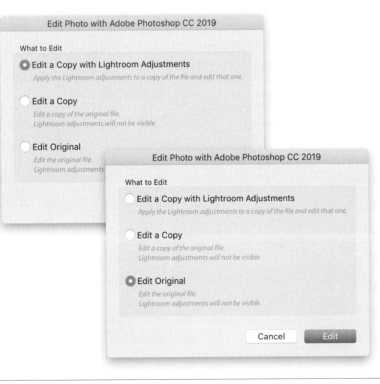

RAW PHOTOS:

To take a RAW image over to Photoshop, press **Command-E (PC: Ctrl-E)**. There's no dialog, no questions to answer—it just opens immediately in Photoshop. (*Note:* If Photoshop's not already open, it will launch it for you automatically.) By the way, you can also send your image over to Photoshop the slow way by going under Lightroom's Photo menu, under Edit In, and choosing **Edit in Adobe Photoshop CC** (as shown here), but I'd only do it that way if you're charging by the hour.

JPEG, TIFF, OR PSD PHOTOS:

If your images are JPEGs, TIFFs, or PSDs, then it's slightly different. It's the same keyboard shortcut (Command-E [PC: Ctrl-E]), but a dialog will appear asking you to choose how this image is going over. The three choices are: (1) Edit a Copy with Lightroom Adjustments (this is what I would normally choose, as I want anything I've done to the photo in Lightroom to still be there when it heads over to Photoshop). (2) Edit a Copy (I'm not sure I've ever chosen this one, because none of my changes would be included in the copy). Or, (3) Edit Original. I only choose this one in one very specific scenario: when I've taken an image over to Photoshop, then saved the file with all its layers still intact and let it go back to Lightroom. In Lightroom, if you want to reopen that same layered file in Photoshop again and have all those layers still intact, choose Edit Original, and when it opens back up in Photoshop, those layers will all still be there. Outside of that, I wouldn't risk messing up my original file, so I wouldn't advise Edit Original outside of that very specific scenario.

HOW TO GET IT BACK INTO LIGHTROOM:

Once your image is in Photoshop, you can do anything you'd like to it, just as if you didn't own Lightroom. When you're done editing in Photoshop, getting your image back to Lightroom is simple. Just do two things: (1) save the file (press **Command-S [PC: Ctrl-S]**), and then (2) simply close the file. The image automatically returns to Lightroom, and as long as you turned on the Stack with Original checkbox in the External Editing preferences (we'll look at that option on page 38), the edited copy will appear right next to the original. That's it. Don't overthink it.

NOT SENDING IT BACK TO LIGHTROOM:

If, after you send an image over to Photoshop, you decide you don't want to edit it after all, just click on the window's Close button (or press **Command-W [PC: Ctrl-W]**), and then when it asks if you want to save the document, choose Don't Save. Easy peasy.

CHOOSING HOW YOUR FILES ARE SENT TO PHOTOSHOP

When you move an image from Lightroom to any other program, it's called "external editing" since you're now editing the image outside of Lightroom. There's a set of External Editing preferences, so you can choose which programs to use for your external editing and exactly how (and in what format) those images are going to go over to that other program. Here's how to set things up your way from the start:

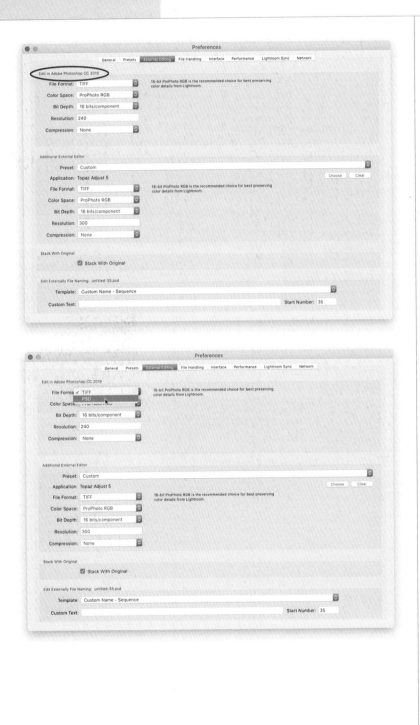

STEP ONE:
Press **Command-,** (comma; **PC: Ctrl-,**) to bring up Lightroom's preferences, and then click on the External Editing tab up top (seen here). If you have Photoshop installed on your computer (and I'm assuming if you bought this book you do), it automatically becomes the default choice as your External Editor, so you don't have to do anything to make that happen—it's good to go (if you have more than one version, it uses the latest version as the default, which in my case would be Photoshop CC 2019; it's circled here in red). If, instead, you have Photoshop Elements installed, then that becomes the default External Editor.

STEP TWO:
Right below that, it shows you the default settings for what kind of file it's going to send over to Photoshop. By default, it sends a copy of the file over to Photoshop in TIFF format, embeds that file with the ProPhoto RGB color profile, sets the bit depth to 16 bits, and sets the resolution to 240 ppi. Let's start with the File Format choice: I change mine to go over to Photoshop as a PSD (Photoshop's native file format) rather than a TIFF, simply because its file size is often much smaller but without any loss of quality.

STEP THREE:

Next, you can choose the Bit Depth of the file going over to Photoshop. If your goal is to maintain the maximum quality, leave it set at 16 Bits/Component. The downside of 16-bit editing are: (1) some of Photoshop's filters and features will be disabled (stuff like the Filter Gallery), and (2) the file size will be approximately double (so a 36-MB TIFF becomes a 72-MB TIFF). Neither may be an issue for you, but I thought you should know. By the way, I usually work in 8-bit mode myself.

STEP FOUR:

From the Color Space pop-up menu, you get to choose your file's color space. Adobe recommends ProPhoto RGB for the best color fidelity, and if you keep it at that, I'd go to Photoshop and change your Photoshop color space to ProPhoto RGB, as well—that way, both programs are using the same color space, so your color will be consistent as you move files back and forth. To change your Color Space to ProPhoto RGB in Photoshop, go under Photoshop's Edit menu, and choose Color Settings. In the dialog that appears, in the Working Spaces section, from the RGB pop-up menu, choose **ProPhoto RGB** (as shown here). Click OK, and Photoshop and Lightroom are now both using the same color space. (By the way, while you can change Photoshop's color space, Lightroom's working color space is set to ProPhoto RGB and you can't change it. So, although you can't change Lightroom's color space, you can change it for files leaving Lightroom.)

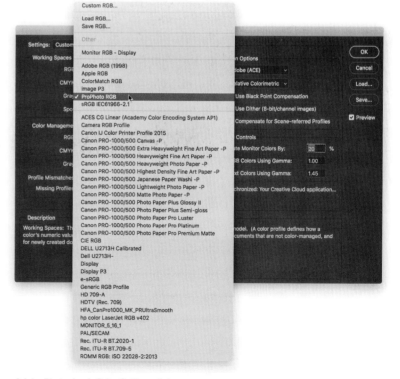

Adobe Photoshop's Color Settings dialog

Continued

STEP FIVE:
You also get to choose the resolution of the file you're sending over, but I leave mine set at the default of 240 ppi (so it's going over at the native resolution of the file). I've never found an occasion where I needed to change this resolution setting, so I just leave it alone.

STEP SIX:
If you want to use a second program to edit your photos, you can choose that in the Additional External Editor section. So, for example, if you wanted to send your image over to a separate plug-in or another image editing application (gasp!), this is where you'd choose it. Just click on the Choose button over there on the right, navigate your way to the program or plug-in you want to use, and then click the Choose (PC: Open) button, and that application or plug-in will now be displayed under Additional External Editor (shown circled here in red). To use this second editor (instead of Photoshop), go under Lightroom's Photo menu, under **Edit In**, and choose the other application (in this case, it would be Topaz Adjust 5, or press **Command-Option-E (PC: Ctrl-Alt-E)**. Next, there's a Stack With Original checkbox. I recommend leaving this on, because it puts the edited copy of your image (the one you sent over to Photoshop) right beside your original file back in Lightroom. That way, when you're working in Lightroom, it's easy to find the edited copy—it's right beside the original (as seen in the grid here).

STEP SEVEN:

At the bottom of the dialog, you can choose the name applied to photos you send over to Photoshop for editing. You have pretty much the same naming choices as you do in Lightroom's regular Import window, where hopefully you chose some sort of custom name because the default name of "IMG_0002" is pretty much meaningless. Here's what I recommend for your External Editing preferences: from the Template pop-up menu, choose **Filename** first, then go under that same menu again and choose **Edit** (as shown here).

STEP EIGHT:

This brings up the Filename Template Editor (shown here). You'll see that Filename is already chosen in the field up top. Click your cursor right after it and type in "-PSedit," but don't click Done yet. From the Preset pop-up menu up top, choose **Save Current Settings as New Preset** (as shown here at right) and save this setup, so you don't have to build it again—you can choose this naming preset anytime you want. Now, click Done, and your images edited in Photoshop will be named with their original filename + -PSedit (so a file named "Venice-57.jpg" in Lightroom and edited over in Photoshop will come back to Lightroom named "Venice-57-PSedit.psd," making it easy to identify at a glance). Okay, your preferences are set; let's put them to work.

After Filename, type in "-PSedit" *Save this as a template*

GET SMART

SMART OBJECTS AND HDR

Okay, I named this chapter after the Smart Objects feature in Photoshop (which you can jump to directly from Lightroom), even though it's probably not the coolest thing in this chapter. I chose "Get Smart" because it's hard to find a movie or song title with the acronym HDR in it. Now, of course, the meaning behind the acronym HDR itself is one of the most misquoted of all, as I constantly see it referred to incorrectly as High Dynamic Range photography, when in fact its roots can be traced back to the Latin phrase *Hominem Dictu Regnum*, which is a phrase used in ancient photographic literature representing the belief that any photo with large white glows around the edges, overly vibrant Harry Potter-like colors, and solid black clouds should be taken to the banks of a nearby river and beaten with a rock until it can no longer be determined to be of photographic origin. So, basically, you can see why I went with "Get Smart." However, this created quite a conundrum because now I had to decide whether it would be the one from the classic TV show *Get Smart* or the movie version of *Get Smart* (which was based on the TV show), even though my readers would never know which I had chosen when I wrote this (by the way, the word "conundrum," surprisingly, does not have a Latin origin. It's actually a phrase that was used in 15th century England to describe "a convict who can no longer play the drums." I don't know about you, but I find this stuff fascinatum!). Anyway, I hope that your not knowing which version of *Get Smart* I used doesn't *In necessariis unitas, in dubiis libertas, in omnibus caritas*, which roughly means "If it's necessary to fly United Airlines to Dubai, don't leave your seat while the snack cart is in the aisle."

KEEPING YOUR RAW IMAGE EDITABLE USING SMART OBJECTS

If you want to be able to re-edit your RAW image in Photoshop, instead of making the jump like we normally do (where Lightroom brings a copy of your RAW image over to Photoshop), you can keep that "RAW editibility" by choosing to take your RAW image over to Photoshop as a smart object. Once you do that, you can re-edit the RAW image using Photoshop's Camera Raw plug-in, which is pretty much identical to editing it in Lightroom because Camera Raw is built into Lightroom. Adobe just calls it something different in Lightroom—the Develop module. It's the same sliders, in the same order, and they do the same thing.

STEP ONE:
To take your image over to Photoshop as a re-editable RAW image, go under the Photo menu, under Edit In, and choose **Open as Smart Object in Photoshop** (as shown here).

STEP TWO:
When you choose Open as Smart Object in Photoshop, your image appears in Photoshop like always, but you can tell it's a smart object by looking in the Layers panel—in the bottom-right corner of the layer's thumbnail, you'll see a little page icon (seen here). That's letting you know it's an editable smart object.

STEP THREE:

You can now add layers on top of this smart object layer and do other "Photoshop stuff." Here, I added two Type layers (and just in case you were wondering, that awesome script font is Cezanne from the font house P22). I also added a new layer behind those two Type layers (well, I added a new blank layer and clicked-and-dragged it below my Type layers in the Layers panel), where I made a horizontal rectangular selection that was a little larger than the area with my type, filled it with black, and lowered the opacity to create a backscreen behind it, so the type was easier to read. (*Note:* We looked at how to do all this back in Chapter 1.)

STEP FOUR:

Now, if at some point during my time here in Photoshop I felt I wanted to edit my RAW photo on the Background layer, all I would have to do is go to the Layers panel and double-click directly on that layer's thumbnail (as shown in the previous step), and it would open that RAW image file inside of Photoshop's Camera Raw plug-in (seen here). Here, in Camera Raw, you'll notice that it has the same sliders, in the same order that they are in Lightroom's Develop module. This technique of opening your image as a smart object is the only way you're able to still work with the RAW image and have it editable here in Photoshop. Otherwise, you'd be working with a copy made from the RAW file that is now either a JPEG, TIFF, or PSD, depending on your External Editing settings in Lightroom's preferences (see page 36), and you'd lose the advantage of working on the actual RAW file again if you needed to edit it. So, in short: smart object layers are kinda awesome.

CREATING TONE-MAPPED-LOOKING HDR

Lightroom has a built-in HDR feature, and it does a great job of combining bracketed exposures into a realistic-looking image. But, what if you don't want a "realistic-looking" image? What if you want that tone-mapped, "looks like you did this in Photomatix" look? Well, Photoshop has a feature that does just that. It kinda stinks for creating a realistic look, but for that full-on HDR look, it's got it down. That being said, in this project (don't forget to download these images and follow along), I'm going to show you the technique I use to get the best of both worlds—something between full-on, super-tone-mapped HDR and a realistic look.

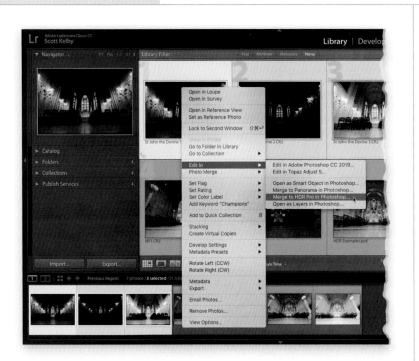

STEP ONE:
In Lightroom, select your bracketed shots by Command-clicking (PC: Ctrl-clicking) on them. Here, I've selected three bracketed shots (one with the normal exposure, one two stops underexposed, and one two stops overexposed. These were, taken at the Cathedral of Saint John the Divine in New York City). Once they're selected, go under the Photo menu, under Edit In, and choose **Merge to HDR Pro in Photoshop**. You can also do this by Right-clicking on any of those three selected photos and choosing the same thing from the pop-up menu that appears (as shown here).

STEP TWO:
This launches Photoshop (if it's not already open), brings up the Merge to HDR Pro dialog (shown here), and compiles your selected images into one flat-looking, fairly ugly image (as seen here), but that's just reflecting the default settings. By the way, although I used just three bracketed images total to make this ugly HDR, you can use five frames, seven, nine, whatever you like. It really doesn't matter how many you choose, because it will still look pretty ugly. Rather than dragging all these sliders around, there are some built-in presets found in the Preset pop-up menu in the top-right corner of the dialog. These are a collection of HDR presets that are, for the most part, pretty unusable.

STEP THREE:

But, Adobe must have gotten tired of hearing me whine about how bad these presets are because, a few years back, they asked if they could include one of my presets, and it has been in Merge to HDR Pro ever since—it's called "Scott5." So, go ahead and choose **Scott5**, from the Preset pop-up menu, and you'll see that it gives you that over-the-top HDR-tone-mapped look (I know, it looks bad right now, but it'll get better in just a moment). After you choose Scott 5, turn on the Edge Smoothness checkbox (found right under the Strength slider) to remove some of the harshness (the Edge Smoothness feature hadn't been added to Merge to HDR Pro yet back when I created that preset, or I would have had it on already as part of the preset). Okay, it's looking more "HDR-like" but it's still a bit too dark overall, so don't hit the OK button quite yet.

STEP FOUR:

To brighten the overall image, go to the Exposure slider, right there in the Merge to HDR Pro dialog, and drag it over to the right until it reads 1.20 (as seen here). Okay, that helps a lot. Now, down in the Advanced tab, set your Shadow slider to 0 (zero) to open up the shadows a bit more in the ceiling, then go ahead and click OK to open your now tone-mapped image in Photoshop. It's looking pretty over-the-top (as expected), but we're not done yet. The next step is going to start the process of bringing back a bit of realism that makes a big difference.

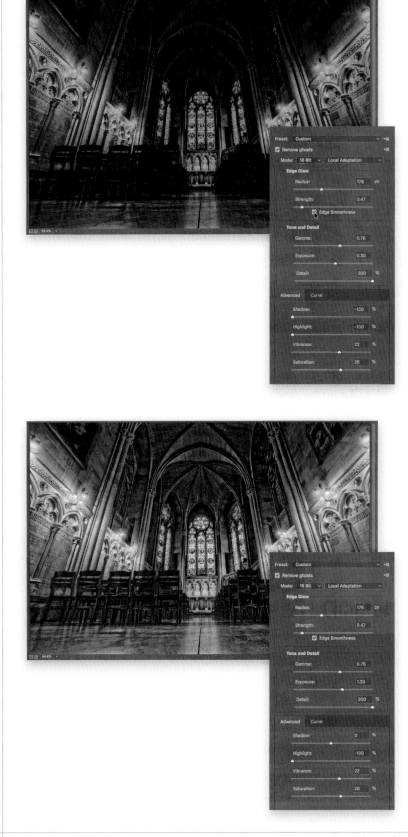

Continued

STEP FIVE:
Switch back to Lightroom for just a second and, within the three bracketed photos, click on the regular normal exposure. Now, press **Command-E (PC: Ctrl-E)** to bring a copy of that normal exposure image over to Photoshop. Press **Command-A (PC: Ctrl-A)** to select the entire image, and then we're going to do a standard ol' copy-and-paste—we're going to copy this image and paste it on top of our tone-mapped HDR image. So, start by copying it (as shown here), but of course, you'll just press **Command-C (PC: Ctrl-C)** to Copy the image into memory.

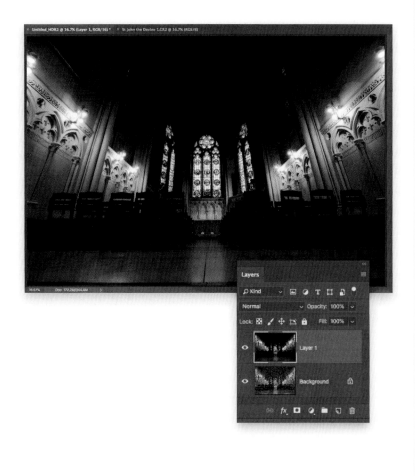

STEP SIX:
Now switch to the HDR document, and press **Command-V (PC: Ctrl-V)** to Paste your normal exposure image right on top of your HDR image. It will appear on its own layer (as seen in the Layers panel below), and thus will cover your HDR image, on the layer below it, from view (5 bonus points for using "thus" in a sentence).

Note: If you shot this image on a tripod or a Platypod (and I hope you did), this pasted image will align perfectly with the HDR image below it. However, if you hand-held your HDR, their alignment will probably be a little off. Luckily, Photoshop can actually align them for you: Just press-and-hold the Command (PC: Ctrl) key and, in the Layers panel, click on both layers to select them, then go under the Edit menu and choose **Auto Align Layers**. When the dialog appears, make sure the Auto radio button is selected, then just click OK, and it will align both images for you. You may have to use the Crop tool **(C)** after this to crop away any gaps along the outside edge of your image.

STEP SEVEN:

Next, near the top right of the Layers panel, lower the Opacity amount of this top layer (the normal exposure layer) to around 40% or 50%, so the HDR image below it starts showing through and you get a blend of the normal image and the HDR tone-mapped version you created here in Photoshop. The lower you set the Opacity, the more the HDR image will show through (here, I went to 50%, so it's 50% HDR and 50% original image). This way, you get the greatly enhanced detail in the stone, and in the roof, and the floor, etc., but it doesn't look so over-the-top, like the tone-mapped image.

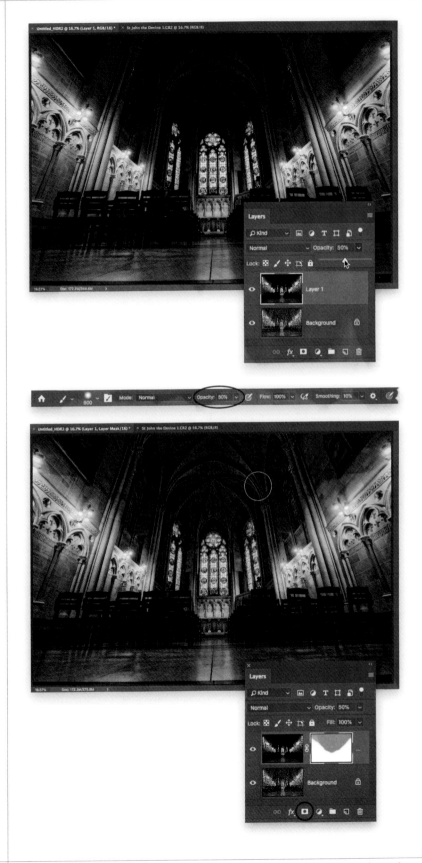

STEP EIGHT:

This next step is pretty important to the overall look—I add a layer mask and paint over areas that I think need more detail or brightness, and by doing so, it brings back a little more of the HDR look in those areas. If you look back at the image in Step Seven, you'll notice the ceiling is still a bit dark. In fact, it's kinda like the bottom 1/3 of the image looks good, but the top 2/3 is too dark and needs more detail. So, here's what to do: At the bottom of the Layers panel, click on the Add Layer Mask icon (the third icon from the left; it looks like a rectangle with a circle in the center) and that adds a white layer mask thumbnail to that image layer. Then, get the brush tool **(B)** from the Toolbar. Press **D**, then **X** to set your Foreground color to black, and then up in the Options bar, lower the Opacity of the brush to 50%. That way, when you paint, it doesn't bring back the full HDR, it only brings back 50% of it, and just where we need it. Here, I painted over the top 2/3 of the image. *Note:* You can use keyboard shortcuts to resize your brush: **Command-] (PC: Ctrl-])** will make it larger; **Command-[(PC: Ctrl-[)** will make it smaller.

Continued

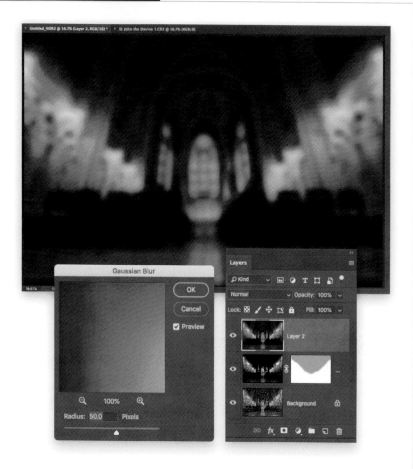

STEP NINE:
Now we're down to the finishing moves—some we'll do here, then we'll head back to Lightroom to finish it off. Start by creating what's called a "merged layer," which is a new layer on top of the layer stack that looks like you flattened the image, but you didn't (by the way, "flattening" means going to the Layers panel's flyout menu in the top right, by clicking on the little lines icon, and choosing **Flatten Image**, which flattens all the layers down so there are no more layers—just the Background layer). To create this merged layer, press **Command-Option-Shift-E (PC: Ctrl-Alt-Shift-E)**. Now, we're going to blur this layer to death (it's a figure of speech, and one we use for blurring or sharpening), and this will help us create a soft glow to our image, which takes off some of the edginess. To "blur this to death," go under the Filter menu, under Blur, and choose **Gaussian Blur**. When the Gaussian Blur dialog appears, enter 50 pixels (as seen here) and click OK.

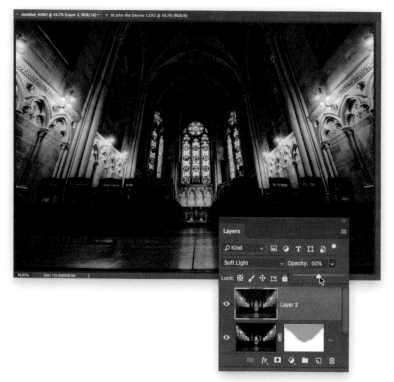

STEP 10:
To turn that massive blur into a glow, we do two things: (1) Near the top left of the Layers panel, click-and-hold where it says "Normal" and, from the pop-up menu that appears, change the layer blend mode to **Soft Light** (we looked at layer blend modes back in Chapter 1). This adds contrast and warmth to the image, but it also takes away a lot of the blur. Then, (2) near the top right of the Layers panel, lower the Opacity of this layer to around 50%, and now we have a nice, subtle, soft glow that helps keep the image from looking harsh.

STEP 11:

At this point, while I'm still in Photoshop, I apply some sharpening. You can either flatten the image now (again, getting rid of all the layers by going to the Layers panel's flyout menu at the top-right corner of the panel and choosing Flatten Image), or if you want to keep your layers intact (in case you change your mind later), then you can create another merged layer at the top of the layer stack (which is what I did here). Next, go under the Filter menu, under Sharpen, and choose **Unsharp Mask** (it sounds like it would make things blurry, but this filter is named after an old traditional darkroom technique they used to use to create sharpness). To add some nice, punchy sharpening, enter Amount: 120%, Radius: 1.1, Threshold: 3 (as seen here), and then click OK to sharpen the image.

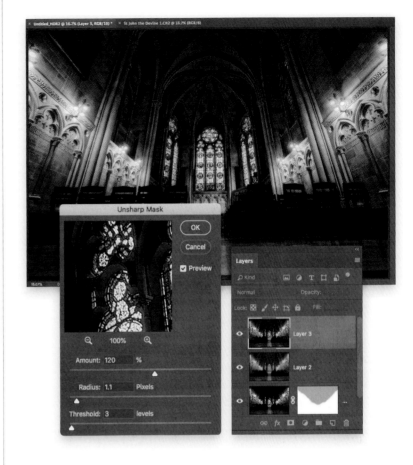

STEP 12:

We can do the rest of the finishing effects over in Lightroom, so let's save the document and close it to send it back to Lightroom (remember, that's all you have to do when you're done editing in Photoshop—and no, you do not have to flatten your image before sending it back to Lightroom. Just save and close. That's it).

Continued Smart Objects and HDR • Chapter 3 **49**

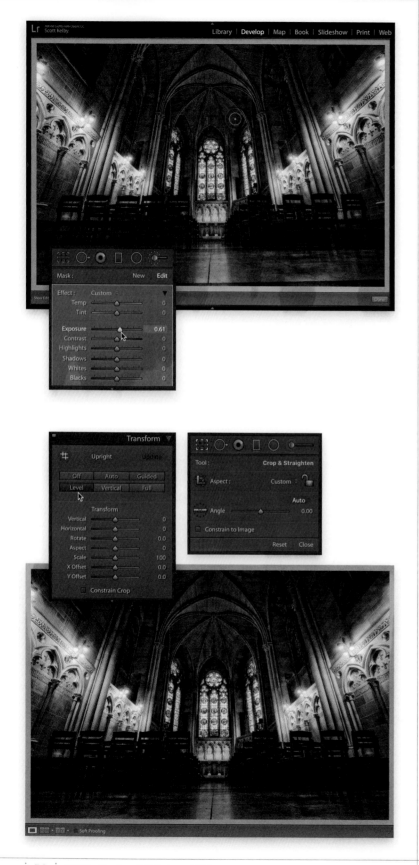

STEP 13:
With the image back in Lightroom, for this particular image, I think the ceiling could still be just a little bit brighter—maybe half a stop. To do that, in the Develop module, grab the Adjustment Brush **(K)** from the toolbox beneath the histogram, then double-click on the word Effect, near the top left of the panel, to zero out all the sliders. Next, drag the Exposure slider over to the right to around half a stop or so brighter (here, I dragged it over to 0.61, so just a little brighter than half a stop). Now, paint over some of the ceiling areas to bring them out a bit. I also ended up painting over the backs of the chairs—it seems like they could be a half stop brighter, too.

STEP 14:
You've probably noticed by now that our image was a little crooked, and at the bottom-right corner there was a line of tile out of place because of it. So, let's fix both of those. To straighten out the image, go to the Develop module's Transform panel and click the Level button to perform an auto-straighten. Then, grab the Crop Overlay tool **(R)**, from the toolbox beneath the histogram, and crop away anything left over that's showing in the bottom-right corner.

STEP 15:

Our final step is a finishing move I do to all HDR images, and that is to darken the outside edges all the way around—not just in the corners (like bad lens vignetting); I mean evenly around the outside edges. We do that by going to the Develop module's Effects panel and, under Post-Crop Vignetting, dragging the Amount slider to the left until the edges look darkened, but not making it look like an obvious vignette (here, I only dragged it to the left to −16. It's subtle, but it does make a difference—toggle the panel on/off, by clicking on the switch in the left side of the panel header, and you'll see what I mean).

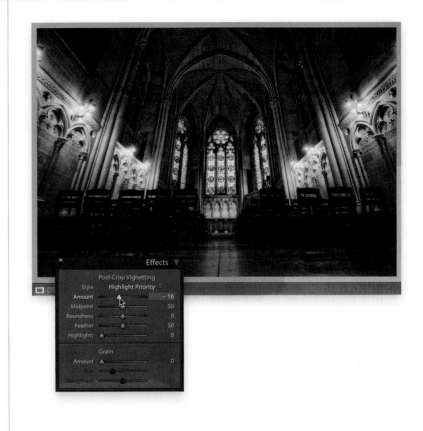

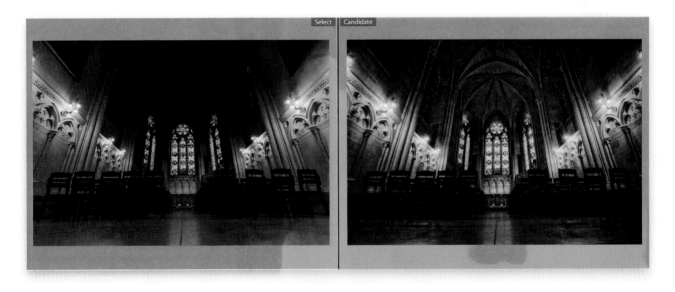

STEP 16:

This isn't really a step, but I wanted to show you a side-by-side comparison. That's Lightroom's built-in HDR feature on the left, with an Auto correction applied during the process. You can see that it looks pretty much like the original exposure. On the right is the same image processed with Photoshop's Merge to HDR Pro feature.

TECHNIQUE FOR "SHARPER THAN LIGHTROOM" HDR IMAGES

There's kind of a hidden technique you can do in Photoshop (and it's incredibly easy) that creates a sharper and more color-accurate HDR image than Lightroom makes. You do this by creating a 32-bit super-high-quality HDR image, and the result is so sharp and crisp that you might not need to sharpen the image at all (and I sharpen every image, so for me to say that, the result must be really sharp).

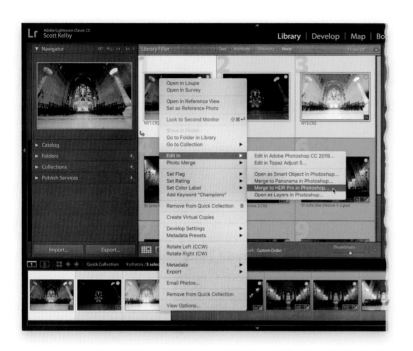

STEP ONE:
In Lightroom, select your bracketed shots by Command-clicking (PC: Ctrl-clicking) on them (here, I've selected three bracketed shots). Once they're selected, go under the Photo menu, under Edit In, and choose **Merge to HDR Pro in Photoshop**, or Right-click on one of the selected images and choose it from the pop-up menu (as shown here), just like you would to create the tone-mapped HDR image you just learned in the previous project.

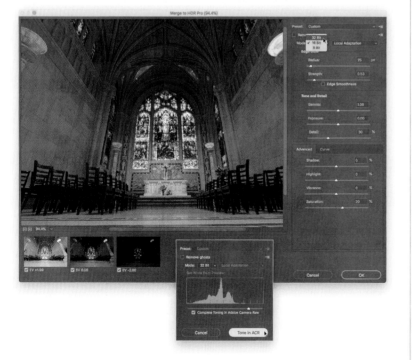

STEP TWO:
This launches Photoshop (if it's not already open), and brings up the Merge to HDR Pro dialog (shown here). At the top right, you'll see that the Mode pop-up menu is set to 16 Bit. Click-and-hold on that pop-up menu and choose **32 Bit** (as shown here). That will hide all the sliders and replace them with a histogram (seen in the inset below) and a slider (which we will ignore)—we don't want to make any changes here anyway because we're looking to make a realistic HDR image, not a tone-mapped effect look. When you choose 32 Bit, the OK button changes into Tone in ACR (and the ACR part is an acronym for Adobe Camera Raw). So, go ahead and click that button now.

STEP THREE:

This brings up Photoshop's Camera Raw window, so now you can edit the photo like you would in Lightroom's Develop module (it's the same sliders, in the same order, that do the same thing). Here, I fixed the white balance, increased the Exposure, added a little Contrast, pulled back the Highlights, adjusted the Shadows, Whites, and Blacks, added some Clarity to bring out the detail, and a little Vibrance to make it a little more colorful—pretty minor stuff. The major stuff I did with Camera Raw's Adjustment Brush **(K):** I brightened the exposure on the ceiling by nearly a stop, I darkened the floor at the bottom of the frame by around a stop, I pulled back the highlights on the altar—generally, I just balanced out the light in the small cathedral so it looks more balanced overall. No sharpening at all, though. Now, click OK to open your image in Photoshop (it automatically down-samples it to 16 bit when it opens it in Photoshop).

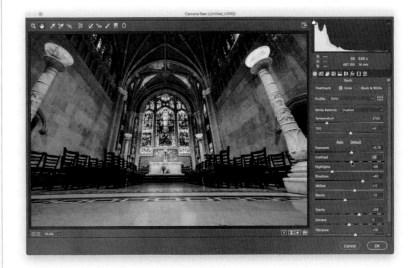

HDR processed in Lightroom

The sharper 32-bit HDR processed in Photoshop's Merge to HDR Pro

STEP FOUR:

On the left is the same three bracketed frames merged together in Lightroom's built-in HDR feature, and I used the exact same toning as I did in the Photoshop image on the right. Look how much sharper and more detailed the image on the right is. It's like night and day, and I haven't even applied any sharpening. Look at the detail in the faces—on the left there is hardly any visible detail, and on the right there is. The color fidelity is better, as well. It's just a better-quality, more realistic HDR all the way around. So, when it really matters, jump over to Photoshop and compile that HDR image over there.

RE-TOUCH

RETOUCHING PORTRAITS

I had it made when it came to naming this chapter because when I typed the word "retouch" into the iTunes Store's Search field, I not only found songs named "Retouch," but it brought up an artist named "Re-touch," as well. So, I decided to go with that one, since it wasn't so obvious. Plus, once I previewed a few of his tracks, I realized there was no way he was paying his mortgage with income from his music career, so maybe this mention will give him some kind of boost. Okay, I'm just kidding, his music is actually pretty good—especially if you like bass drum. I mean, really, really like bass drum for long extended periods of time, and you like it followed by layering weird synthesizer sounds. If that sounds like a dig, it's not because there are a lot of remixes of Re-touch's tunes by everybody from Tom Novy to Goldie-Lox to Overnoise, which alone is pretty impressive (I have no idea who those people are, but it's only because I am very old and these tunes are probably played well after the Early Bird Special ends at Denny's, so I would've missed them, but I'm sure if they played these def tracks at Denny's around my dinner time [around 4:30 p.m.], there would be plenty of dentures just a-clackin' away. We call that "crack-a-lackin'," but that's just because we're so "street." Ball 'til ya fall, homies!). Anyway, just to circle back around for a moment, you can actually do some minor retouching right within Lightroom itself, but for more serious stuff, you've got to jump over to Photoshop because it was born for this stuff. Now, Adobe has done a number of studies, using select focus groups across a wide range of demographics, and these studies have revealed that high-end professional retouchers using Photoshop can increase not only their productivity, but the realism of their retouching by putting on noise-canceling headphones and listening to a long bass drum track followed by layered weird synthesizer sounds, and then mentally picturing themselves at Denny's. I am not making this up. Google it. You'll see.

RETOUCHING FACIAL FEATURES THE EASY WAY

You know that term that often gets tossed around, "Photoshop magic"? Yeah, that one. Well, you're about to experience it firsthand. For many years, we've had the Liquify filter, which lets you take a brush and move parts of your subject like they were made of molasses. It's incredibly useful for retouching (and we'll tackle that in a few pages), but more recently, Adobe has taken this filter to a whole new level by adding facial recognition, and now things that required a lot of finesse to pull off are just the move of a slider away. This is pretty awesome stuff.

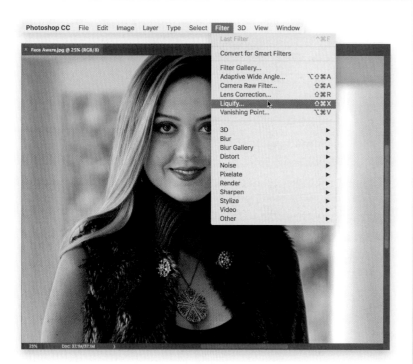

STEP ONE:
In Lightroom, select the image you want to retouch and then press **Command-E (PC: Ctrl-E)** to take it over to Photoshop. (I'm aware our subject here doesn't actually need facial retouching, but I had to pick some photo to retouch, so….) Now, go under the Filter menu and choose **Liquify** (as shown here), or just use the keyboard shortcut **Command-Shift-X (PC: Ctrl-Shift-X)**.

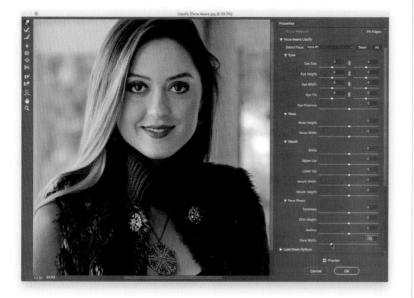

STEP TWO:
That brings up the Liquify dialog (seen here), with a Toolbar on the left and sliders on the right. As I mentioned above, this filter uses facial recognition to automatically assign regions of a face to adjustment sliders in the Face-Aware Liquify section. To adjust any area, all you have to do is drag the corresponding slider to the left to reduce that area or facial feature, or to the right to enlarge that area. Here, in the Face Shape section down near the bottom, I dragged the Face Width slider to the left to thin her face.

TIP: HOW TO HANDLE GROUP SHOTS
If there's more than one person in the photo you're retouching, Liquify automatically recognizes that, and you can choose which face to adjust by choosing it from the Select Face pop-up menu at the top of the Face-Aware Liquify section. You'll see each face listed as Face #1, Face #2, and so on.

STEP THREE:

What's most amazing about this is how seamlessly it makes these adjustments— everything moves, reduces, or enlarges so naturally. Go ahead and drag a few more sliders and you'll see what I mean. Here, I stayed in the Face Shape section and dragged the Jawline slider to the left to tighten the jawline (this is one of my favorite moves in Face-Aware Liquify). I also tweaked her chin height and then pulled down her forehead a little bit (sometimes adjusting one area makes other areas, that didn't stand out before, suddenly stand out). Then, I moved up to the Nose section and thinned her nose a little (I know, she didn't need it, but it would be a really boring project if I didn't adjust some things just to show you how to do it).

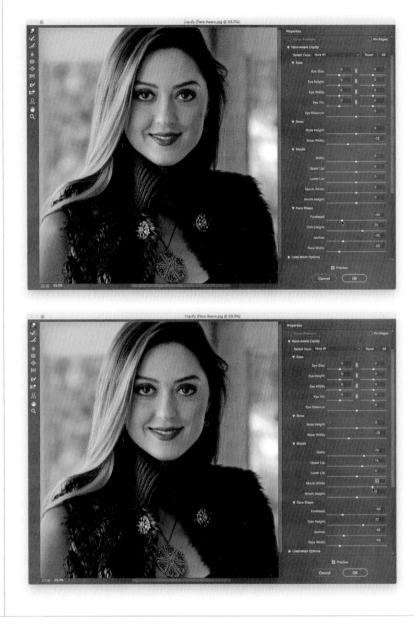

STEP FOUR:

Other adjustments that I think are particularly helpful are in the Mouth section. The Smile slider is good when you have a great shot, but either your subject didn't smile or you want a bigger or wider smile (here, I dragged the Smile slider to the right to give her a bigger smile, then I widened her smile by dragging the Mouth Width slider to the right, and then adjusted her upper lip slightly). The great thing about this is that if you move a slider one way or the other, and it doesn't look good, you can just drag the slider back to 0 (zero)—no harm done.

MAKING FACIAL FEATURES SYMMETRICAL

More often than not, the features on your subject's face won't be perfectly symmetrical (one eye might be higher than the other, or their nose might be a little crooked at the nostrils or the bridge, or one side of their smile might extend higher than the other, and so on). Luckily, you can bring all these misaligned features back into alignment using just a few tools, and some techniques you've already learned (but we do get to learn a helpful new tool this time, as well).

STEP ONE:
Here's the image we want to retouch, opened in Photoshop, and there's a very common problem here (well, when it comes to facial symmetry anyway), and that is our subject's eyes aren't lined up perfectly symmetrically. There's a surprisingly easy fix for this, though.

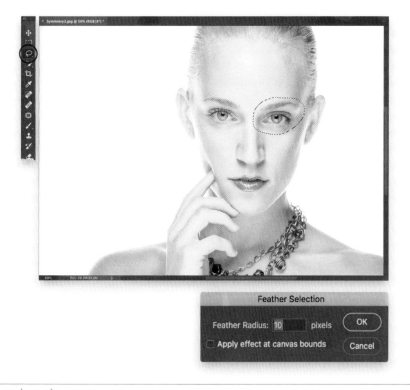

STEP TWO:
Get the Lasso tool (**L**) and make a very loose selection around both the eye and eyebrow on the right (as shown here), because we're going to need to move them together as a unit. Of course, at this point, if we moved this selected area, you'd see a very hard edge (a dead giveaway), so we'll need to soften it by adding a feather to the edges that will help it blend right in. So, go under the Select menu, under Modify, and choose **Feather**. When the Feather Selection dialog appears, enter 10 pixels (as seen here), click OK, and now you've softened the edges of your selection.

Feather Selection

Feather Radius: 10 pixels OK

☐ Apply effect at canvas bounds Cancel

STEP THREE:
Press **Command-J (PC: Ctrl-J)** to copy your selected eye area (with its soft edges) up to its own separate layer. Here, I hid the Background layer, so you can see what just the eye area looks like. What's nice about seeing this view is that you can see the area you selected has soft edges, instead of sharp, harsh edges (the checkerboard pattern shows you which parts of this layer are transparent). By the way, to hide a layer (like the Background layer, in this case), go to the Layers panel and click on the Eye icon to the left of the layer's thumbnail. To see the layer again, click where that Eye icon used to be.

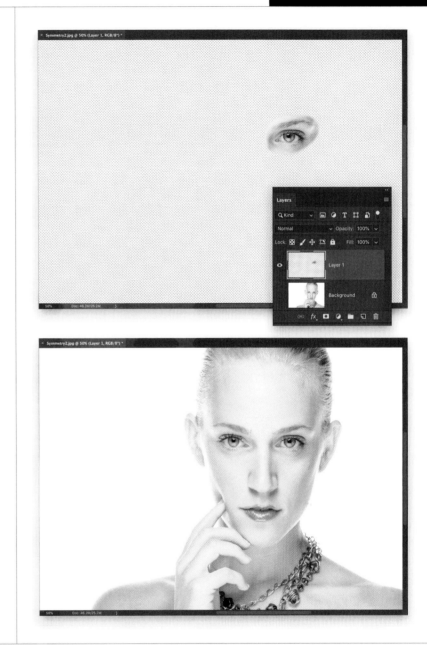

STEP FOUR:
Now, switch to the Move tool **(V)** and then press the **Up Arrow key** on your keyboard a few times until her eyes line up (as seen here). In this case, I had to hit the Up Arrow key 12 times until they lined up. Take a look at the before and after below to see what a difference this little move makes. On the next page, we'll look at continuing our facial symmetry project by using a different (but also very popular) technique on her lips.

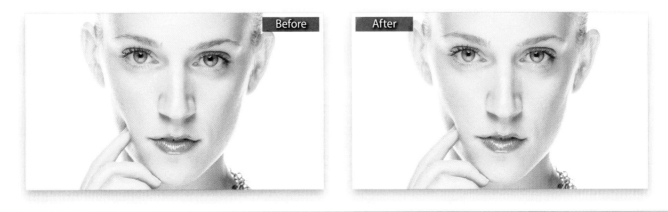

Before

After

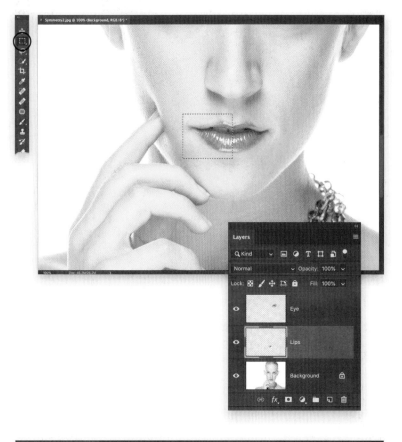

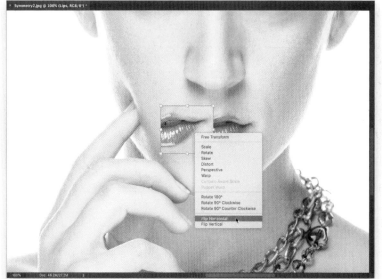

STEP FIVE:
Now let's work on making her lips more symmetrical. If you zoom in (press **Command-+** [plus sign; **PC: Ctrl-+**]), you'll see that the left side of her lips doesn't look as wide as the right, and they turn up a bit, but this is an easy fix (and when you see the final before and after, you'll see it was worth doing). Click on the Background layer to make it active, then get the Rectangular Marquee tool **(M)** from the Toolbar and make a rectangular selection from the center of her lips to outside of the right edge of her lips (her right, as seen here; we looked at selections back in Chapter 1). Press **Command-J (PC: Ctrl-J)** to copy just that selected area up onto its own separate layer. Now that I have three layers, I went ahead and renamed them with descriptive names (to do that, in the Layers panel, just double-click directly on the names themselves. This highlights the text, so you can type in a new name. When you're done renaming, press the **Return [PC: Enter] key** to lock in your rename).

STEP SIX:
Press **Command-T (PC: Ctrl-T)** to bring up Free Transform (you can tell it's engaged when you see control points around the area you put up on its own layer). Now, Right-click anywhere inside your Free Transform bounding box and, from the pop-up menu that appears, choose **Flip Horizontal** (as shown here) to flip your right 1/2 lip over to a left 1/2 lip (as seen here).

STEP SEVEN:

Once you've made the flip, move your cursor inside the Free Transform bounding box again, but this time you're just going to drag the flipped lip layer into place over her left lip (as shown here). Now, just click anywhere outside the bounding box to lock in your horizontal flip. If you look at the edges of the area we just flipped, you can see the skin around her lips is a little lighter than the skin its covering. So, in the next step, we'll have to erase those edge areas, so you don't see a noticeable difference.

STEP EIGHT:

Start by clicking on the Add Layer Mask icon (it's the third icon from the left—it looks like a rectangle with a circle in its center) at the bottom of the Layers panel. If you look in the Layers panel, you can see it added an additional thumbnail to the right of your lips layer. That's the layer mask you just added, and that allows us to hide/show areas using the Brush tool (it's kind of like an eraser that's not permanent, if you make a mistake). Now, get the Brush tool **(B)** from the Toolbar, choose a soft-edged brush from the Brush Picker up in the Options Bar, press **X** on your keyboard to set your Foreground color to black, and then paint over the edges of your flipped lip layer, so it blends in with the skin from the original behind it. Lastly, paint a single black stroke down the center of her lips to better blend that edge (as shown here) to complete the symmetry retouch. A before and after of the lips are shown below.

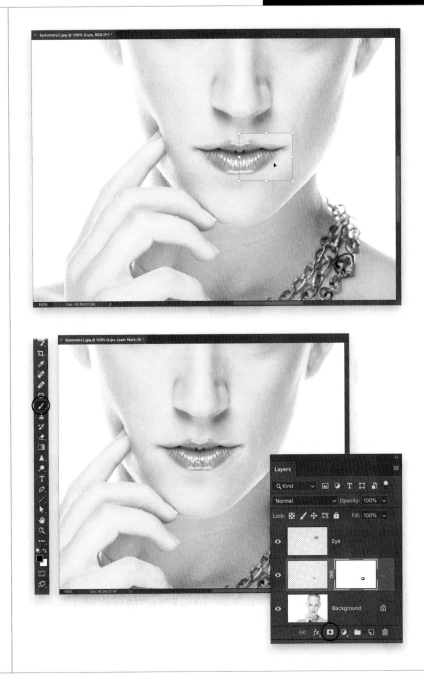

Before

After

TRIMMING EYEBROWS

This retouch requires you to pick up one part of your image to cover up another part of it, and, of course, Lightroom doesn't have any way to do that. But, luckily, this is the stuff Photoshop is made for. This technique is actually very simple and very quick, but has a big impact when it comes to your subject having perfect eyebrows every time.

STEP ONE:
Once your image is open in Photoshop, start by getting the Lasso tool **(L)** and drawing a shape that kind of looks like an eyebrow itself. Draw this right above one of your subject's existing eyebrows (as shown in the next step).

STEP TWO:
You need to soften the edges of the selection just a little bit, so go under the Select menu, under Modify, and choose **Feather**. When the dialog appears, enter 10 pixels (just enough to add a little bit of edge softening), and click OK.

STEP THREE:

Now, press **Command-J (PC: Ctrl-J)** to place that selected area up on its own separate layer. Here, I turned off the Background layer (by clicking on the Eye icon to the left of the layer thumbnail), so you can see just the selected area with its feathered edges. Switch to the Move tool **(V)** and click-and-drag that shape straight down until it starts to cut off the top of the real eyebrow, and perfectly trims it. Then, go to the Layers panel, click on the Background layer, and do the exact same thing for the other eyebrow. A before and after is shown below.

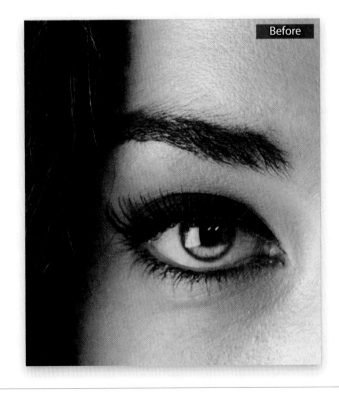

Before

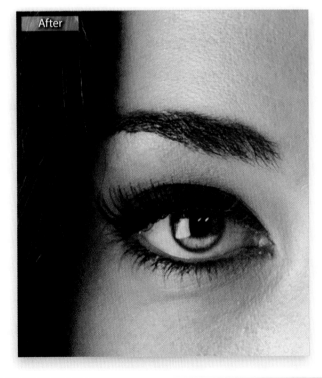

After

REMOVING EYE VEINS

Technically, you can remove some eye veins while you're still in Lightroom using the Spot Removal tool, but if you've ever tried it, it's pretty tricky and the results are…well…let's say there's a reason we almost always jump over to Photoshop for a retouch like this. The only time I'd consider doing it in Lightroom alone is if your subject has just one single red vein, and unfortunately that rarely happens, so it's handy to know this technique.

STEP ONE:

Here's the image we're going to retouch in Photoshop. We'll need to zoom in tight (to at least 100%) to really see what we're working on, so grab the Zoom tool **(Z)** and zoom in on the eye on the right (you can see this in the next step). Then, click on the Create a New Layer icon (it's the second one from the right) at the bottom of the Layers panel to create a new blank layer. We're going to do our retouching on this empty layer, so later we can add a filter on top of it that will add texture back into the areas we retouched to make them look more realistic.

STEP TWO:

You're going to remove these red veins using the Brush tool (with temporary help from the Eyedropper tool). So, get the Brush tool **(B)**, then press-and-hold the **Option (PC: Alt) key** and your cursor will temporarily switch to the Eyedropper tool, so you can steal any color in your image and make it your Foreground color. You're going to want to click the Eyedropper tool right near the red vein you want to remove (as shown here, where I'm clicking it right below the vein I want to remove). A large circular ring appears around your Eyedropper tool when you click—the top half of the inside of the ring shows the exact color you just sampled (the bottom half is the color it was before you sampled) and the outside of it is a neutral gray to help you see the color without being influenced by surrounding colors.

STEP THREE:

Let go of the Option (PC: Alt) key to return to the Brush tool, set your brush Opacity (up in the Options Bar) to 20%, and choose a small, soft-edged brush that's just a little bit larger than the vein you want to remove from the Brush Picker (click on the down-facing arrow to the right of the brush thumbnail in the left side of the Options Bar). Now, start painting a few strokes right over the vein and, in just moments, it's gone! Remember, at 20% opacity, the paint builds up, giving you a lot of control as you build up your paint over the vein, so don't be afraid to go over the same stroke more than once. Since the eye itself is a sphere, the shading changes as you move across it, so be sure to sample again near what you're painting over as you're removing these veins to make sure the color and tone stay right on the money (I resampled about 10 or 12 times during this retouch).

STEP FOUR:

Lastly, to keep the whites of the eyes from looking pasty after your retouch, we're going to add a tiny bit of noise to your retouch layer. So, go under the Filter menu, under Noise and choose **Add Noise**. When the filter dialog appears, choose an Amount of 1%, click on the Uniform radio button, and turn on the Monochromatic checkbox. Click OK to add this texture to your retouch. Although it's subtle, it does make a difference.

REMOVING BLEMISHES

Lightroom has a Spot Removal tool and it is well-named—it's for removing spots. But, it's not a serious retouching tool anywhere along the lines of Photoshop's brilliant Healing Brush, Spot Healing Brush, and Patch tools—they are light years ahead of the pretty lame Spot Removal tool in Lightroom. But, the only way you'll truly appreciate how much ridiculously better these tools are is to use them a few times, and then you'll totally "get" why and you'll know why it's worth jumping over to Photoshop to use them (by the way, they are for way more than just retouching, as you'll see in Chapter 8).

STEP ONE:

Open the image you want to retouch in Photoshop. Here, we want to remove blemishes mostly from her forehead, cheeks, and neck. There are three "healing" tools that we work with, and what and where we're retouching, helps us choose the right one for the task. All three sample an area from a different part of the face (well, only because we're retouching a face here) to use as a basis for the retouch. It doesn't exactly clone that area, it just uses it to help make its repair realistic. The Spot Healing Brush (circled here in the Toolbar) chooses an area to sample for you automatically—use the **Left/Right Bracket keys** on your keyboard to make your brush a little larger than the blemish and just click. So, while it's the easiest to use, it's the least accurate on faces, because in different areas, our skin goes in different directions. The Spot Healing Brush sometimes chooses to sample from an area where the skin's going in the wrong direction, and you end up with a smudge. Not really a problem on body parts, just on faces.

STEP TWO:

With the Healing Brush (circled here), you tell Photoshop where to sample from—choose a nearby area of skin to where you're retouching and the result is much better, but it's a little more work. Simply move your cursor over a clean area of nearby skin, press-and-hold the Option (PC: Alt) key, and click once in that area to sample it. Then, move your cursor over the blemish you want to remove, make your brush a little larger than the blemish, and just click once. Don't paint. Just click once and it's gone. *Note:* Look at the middle image here. A preview of the retouch appears inside your round brush cursor, but it doesn't apply it until you actually click.

(1) *Option-click (PC: Alt-click) on a nearby clean area of skin*

(2) *Move your cursor over the blemish you want to remove*

(3) *Click once to remove the blemish*

STEP THREE:

The third healing tool is the Patch tool (circled here) and, generally, it's used for removing larger blemishes (like a long scar on an arm or a large birthmark), or for removing a bunch of nearby blemishes at once. You use it like the Lasso tool: Click-and-drag a selection around the area of blemishes you want to remove (as seen here on the left). Then, click inside that selected area, drag it to a nearby area of clean skin (as seen here on the right), and you'll see a preview of how the repair will look. If it looks good, just let go of your mouse button and the selection snaps back into place and the blemishes are gone.

STEP FOUR:

This last step is for when you want to reduce something, rather than remove it. For example, if you want to reduce a mole, or an area of freckles, but not totally get rid of them. The secret is this: go ahead and remove the mole or blemish, but immediately after removing it (before doing anything else), go under the Edit menu and choose **Fade Healing Brush** (or Fade Patch tool, if that's what you used last). This brings up the Fade dialog, which essentially is "undo on a slider." Drag the slider to the left and it brings back some of the blemish or mole (in this case, the little mole above her lip), so you're reducing it, not totally removing it.

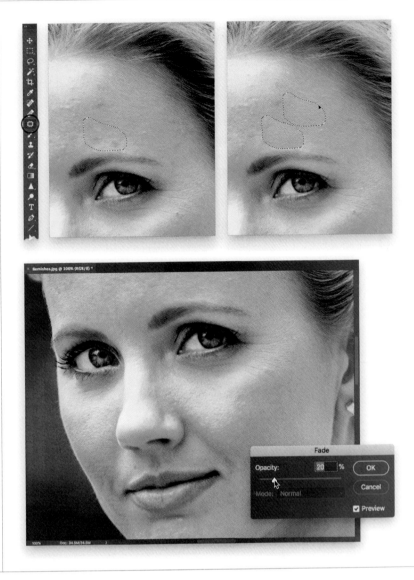

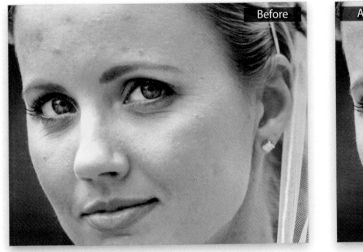

Before

After

THE SECRET TO GREAT-LOOKING SKIN

The problem with Lightroom's method for skin softening is that it's so soft it pretty much obliterates the skin texture, and your subject's skin winds up looking pretty plastic. That's why, when it comes to softening skin and keeping texture, we always head over to Photoshop. We're going to do a technique called "Frequency Separation," which is wonderful for fixing uneven, splotchy skin and getting rid of a multitude of problems, but without losing the critical skin detail. It's pretty amazing, really.

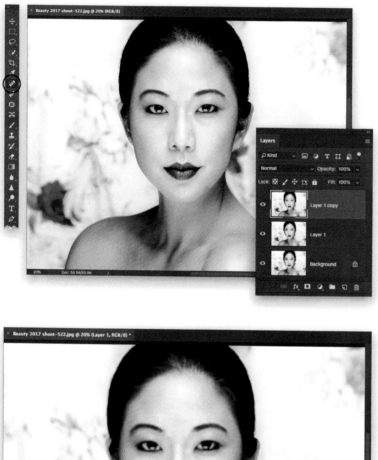

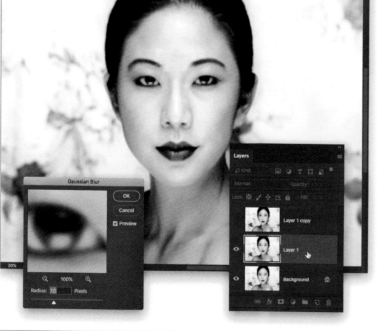

STEP ONE:
In Lightroom, select the image you want to retouch, then press **Command-E (PC: Ctrl-E)** to open it in Photoshop. Before we do any skin retouching, we always remove any large, obvious blemishes first. You can do that in Lightroom using the Spot Removal tool **(Q)** before you even bring it over to Photoshop, or you can use Photoshop's Spot Healing Brush **(J)**, which is awesome (see page 66). Basically, you make your brush a little larger than the blemish you want to remove (using the **Left/Right Bracket keys** on your keyboard), then simply click once over the blemish and it is gone. Once you've removed any major blemishes (either in Lightroom or here in Photoshop), you're going to duplicate the Background layer twice, so press **Command-J (PC: Ctrl-J)** to duplicate it, and then press it again to make a second copy.

STEP TWO:
Click on the Eye icon to the left of the *top* layer's thumbnail to hide it from view, since we'll be working on the layer below it—the middle layer, Layer 1. Now, click on the middle layer to make it active (as shown here), then go under the Filter menu, under Blur, and choose **Gaussian Blur**. When the filter dialog appears (seen here on the left), we're going to increase the Radius amount until the skin is blurry, so it looks like all the tones are blending together (I usually wind up around 7 pixels for my 30-megapixel camera, but if you have a higher resolution camera, you might have to go to 8 or 9 pixels. The higher resolution your camera, the higher this number will need to go). Click OK, and we're done with that middle layer for now.

STEP THREE:

In the Layers panel, click on the top layer to make it the active layer, then click where that Eye icon used to be (to the left of the layer's thumbnail) to make it visible again. Then, go under the Image menu and choose **Apply Image**. When the Apply Image dialog appears, you're going to input a few settings that you need for this technique. I would explain these in detail if I only understood them, but here's what I do know: they work, so use these settings. From the Layer pop-up menu, choose Layer 1; from the Blending pop-up menu, choose Subtract; for Scale choose 2; for Offset chose 128; and then click OK. Your layer should look gray with a blurry version of your image (as seen here).

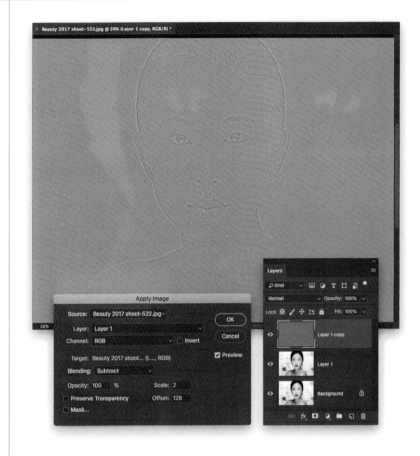

STEP FOUR:

From the pop-up menu near the top left of the Layers panel (where it says "Normal"), change the blend mode to **Linear Light** (as seen here). At this point, the image should just look like the normal image (not blurry, not gray, just normal, regular). Don't worry, this gets a whole lot more interesting in a minute (apologies to my editor, who I imagine just shuddered reading the phrase "a whole lot").

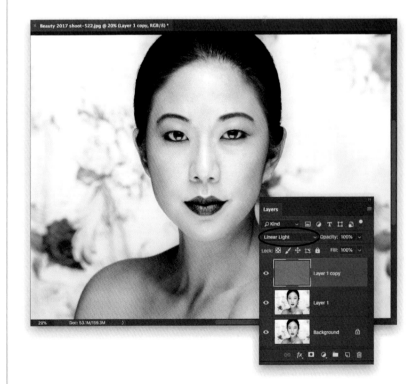

Continued

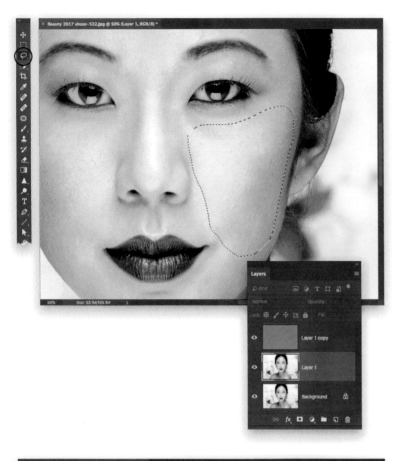

STEP FIVE:
You're going to do your work on the middle layer, so go ahead and click on it in the Layers panel to make it the active layer again. Finally, we're getting to the good part. Get the Lasso tool **(L)** from the Toolbar (this is the one that lets you draw free-form selections), and click-and-drag it around an uneven area of your subject's skin. It can be a fairly large area, like their entire chin area or most of a cheek (like you see here, where I selected her cheek on the right), etc.

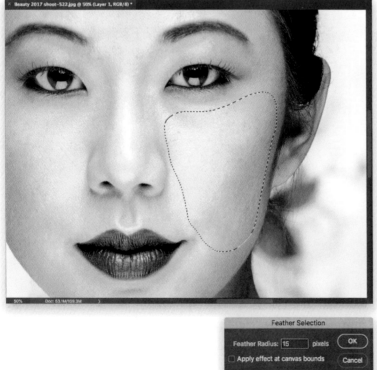

STEP SIX:
Now that our selection is in place, we're going to do something that we do very often in retouching—soften the edges of that selection you just made. Right now, if we did anything to this area, you'd see a very obvious, hard edge along that selection you made, and it would look pretty terrible (and obviously retouched). So, we soften those edges so they're not hard and obvious, but instead, we get a smooth blend from the area we retouched to the surrounding skin. It's called "feathering" your selection, and to do that, you go up under the Select menu, under Modify, and choose **Feather**. When the dialog appears, I usually enter 15 pixels as my Feather Radius (the higher the number, the softer the edge, and again, if you have a 52-megapixel camera or something like that, you should use 20 pixels or so. In this case, we're going for a feather of 15). Click OK to soften the edges of that lasso-selected area.

STEP SEVEN:

Next, you're going to apply a Gaussian Blur to your selected area (I usually wind up using 24 pixels, but again, higher megapixel cameras need a higher number, so try 32 and see how it looks), and once you apply this blur, that's it, it smooths out the skin! It blends in perfectly, and there's plenty of skin texture there, as well. It's a pretty magical technique. Now, you're going to repeat just the last parts of this process for other areas of skin (this includes the face, arms, chest, etc.): (1) Make a selection around another skin area with the Lasso tool. (2) Apply about a 15-pixel Feather Radius to the edges. (3) Apply a 24-pixel Gaussian Blur to finish the technique. Press **Command-D (PC: Ctrl-D)** to Deselect, then repeat somewhere else on your subject's face or other area of skin. I put a before and after below, so you can see the difference.

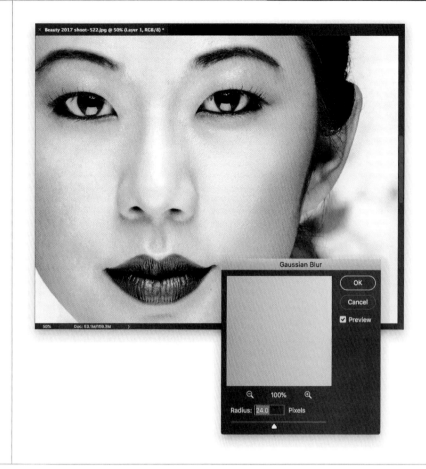

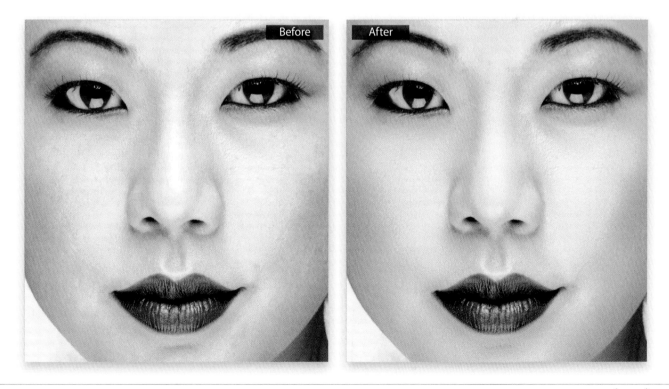

LIQUIFY'S OTHER KILLER TOOL FOR RETOUCHING BODY PARTS

There's more to the awesome Liquify filter than just the facial recognition sliders (which we looked at earlier in this chapter)—namely, there's the Forward Warp tool, which is way more useful and easier to use than it sounds. It lets you move your subject around like they were made of a thick liquid (think molasses), and there are two tricks to using it well: (1) make your brush just a little larger than the size of the thing you want to move, and (2) just slowly nudge with it. Don't paint big strokes; just gently nudge. Do those two things, and you'll make realistic retouches and leave no sense of what was done.

STEP ONE:
In this particular pose, it looks like our subject has a small bone sticking out of her shoulder on the right (I circled it here in red). This is a 10-second fix using Photoshop's Liquify filter, so go under the Filter menu up top and choose **Liquify** (as shown here).

STEP TWO:
When the Liquify dialog appears, chose the top tool in the Toolbar on the left: the Forward Warp tool (**W**; the one that moves things around like they're made of a thick liquid). We're going to use it to get rid of that bump on her shoulder. Remember, one of the two main tricks for success with this tool is to make your brush just a little bigger than the thing you want to retouch. You resize the brush by using the **Left and Right Bracket keys** on your keyboard (they're to the immediate right of the P key on a standard US keyboard). Pressing the Left Bracket key makes the brush smaller; pressing the Right Bracket key makes it larger. Here, I've made it a little larger than the area we want to retouch.

STEP THREE:

Now take the Forward Warp tool's brush and just nudge that bump right down (as shown here). The whole process takes all of 10 seconds. If for any reason you don't like the results, press **Command-Z (PC: Ctrl-Z)** to Undo your retouch, and give it another try. Remember the second tip: just gently nudge with this brush for the best results.

TIP: FREEZING PARTS YOU DON'T WANT TO MOVE

If you're moving a large section of anything (like maybe someone's ears, or the side of their face, or their waist, etc.), when you use the Forward Warp tool, you always run the risk of moving things you don't want to move (like their eyes, or cheeks, or nose). You can lock down any areas you don't want to move at all by painting over them with the Freeze Mask tool (**F**; it's the fifth tool from the bottom in the Toolbar). Just paint over those areas and they appear in a red tint, letting you know they're frozen and will now not move, no matter what. When you're done with the Forward Warp tool, you can erase those red frozen areas with the Thaw Mask tool (**D**; it's right below the Freeze Mask tool). Just paint over the red areas to unfreeze them.

STEP FOUR:

After we're done fixing that shoulder bone, we can make a small adjustment where her arm meets her blouse (as shown here). Remember the two important tips for the best results: (1) make the brush just a little larger than what you want to move, and (2) just gently nudge with the brush.

CREATING BEAUTIFUL TEETH

If someone is smiling in a photo I've taken, I always take a few moments to make sure their teeth line up nicely, without any distracting gaps between them. I'll fix those that look too pointy or too short compared to the teeth on either side, or anything that might draw attention. We use the Liquify filter for this because it lets you literally move the teeth around, tooth by tooth, as if they were made of a thick liquid. You can just kind of push and pull them in the direction you need them to go. Here's how it works:

STEP ONE:
With the image we want to retouch open in Photoshop, let's evaluate what we need to do: The front tooth on the left has a little notch out of it on the bottom right, as does the second tooth from the left. The front tooth on the right has a tiny gap on the bottom left, and I would flatten a few teeth and, generally, just try to even them all out a bit. Her teeth are actually pretty nice, but the angle of this shot makes them look more uneven than they are. So, go under the Filter menu and choose **Liquify**.

STEP TWO:
When the Liquify dialog appears (seen here; I'm only showing the left side because we're not going to touch any of the sliders or controls on the right—this is all brush work), start by zooming in (press **Command-+** [plus sign; **PC: Ctrl-+**] a few times. I zoomed in to 200%). Then, make sure you have selected the first tool at the top of the Toolbox on the left (the Forward Warp tool **[W]**; it lets you nudge things around like they were made of molasses). The key to working with teeth is to make a number of very small moves—don't just get a big brush and push stuff around. We'll start on that front tooth on the left (I zoomed in on the inset, so you can see the before tooth and the little notch on the bottom right side that's making the bottom of the tooth look uneven). Now, make your brush size just a little larger than that notch (use the **Left/Right Bracket keys** to change the brush size), and gently nudge the area just above that notch downward to fill in the area, making the bottom of the tooth even. That's what you see me doing here—nudging the part of the tooth above the notch down to fill in the notch, so it looks even (it's easier than it sounds).

STEP THREE:

Now, let's work on the front tooth on the right. It's just a tiny notch at the bottom left, so shrink your brush size *way* down, then click right above the notch and gently nudge down a few strokes to fill it in (as shown here). Next, we're going to do more of the same, so let's work on the notch on bottom right of the second tooth from the left. Again, resize your brush to the size of the notch, click right above it, and drag down to fill it in. Making your brush size just a little bigger than the area you want to adjust is one of the big secrets to mastering retouching with Liquify. If you get into trouble, it's probably because your brush is too big.

STEP FOUR:

That's basically the process—just move from tooth to tooth. To make a tooth longer, click inside it near the bottom and nudge it down. In looking at the two front teeth (now that their bottoms are pretty straight), I see that the tooth on the left is overlapping the one on the right a bit. So, let's gently nudge the right edge of the tooth on the left over to the left a bit, so they don't appear to overlap as much (as shown here). My goal is to make everything pretty straight all the way across. A dentist would cringe if they saw what I did here, because it's not "dentically" correct (hey, I just coined another new term), but we don't have to worry about the teeth actually working to eat food, they just have to work in the context of our photo. To see a quick before/after, turn off/on the Preview checkbox at the bottom right of the dialog.

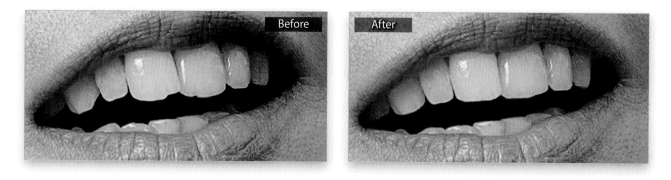

Before

After

REDUCING JAWS AND JOWLS

This is a retouch you usually do when there's more than one person in the photo, but you want to slim just one of them. This is one of those techniques that, when you look at it, you think, "There's no way this is going to work." But, it actually works amazingly well, even though it only takes a few seconds. Go figure.

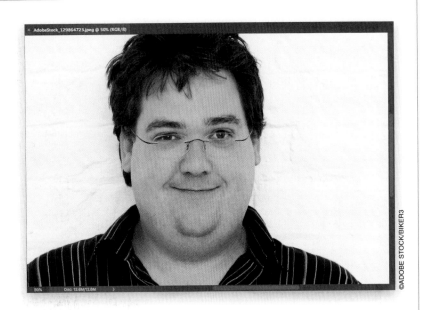

STEP ONE:
In Lightroom, click on the image you want to retouch and then press **Command-E (PC: Ctrl-E)** to open it in Photoshop. Here, we're going to reduce his jaw area and jowls.

STEP TWO:
Get the Lasso tool **(L)** and draw a very loose selection around the jowl area that you want to reduce (as shown here, where I zoomed in a bit tighter just to help you see the area I selected better). I avoided selecting his chin because this technique would make it smaller, as well. If you want that, go ahead and select the chin area, too, but in this case, I think his chin itself looks fairly proportional to the rest of his face. Now that our selection is in place, let's soften its edges to help hide the fact that we did a retouch by going under the Select menu, under Modify, and choosing **Feather**. When the Feather Selection dialog appears, enter 10 pixels and click OK.

STEP THREE:

Now, go under the Filter menu, under Distort, and choose **Pinch**. When the Pinch dialog appears, drag the Amount slider to the right to the point where it reduces the jowl area, but without looking too obvious. In this case, I chose 58%, but depending on your subject, you might need to use more or less—it all depends on the photo. Unfortunately, this filter doesn't show you an onscreen preview. So, to see a quick before and after of what the filter is doing, take your cursor and click-and-hold right inside the preview window (as I'm doing here) to see the before, then let go to see the after. Click OK, and the Pinch filter is applied to your selected area (a before/after is shown below). In some cases, applying the filter once just isn't enough (it's too subtle), so to apply the same filter again, using the exact same settings, press **Command-Control-F (PC: Ctrl-Alt-F)**. When you're done, press **Command-D (PC: Ctrl-D)** to Deselect.

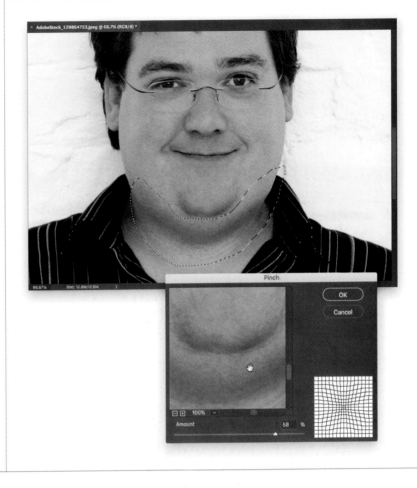

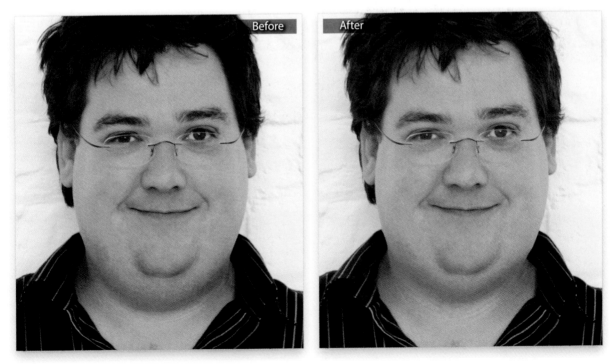

Before

After

REPOSITIONING BODY PARTS USING PUPPET WARP

You reach for Puppet Warp when you need to reposition a body part. It can be a big part of the body, like from the waist up, or the head and shoulders, or it can be as small as repositioning somebody's hand or fingers. It works astonishingly well, and it is an underused and underestimated retouching tool. Use it once or twice, and you'll see how powerful it is and will want to add it to your retouching arsenal. In the first example here, we're going to reposition our subject's head, so it's more upright and not leaning to the left.

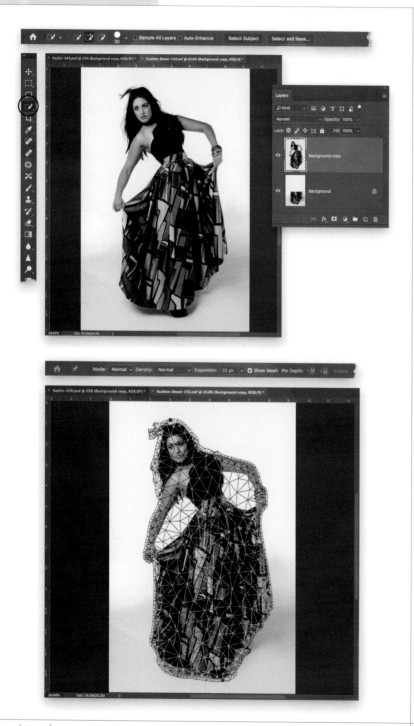

STEP ONE:
First, select your subject and put them up on their own layer (as seen here). I did this by getting the Quick Selection tool **(W)**, and then, up in the Options Bar, clicking the Select Subject button to have Photoshop automatically put a basic selection around my subject. Then, I clicked the Select and Mask button, chose the Refine Edge Brush tool **(R;** in the Select and Mask Toolbar), and painted along the edges of her hair to select the ends. Then, I chose to put my selected subject up on her own layer. (*Note:* We'll look at how to make selections like this more in Chapter 5. It's way easier than you'd think.) With your subject on their own layer, use the Clone Stamp tool **(S)** to get rid of them on the Background layer by Option-clicking (PC: Alt-clicking) on a background area to sample it, then painting over the subject to clone them away (here, I only cloned away her top half, since we're only adjusting that area).

STEP TWO:
Next, go under the Edit menu and choose **Puppet Warp**. This brings up a mesh over your image (seen here). The mesh is right up against the edges of your subject, and this can sometimes create jaggy edges around them. So, in the Options Bar, increase the Expansion amount to between 20 and 25 pixels. That expands the outside edges of the mesh, giving you a little breathing room, so you don't get those "jaggies." By the way, for a simple reposition like this, leaving the Density pop-up menu, in the Options Bar, set to Normal will work just fine. If what you're moving is smaller and/or more detailed, like feet or hands, choose More Points for a tighter mesh, or if what you want to move is large and simple, choose Fewer Points for a looser mesh with less points.

STEP THREE:

Now we're going to click to add anchor points on areas we don't want to move to lock them down. We'll start by clicking on the left side of her dress, and then we'll continue on up—one on her left elbow, one near her shoulder, one right below her neck, and one on her forehead (that's the one we'll move to make her head more upright). Then, click down her right side—one near her shoulder, one on the outside of her forearm, and then another one on the right side of the dress (you can see all my anchor points circled here in red). Although we're only going to move the one of her forehead (so we can reposition her head, so it's more upright instead of leaning to the left), you can click-and-move any of these points. If we don't touch them, they act as anchors to keep those areas from moving. If you start moving an area and it moves other areas right around it, too (and you didn't want those other areas to move), click to add more points nearby to keep those areas from moving.

STEP FOUR:

When I'm working with Puppet Warp, once my anchor points are in place, I like to hide the mesh from view so it's not distracting me from having a clear view of the changes I'm making. To hide it, press **Command-H (PC: Ctrl-H)**. With that mesh hidden, the only things that are left visible are those anchor points we laid down (look at how much easier it is to see what you're doing with that mesh hidden from view). Now, click on the point on the top of her forehead and drag it slightly to the right, so her head is more upright (as shown here). The area around her head moves pretty naturally, and the whole repositioning is very fluid-like.

TIP: REMOVING PINS

To remove a pin you've added, press-and-hold the Option (PC: Alt) key, then move your cursor over the pin you want to remove, and it will change into a pair of scissors. Click once with the scissors to remove that pin.

Continued

Here, her head is tilted to the left

After using Puppet Warp, her head is more upright

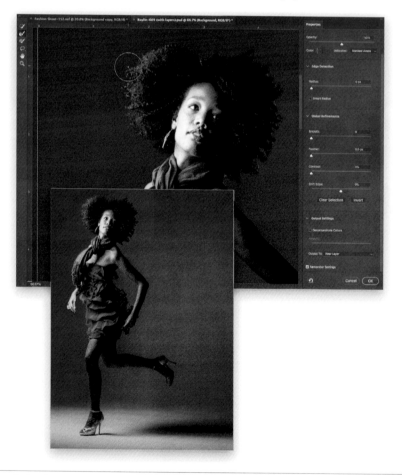

STEP FIVE:
When you're done with your Puppet Warp adjustment, press the **Return (PC: Enter) key** to lock in your adjustment. I put a before/after here, so you can see her before the adjustment, with her head tilted to the left (on the left), and after Puppet Warp, with her head more straightened and upright (on the right). Okay, let's look at another example, because I really want you to be able to use this when you need to.

STEP SIX:
In this shot, I fired my camera a split-second too soon and didn't get her leg bent up high enough. But, that's an easy thing to fix with Puppet Warp. Remember, the first step is to put a selection around your subject, and then put them up on their own layer, which is what I did here, using the same technique as before—I chose the Quick Selection tool from the Toolbar, then clicked the Select Subject button in the Options Bar to put a basic selection in place. Next, I fine-tuned the selection by clicking the Select and Mask button. When the Select and Mask options appeared, I used the Refine Edge Brush tool to paint over the edges of her hair (as shown here). By the way, to make things easier for me to see what's selected, from the View pop-up menu, at the top of the Properties panel, I choose **Overlay**. That puts a red tint over everything that's not selected, and things that I have selected appear in color, like you see here. Again, there's more about this selection stuff in Chapter 5. When you're done, near the bottom of the Properties panel, choose **New Layer** from the Output To pop-up menu, so your selected subject appears on their own separate layer.

STEP SEVEN:

With your subject now up on their own layer, go under the Edit menu and choose Puppet Warp to put a mesh over your subject (as seen here). Now, put down your anchor pins (I added them on her left wrist; her opposite leg, right where her dress ends; one on the bend of her bent leg; one just below the knee on her straight leg; and the one I want to move, I put on the top of her left foot (they're all circled here in red). Next, click on that foot pin and drag it up so the leg bends upward more, like you see here on the right, where I simply dragged it up. When it looks good to you, hit Return (PC: Enter) to lock in your change. Now you have that matter of the extra leg on the original Background layer. In the Layers panel, hide the top layer by clicking on the Eye icon to the left of the layer's thumbnail, and then click on the Background layer to make it active. Then, get the Lasso tool **(L)** from the Toolbar, draw a loose selection around the part of her leg that you moved, then hit **Delete (PC: Backspace)** and choose **Content-Aware**, from the Fill dialog's Contents pop-up menu, to automatically fill that area with some of the gray background. Click OK, press **Command-D (PC: Ctrl-D)** to Deselect, and then click where the Eye icon used to be to the left of the top layer's thumbnail to turn it back on. Easy peasy!

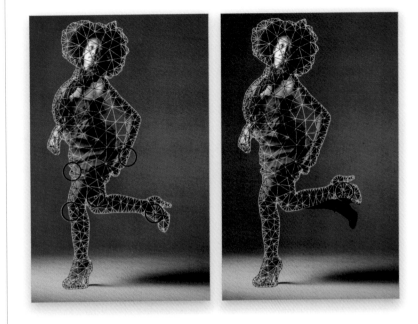

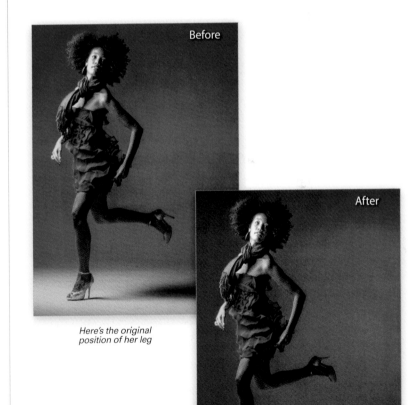

Here's the original position of her leg

Here's the same leg kicked up higher

STEP EIGHT:

Here's the before and after, with the original on the left and the version after the Puppet Warp adjustment on the leg on the right, with it kicked up higher.

COVERING STUDIO MISTAKES

I usually run into this problem (or something like it) while I'm doing a portrait retouch (due to my frequent use of seamless paper backgrounds in the studio), so I'm including it here in the retouching chapter, although you could make a case for it to be in the chapter where we fix, repair, remove, and cover stuff (Chapter 8). But, anyway, it just seems like it should be here (it's such an easy fix that if you learn it now, you'll wind up using it in other places).

STEP ONE:

In this instance, my seamless roll of red paper wasn't wide enough to cover my background stands and other gear, so we're going to use a quick retouching trick to extend the background. Get the Rectangular Marquee tool **(M)** from the Toolbar (by the way, this gets my vote for the "This tool should be renamed" annual award. Just change the word "Marquee" to "Selection," and then we'll all know what it means). Anyway, get that tool and click-and-drag out a tall selection in a clean area of background right near where the problem is. Now, press **Command-T (PC: Ctrl-T)** to bring up the Free Transform bounding box around your selected area. You can see here it added control points to the corners and at the center of each side (we learned about Free Transform back in Chapter 1).

STEP TWO:

When you move your cursor over a control point, if you look really closely, you can see that it turns into a two-headed arrow, which you can drag in or out. So, to cover all the junk you see on the right, behind my red seamless paper, just grab the right center control point and simply stretch that selected area out, right off the edge of the image, so it covers over that stuff (as shown here). When you're done with this side, just click anywhere outside the bounding box to lock in your transformation, then press **Command-D (PC: Ctrl-D)** to Deselect your rectangular selection. Okay, now let's fix the other side.

STEP THREE:

There's a much smaller gap on the left side (but it's still a gap), and we'll do the same thing to fix it. With the Rectangular Marquee tool, click-and-drag out a tall rectangular selection in a nearby area of clean background. Then, press Command-T (PC: Ctrl-T) to bring up the Free Transform bounding box around your selected area (as seen here).

STEP FOUR:

Now, the same technique, different side. Grab the left center control point and drag it all the way over to the left (it's okay to pull it right off the edge of the image) to stretch that clean selected area over so it covers that gap (as shown here). Click anywhere outside the bounding box to lock in your transformation, then press Command-D (PC: Ctrl-D) to Deselect. Told ya it was easy.

COMPOSITE

COMPOSITING & BLENDING MULTIPLE IMAGES

Who would have thought that there would be a dozen or more tunes named "Composite"? Moreover, who would have thought that the very first one I previewed in the iTunes Store (the one by Isotroph) would be a bass drum track followed by some layered synthesizer tracks? This seems to be a theme in the iTunes Store, but maybe in reality these "bass drum, then weird synth" songs are primarily found on tracks that are obviously named after features in Photoshop. Hey, it's certainly possible. So, I started doing searches in the iTunes Store for other Photoshop features and, sure enough, it's the same "bass drum, then weird synth" style of music. For example, I listened to a preview of "Healing Brush" by the Unsharp Masks, and it was 9½ minutes of bass drum followed by a sweeping resonance slider on a synth. I had to buy it. I even gifted copies of it to friends. It's intoxicating. But then it hit me. I have a synth. I have four, in fact (a Korg M3, a Korg TR, a classic Roland D-50, and a Roland U-20), and my son has a Yamaha bass drum (among other drums, but I'm sure he'd loan me that one. After all, how many drums do you really need, right?). Anyway, so I hooked up the synths, put my right foot on the Yamaha bass drum pedal, and picked some weird sounding patches, then I hit the Record button in the Garage Band app. Now, I don't want to brag here or anything, but I made magic. It was like Pandora Radio, the ancient Greek goddess of inhumanely long bass drum tracks, came down from her perch high atop Mount Zildjian and put this track into my soul. Thus, I turned around and, in one triumphant three-note chord, held continuously for 6 minutes and 18 seconds with a quarter-note bass drum track beneath it, I took her offering and returned it to the world as my sonic gift to the pinna. Sadly, it was rejected by the iTunes Store for what they called "remarkably explicit lyrics," but that only happened because at one point during the recording process, my pinky toe got caught between the bass drum pedal and the rim of the drum and I yelped out a few phrases generally only uttered by Jacksonville Jaguar fans during another brutal home game loss, and well, it somehow made it on the tape and the rest, as they say, is history. True story.

KEY TECHNIQUE: MASKING HAIR

Compositing (taking people off one background and putting them on another, realistically) has become really popular over the past few years because the process is getting easier and easier, especially when it comes to making tricky selections to things like wind-blown hair. Plus, some AI and machine learning Adobe has added to Photoshop CC makes it even easier. Don't let the number of steps here make you think it's hard to pull off—it has never been simpler. Here's how it's done:

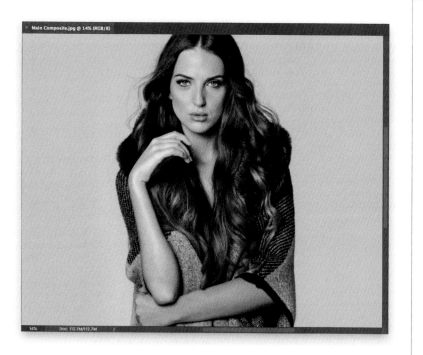

STEP ONE:

Start in Lightroom by choosing the photo of a subject you want to composite onto another background, and then press **Command-E (PC: Ctrl-E)** to take that image over to Photoshop (as seen here). Before we dive into the selection process, your job of selecting someone off the background is much easier if you photograph them on a neutral background color, like gray or tan or beige, etc. In this example, I used a roll of inexpensive white seamless paper for my background and I didn't light it, so it just became light gray, by default (a roll of 56" wide by 36' long white seamless paper goes for around $29.99 at B&H Photo). Of course, you could just buy light gray seamless paper, too, but any neutral solid wall in your house or office will do.

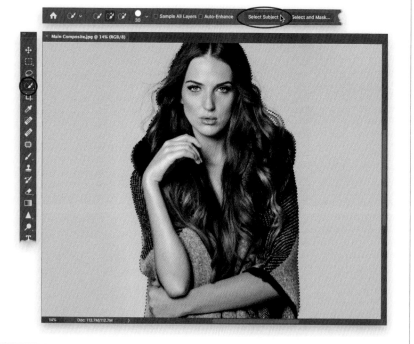

STEP TWO:

We want to select as much of our subject as we can, including her flyaway hair. We do this in two steps: (1) Get the Quick Selection tool **(W)** from the Toolbar (it's the fourth tool down, and shown circled here), but don't actually use it. Instead, we're going to let Photoshop do the initial selection of our subject for us—stuff we used to have to use the Quick Selection tool to do manually (but now Photoshop will do this automatically using machine learning and AI to recognize our subject). Just go up to the Options Bar and click on the Select Subject button (as shown here). That's all you have to do. Wait a few seconds and it will make the basic selection for you (as seen here). It doesn't include all those hard-to-select areas, like the outside edges of her hair, but that's okay—that's for the next step.

STEP THREE:

Once Select Subject has your basic selection in place (it takes all of three seconds, if that), click the button to its immediate right: Select and Mask. This opens up a special workspace for making tricky selections, like hair, and you're going to be shocked at how easy it is to use. Before we start masking, let's change the default view, so it's easier to see what's happening. At the top of the Properties panel, on the right side of the workspace, in the View Mode section, choose **Overlay** from the View pop-up menu (as shown here). This shows the areas that are already selected in full color (as seen here), but with this red tint overlay, any areas where you can see through the red tint are areas that are not selected. So, because this tint is see-through, we can see which areas of her hair are missing from our selection—basically, it's the fan-blown hair on the left and right sides of her head, and the edges of the dark faux fur collar on her coat. In the next step, we're going to tell Photoshop where the tricky hair parts are that aren't yet selected, and then it will "work its magic."

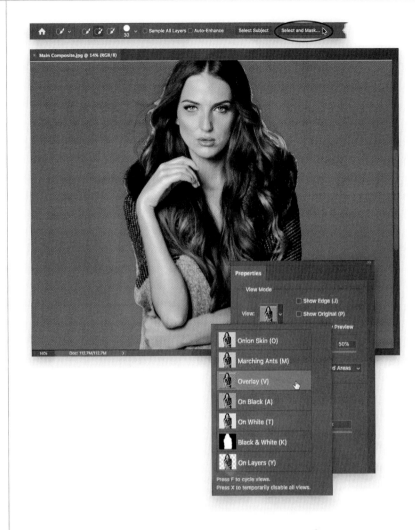

STEP FOUR:

The secret to selecting hair is to use the Refine Edge Brush tool (**R**; the second tool down in the Toolbar on the left side of the workspace). All you have to do is take the brush, let its edge extend over the areas you want to select (as shown here, where about 1/3 of it extends onto her hair), and paint along those parts of her hair. To change the size of the brush, use the **Left/Right Bracket keys** to make it smaller/larger. For those fan-blown wisps of hair, just paint over them too—as you paint over them, you'll see the red tint go away, and those areas turn to full color (as seen here). Look at those areas in the previous step—they had a red tint over them (and you could see parts of the gray background), but now it's gone because they are now part of our selection. Don't paint too quickly—there is some serious math going on in the background, and you might even see a small circular "wait" cursor appear for a moment while it's working its magic.

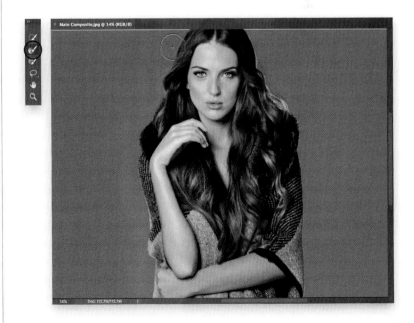

Continued

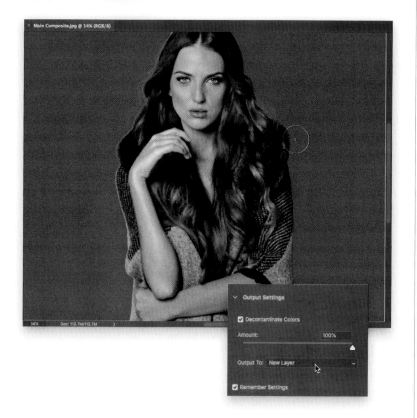

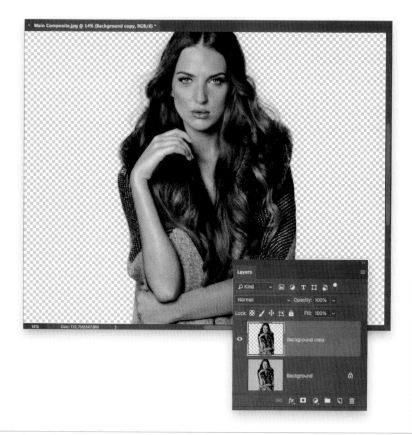

STEP FIVE:

After also painting over her fan-blown hair on the right, you can see those flyaway hairs are now in full color and part of our selection, as well. Here, I'm painting over the edges of her faux fur, and it's getting right between all the tiny gaps in the fur just perfectly (this really is some of that "Photoshop magic" at work). If you make a mistake and it starts selecting too much (parts of her that were already selected start getting a red tint), switch to the next brush down in the Toolbar, the Brush tool **(B)**, and just paint over those tinted areas to bring them back to the full-color selection—think of it as the "undo" brush. Once you're done painting over those tricky areas, head down to the Output Settings section in the Properties panel. This is where you tell Photoshop what to do after you click OK. First, I generally turn on the Decontaminate Colors checkbox to help remove any colors along the edges picked up from the gray background. It usually works well, and I leave the Amount set at 100%. Next, from the Output To pop-up menu, I usually choose **New Layer** (as shown here). When you get a little more advanced and understand how to edit a mask (more on this in the next project), you might choose New Layer with Layer Mask, so you can continue editing the mask manually with a brush after you click OK.

STEP SIX:

Once you click OK, it hides the original Background layer, and your selected subject appears on their own layer (as seen here), with a transparent background (that gray-and-white checkerboard area represents the transparent areas. That's how Photoshop displays transparency when the Background layer is hidden from view). Now, if you look closely, there are a few areas that are kind of "dropping out" (areas that are semi-transparent, but shouldn't be), like near the edges of parts of the fur, and near the edges in the top parts of her coat, and even parts of her flyaway hair aren't all that solid. This is pretty typical, but we're not done—the next step is going to be fixing all those areas in a jiffy.

STEP SEVEN:

This is a trick I discovered years ago, and it has made a huge difference for me (and hopefully, for you, too, now). It's just so darn easy: duplicate the layer twice. That's it—just make two duplicate layers by pressing **Command-J (PC: Ctrl-J)** twice. What this does is builds up the pixels on those edges, and it fills those areas in beautifully. It fills in the hair edges, making them thicker, more noticeable, and fuller. It's like Pantene Pro-V Conditioner for thick, more lustrous hair (sorry—couldn't help myself). Compare the edges and the flyaway hair in this image, with its duplicate layers, to the image in Step Six. Big difference. Once that's done, we don't need all three layers any longer, so let's merge them into a single layer. Press-and-hold the Command (PC: Ctrl) key and click on all three layers in the Layers panel to select them (as seen here, bottom left). Now, press **Command-E (PC: Ctrl-E)** to merge them down into one layer (as seen here, bottom right). Don't worry—it keeps the build-up intact. Then, press **Command-C (PC: Ctrl-C)** to Copy this layer into memory (because it's already on a layer, you don't need to Select All first).

STEP EIGHT:

Open the background image you want her to appear on. This is a city street shot taken in Seattle. I focused on a friend standing in the foreground and held my shutter button halfway down to lock the focus. Then, I recomposed so my friend was out of the frame, but my background was still out of focus and took the shot, knowing I might want to use this as a background for portrait compositing in the future.

TIP: FILLING IN DROPPED-OUT AREAS

If there are areas that have dropped out (are partially see-through) that weren't fixed by my "duplicate the layer twice" trick, then get the History Brush tool **(Y)** from the Toolbar and paint over those areas. This brush is essentially "Undo on a Brush," so when you paint over those dropped-out areas, it paints back in how the image looked when you first opened it. Incredibly handy.

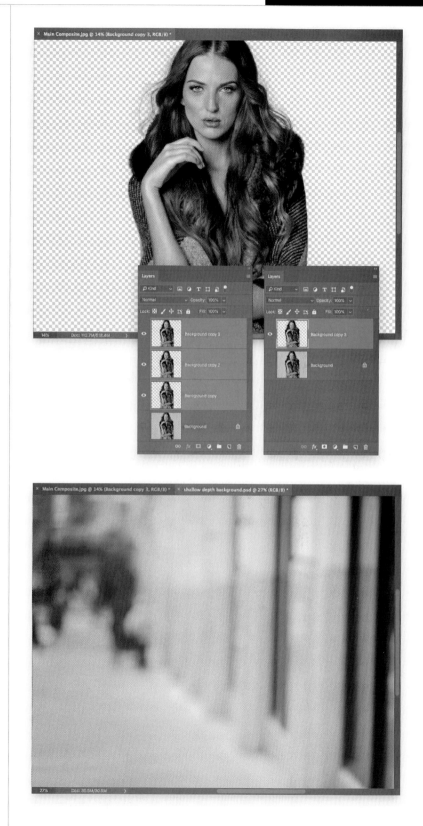

Continued

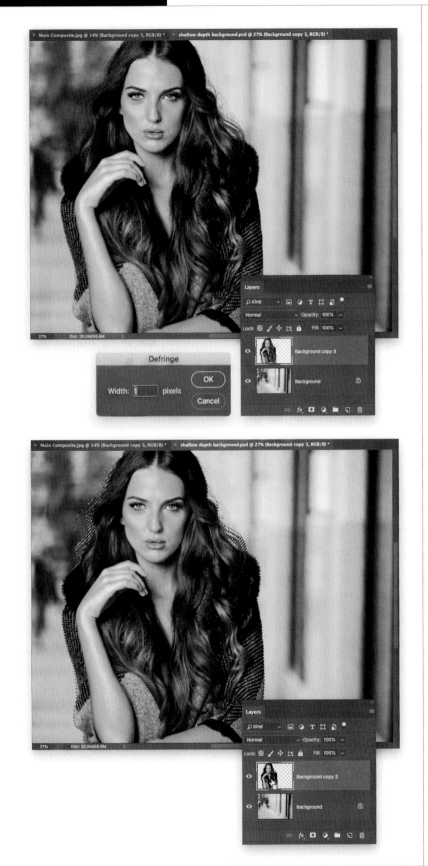

STEP NINE:

Remember how back in Step Seven you copied that merged layer of your subject into memory? (Sure ya do!) Well, now let's paste it on top of this background image (as seen here) by pressing **Command-V (PC: Ctrl-V)**. Then, press **Command-T (PC: Ctrl-T)** to bring up Free Transform, click-and-drag a corner point outward to resize her a bit, move her toward the left side of the background, and then just click anywhere outside the bounding box to lock in your transformation. Now, there's still work to be done because the color is not right (she's too warm to really have been shot on that background), and often, you'll have a thin, little white fringe along the outside edge of your subject layer that you don't see until you paste it on a background. So, first, if you see that little white fringe, go under the Layer menu up top, and all the way at the bottom, under Matting, choose **Defringe**. When the dialog appears (seen here on the left), enter 1 pixel and click OK. That will usually do the trick. If that doesn't work, press **Command-Z (PC: Ctrl-Z)** to Undo the Defringe, and try again, but this time, try 2 pixels. Alternatively, if your subject was originally on a very light or white background, from the Matting menu, try choosing Remove White Matte (or if they came off a very dark background, try Remove Black Matte). Sometimes these work wonders; sometimes they add a messy area around the subject's head, and if that's the case, just Undo.

STEP 10:

In our case, Defringe didn't do much of anything (which is actually pretty rare), but if it doesn't work, no harm done, just Undo. Okay, now let's work on making her overall color tone match the background better. To do that, we first need to bring our selection back around her by pressing-and-holding the Command (PC: Ctrl) key and, in the Layers panel, clicking directly on our subject layer's thumbnail. That reloads the selection of this layer (as seen here where her selection is back in place).

STEP 11:

Now that the selection is back in place, go to the bottom of the Layers panel and click on the Create a New Layer icon (it looks like a page with a turned-up corner and is just to the left of the Trash icon) to create a new blank layer at the top of the layer stack. Next, we're going to steal a color from the background, but not just any color—we want one that predominantly stands out. To me, that light blue in the columns on the right jumps out, so switch to the Eyedropper tool (press the letter **I** on your keyboard), and then click it somewhere inside that blue column to select that color as your new Foreground color (you'll see a circle appear onscreen, with a gray ring around it, as seen here). Now, to fill your selection with this color (yes, it should still be in place), press **Option-Delete (PC: Alt-Backspace)** and it fills just your selected area with this light blue Foreground color (as seen here). Then, press **Command-D (Ctrl-D)** to Deselect. Of course, that fill completely covers our subject on the layer below it, but we'll fix that.

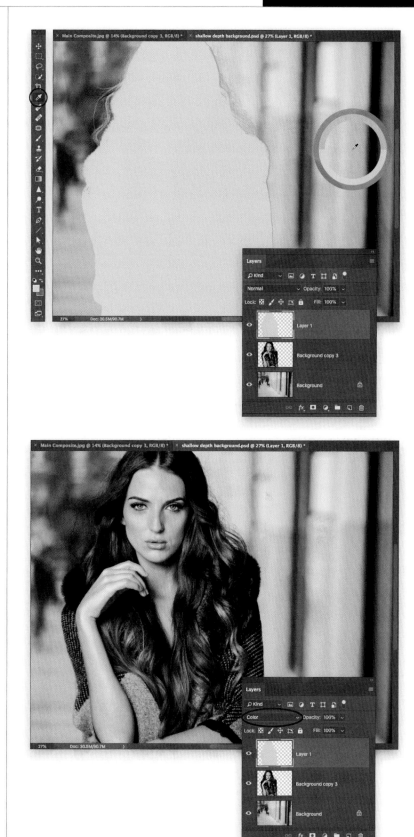

STEP 12:

Next, we're going to change this layer's blend mode to one that will let the color be transparent rather than a solid fill that covers our subject. So, choose **Color** from the blend mode pop-up menu near the top left of the Layers panel (as seen here). This makes the blue fill seethrough and now it's more of a tint. Of course, now she looks monochromatic and kind of blue, but it's a step in the right direction (and we'll adjust that in the next step).

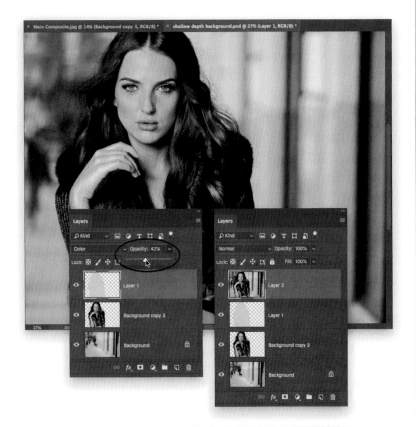

STEP 13:

You're going to go to the Layers panel again, but this time you're going to go up near the top right and lower the Opacity setting for this blue layer until it starts to bring back some of the original color, but with a blue tint on top that better matches the background scene. Here, I lowered it to 42% and now it's a much better match (as seen here). Then, we're going to create a new layer on the top of the layer stack that looks like we flattened the image (took away all the layers). That will allow us to apply an effect to the entire image (instead of just applying it to our current layer). To do this, press **Command-Option-Shift-E (PC: Ctrl-Alt-Shift-E)**, and it creates a new layer at the top of the layer stack that looks like the flattened image (as seen here on the bottom right). Now we're set up for our next step.

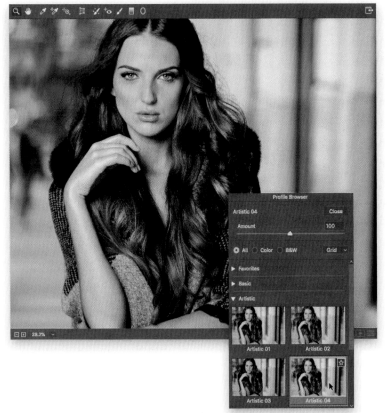

STEP 14:

I always finish up my composites with a few finishing moves that you can do back in Lightroom's Develop module or here in Photoshop, using the Camera Raw filter (they work the exact same way, and do the exact same things, so there's no advantage to doing it here or in Lightroom—just personal prefer-ence). Since this is a Photoshop book, I'll do them here. This first one I feel is really important for making it look like our subject is really on that background, and that is to apply an effect of some sort to the whole image. Doing this kind of visually unifies it, and it makes a big-ger difference than you might think. So, go under the Filter menu and choose **Camera Raw Filter**. Then, near the top right of Camera Raw's Basic panel, click on the icon with the four little boxes to the right of the Profile pop-up menu to bring up the Profile Browser (seen here). Scroll down to the Artistic pro-files and choose one to apply to your image. I chose Artistic 04, which adds a nice, contrasty, blueish hue over the whole image and unifies it nicely.

STEP 15:

Just for fun, let's try a different look so you can see how applying these effects to the merged version of the image affects the overall composite. Here, I clicked on the Artistic 02 profile, and it puts a reddish/brownish tint over the entire image and helps unify the subject with the background. When you're done in the Profile Browser, click the Close button near the top right.

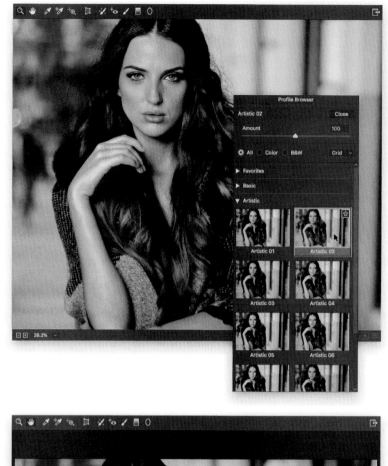

STEP 16:

My final step (and again, one you can do in Lightroom's Develop module, in the Effects panel, as well) is to click on the Effects tab (the fx icon), at the top of Camera Raw's panel area. Then, I softly darken the outside of the image all the way around by going to the Post Crop Vignetting section and dragging the Amount slider to the left (as shown here, where I dragged it to –15). This finishes things off.

BLENDING TWO OR MORE IMAGES

Lightroom doesn't have a feature or function that lets you take one image and have it smoothly blend into another image (or multiple images), and these looks are very popular with everyone from fine art photographers to commercial photographers. The cool thing is that this is another one of those things that Photoshop was born for, so the process is incredibly easy and even lots of fun. It uses layer masking, and once you learn how to do it, it's hard to put the brush down (so to speak).

STEP ONE:
We'll start by opening the first image in Photoshop, so select it in Lightroom, and then press **Command-E (PC: Ctrl-E)** to take it over to Photoshop. This is the image we'll build our collage on top of.

STEP TWO:
Open the second image in Photoshop, as well. We're going to put a selection around this image, copy it into memory, and then we're going to paste it on top of the first image we opened. So, start by going under the Select menu and choosing **All** (or just press **Command-A [PC: Ctrl-A]**) to put a selection around the entire image. Then, go under the Edit menu and choose **Copy** (as shown here, or just press **Command-C [PC: Ctrl-C]**).

STEP THREE:

Now, click on the first image (the one of the bride at the window) and press **Command-V (PC: Ctrl-V)** to Paste the image of the sheet music on top of our bride image (it will appear on its own separate layer). Get the Move tool (**V**; it's the first tool at the top of the Toolbar), and then click-and-drag this image over to the right a bit (as shown here). The idea is to blend these images, so you see the sheet music on the far right, but as it gets closer to the bride, it fades off into nothing. Right now, it's not doing that at all. There's no blend—it has a very obvious, solid, hard edge on the left. But, we're going to fix that shortly.

STEP FOUR:

To blend the two images, our first step is to click on the Add Layer Mask icon at the bottom of the Layers panel (it's the third icon from the left and is circled here in red). This adds a white layer mask thumbnail to the right of your sheet music layer in the Layers panel. Get the Gradient tool from the Toolbox (**G**; it's icon looks like a rectangular black-to-white gradient, so...ya know), then go up to the Options Bar, click on the little down-facing arrow to the right of the gradient thumbnail to bring up the Gradient Picker, and choose the Black, White gradient (it's the third one from the left, in the top row). To the immediate right of the gradient thumbnail are five different gradient styles. Click on the first one, which is the standard Linear Gradient. Now, take the Gradient tool and click-and-drag it from just inside the left edge of your sheet music image, over to the right (as shown here. By the way, I added that red line with the arrow here to help you see which way to drag. When you drag the Gradient tool, you'll just get that thin line right above the red line), and this creates the graduated blend between the two images (as seen here). The farther you drag the Gradient tool, the longer the transition between the solid part of the image and the transparent part.

Continued

STEP FIVE:
Let's open another image in Photoshop. This time it's a champagne glass with a small "love" heart made of thin cork attached. The original color version is seen below left, but we'll probably want to make this image black and white to better blend with the other two black-and-white images. If you just remove the color by using Photoshop's Desaturate command (under the Image menu, under Adjustments, choose Desaturate), it just removes all the color from the image and generally leaves you with kind of a flat-looking black-and-white image (as seen below right). This desaturated version made that cork heart look really dark, but luckily, instead, we can apply a black-and-white profile to get better results (and one where the cork isn't so dark). So, go under the Filter menu and choose **Camera Raw Filter** to bring up Photoshop's version of Lightroom's Develop module—it's the same sliders, in the same order, that do the same thing. Near the top of the Basic panel on the right, click on the icon with the four little squares to the right of the Profile pop-up menu to bring up the Profile Browser (seen here). Scroll down to the B&W profiles and find one that looks good to you (I chose B&W 04 here, and look how much lighter the cork looks. Nice!), and then click OK.

STEP SIX:
Once it's black and white, we can Select All, and then copy-and-paste this champagne glass with the cork "love" tag onto our black-and-white bride and sheet music image. Once it's there, switch to the Move tool and drag it over to the left a bit (like you see here), so it doesn't just cover the entire image. Again, it doesn't blend—you have that hard edge on the right—so we're going to do that whole "add a layer mask, get the Gradient tool, and click-and-drag from just inside the edge over toward the outside" thing to make a smooth blending transition.

STEP SEVEN:

So, click on the Add Layer Mask icon to add a layer mask to this layer, as well. Then, get the Gradient tool again (it will still be set to the Black, White gradient, and Linear Gradient style). However, this time you're going to fade away that hard edge on the right, so you're going to click the Gradient tool just inside the right edge and drag to the left (as shown here. I put another red line with an arrow here, showing where you start [at the red circle] and where to drag over to the left. That thin black line you see above my red arrow, again, is the line that appears when you drag the Gradient tool). When you drag, it fades the edge of that champagne glass layer away.

STEP EIGHT:

The final step is to make that champagne glass layer a little more transparent, so it doesn't take attention off our bride in the center. So, go near the top right of the Layers panel and just lower the Opacity of this layer to around 60%. I also switched back to the Move tool and moved this image a little more to the left. The final image is shown here.

ADDING TEXTURE TO YOUR BACKGROUND

If you shot your subject on a neutral background of some kind (light gray, beige, tan, etc.), instead of pulling the subject off the background and pasting them onto a different one, you can usually use this super-quick trick, which does the opposite—you put a new background on top of your subject, and then use a layer blend mode to bring that texture onto your current background. It's like a composite, only easier.

©ADOBE STOCK/VLNTN

STEP ONE:
Bring the image that you want to add a background texture on top of over to Photoshop by selecting it in Lightroom and then pressing **Command-E (PC: Ctrl-E)**. This technique works best if your subject is on some sort of neutral background (gray, tan, beige, etc.). Shoot your subject on that type of background (like this gray seamless paper), and this technique works like a charm.

STEP TWO:
Next, open the background texture you want to add to your image (this particular background is one I downloaded from Adobe Stock. They're a pretty solid source for background textures. You have probably a thousand or more to choose from cheap, but you can also find completely free background textures online all day long—just Google "Free Background Textures"). Once it's open, press **Command-A (PC: Ctrl-A)** to select the entire image (it literally puts a rectangular selection around the whole image), and copy it into memory by pressing **Command-C (PC: Ctrl-C**; we're going to do a standard copy-and-paste).

STEP THREE:

Return to your portrait image, and then press **Command-V (PC: Ctrl-V)** to Paste your texture image into this document on its own separate layer. Now, you're going to change the layer blend mode of this layer (from the pop-up menu near the top left of the Layers panel), so it blends into the portrait image. There are three layer blend modes that generally work well for adding a background texture: (1) Overlay seems to look the best most consistently, as it blends the background and adds contrast. (2) Soft Light does the same thing, but it doesn't add as much contrast, so the effect looks more subtle. And, (3) I choose Multiply if the background looks too light after I've tried Overlay or Soft Light (I usually try them in that order). Here, I chose **Overlay**. It does a great job of adding the texture, but of course, it also puts it right on top of your subject, so it looks like she has a really bad case of psoriasis.

STEP FOUR:

This next part is going to sound hard, but it's super-easy (for a reason I'll share in just a moment). Stay on this texture layer and click on the Add Layer Mask icon (the third one from the left) at the bottom of the Layers panel. Get the Brush tool **(B)** from the Toolbar, press **D**, then **X** to set your Foreground color to black, and then paint over your subject. As you paint in black, it hides the texture (as shown here, where I'm painting over her hair on the left side). Now, you're probably wondering how to get all the fine edges of hair, especially the fan-blown parts. That's the great part—you don't. You literally don't worry about those. The texture is so fine on those small parts of hair, you don't notice it, which makes the process really quick and easy (this is one you have to try to see for yourself). Get close to the hair edges, but don't try to get all the way to the outside edges. Just "let it go." The last thing I'd do in Lightroom's Develop module is to go to the Profile Browser (we looked at profiles in the last project; they work the same in Lightroom) and choose the Modern 07 profile to unify the two images (as seen in the inset at left).

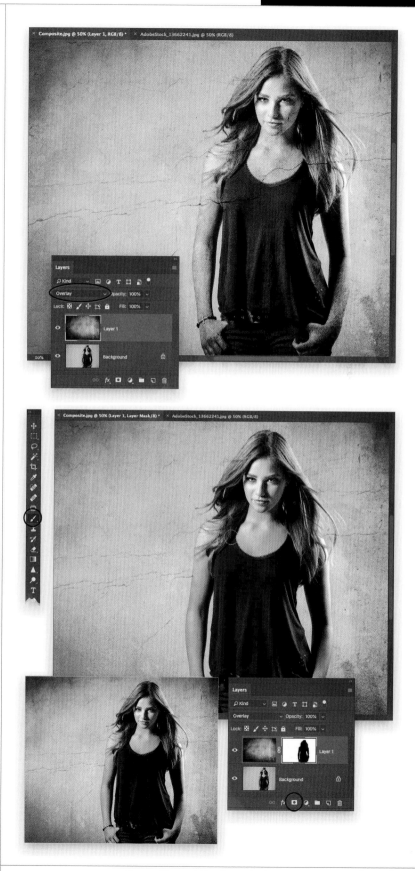

ONE PERSON, MULTIPLE TIMES COMPOSITE

The finished image from this technique makes it look a lot harder than it is (especially because it's not hard at all). Any beginner can do this, first try, as long as you follow one simple rule: shoot this on a tripod and don't move it—just move your subject. You can do this outdoors, indoors, the background doesn't matter, as long as the background isn't moving (it's much trickier if something is moving in the background), but otherwise—piece of cake. Just remember, shoot this on a tripod.

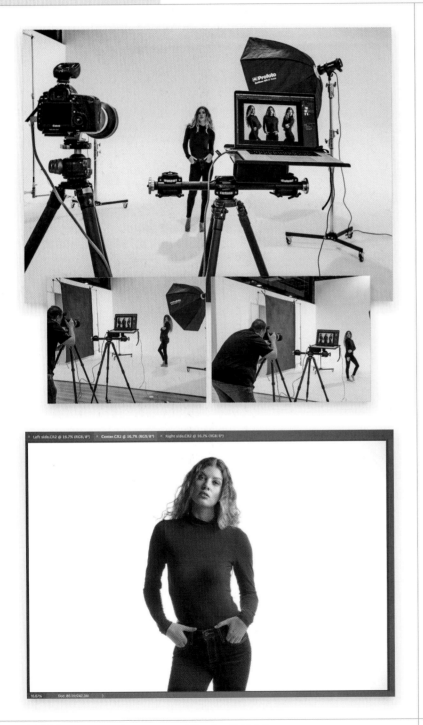

STEP ONE:
Like I said above, shoot this on a tripod and this is a piece of cake. The idea is to place your tripod directly in front of your subject (like you'd generally do), and then don't move your tripod at all during the shoot. Take your first shot, then have your subject move somewhere in your frame—ideally a few feet from where the original shot was taken, so the other images of your subject don't overlap (it's just easier if they don't). Also, don't change your lighting. Just like the tripod, set it up and leave it alone. The only thing that moves during the shoot is your subject (and yes, you can do this outside using natural light, but don't move the sun. Just seeing if you're paying attention). I included a few behind-the-scenes shots here, so you can see what I'm talking about.

STEP TWO:
Okay, select the first image in Lightroom and press **Command-E (PC: Ctrl-E)** to open it in Photoshop. Generally, I choose the image where my subject is the most centered in the image (as seen here), and I'll build off of that one.

STEP THREE:

Open the second image (one where your subject has moved to a different position in the frame) and press **Command-A (PC: Ctrl-A)** to put a selection around the entire image. Now, press **Command-C (PC: Ctrl-C)** to Copy that image into memory. Switch back to the original image document and press **Command-V (PC: Ctrl-V)** to Paste this image on top of your original image (it will appear on its own separate layer, named "Layer 1"). Near the top right of the Layers panel, lower the Opacity of this pasted layer to 80%, so you can see through to the background image (as seen here). Now, get the Move tool **(V)** and click-and-drag this layer over to the right and position it so there's some space between the two versions of her (as shown here), and then raise the Opacity of this layer back to 100%.

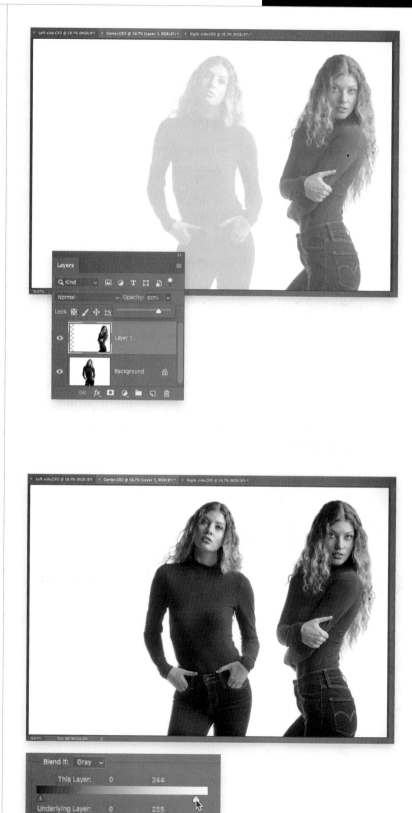

STEP FOUR:

To bring the image on the Background layer through to where we can fully see her again, double-click directly on the top layer's thumbnail to bring up the Blending Options in the Layer Style dialog. The reason why we want to be in this dialog is to use the Blend If options in the bottom center (shown here). All you need to do here is drag the top right slider to the left and the image on the Background layer will be fully visible, as if it comes right through the other image (as seen here). Click OK.

Continued

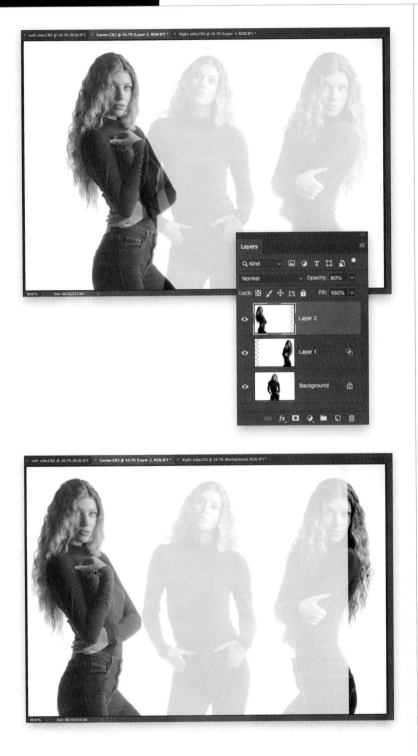

STEP FIVE:
Now open the third image. You're going to do that whole "select all and copy/paste" routine with this image, so go ahead and Select All and copy this image into memory. *Note:* I only used three images for this project, but you can have your subject appear four, five, pretty much as many times as you have room in your frame. If you want your subject to appear more times, you'll just either need to move your tripod back farther (so you're getting a wider image), or use a wider angle lens, so you can fit more in the same frame. Switch back to the document we've been working on and paste this image (it will appear on its own layer, as well, at the top of the layer stack), and then lower the Opacity to see how this version of her fits with the other two. In this case, she's overlapping the center image by quite a bit.

STEP SIX:
Using the Move tool, drag this layer over to the left until there's a little space between the version of her on the left and the version in the center on the Background layer (as shown here). You can then raise the Opacity of this layer back to 100%.

STEP SEVEN:
Next, you're going to do that Blend If trick, again. So, in the Layers panel, double-click on this top layer's thumbnail (Layer 2) to bring up the Layer Style dialog again and, in the Blend If section, click-and-drag the top white slider to the left a bit until you see the other two images on the layers below appear (as seen here). Click OK and that's all there is to it.

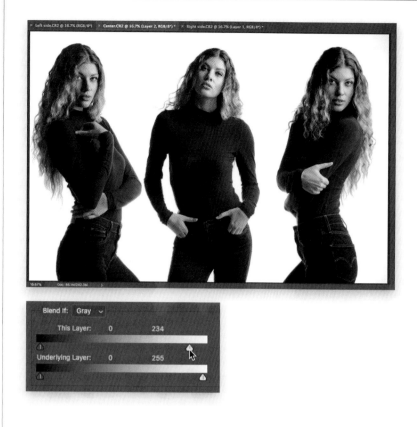

STEP EIGHT:
Optional technique: The Blend If slider worked so well for this because we shot on a white background. But, if you're going to shoot on another color, you're going to need a different technique (it's an easy one). Instead of using the Blend If sliders, you're simply going to erase or delete all the extra space next to your subject in each shot. In this instance, I would get the Rectangular Marquee tool **(M)** and drag it out over all that blank space to her right (as seen here), then hit **Delete (PC: Backspace)** to delete the excess space, and that would reveal the two images on the lower layers (I would, of course, do the same thing and delete the excess to the left of her on the middle layer, as well). That's about the quickest way, but you could also just add layer masks to the two top layers (we looked at working with layer masks like this in the last project), then paint over the blank space with the Brush tool **(B)**, with your Foreground color set to black, and it would reveal the subject on the lower layers.

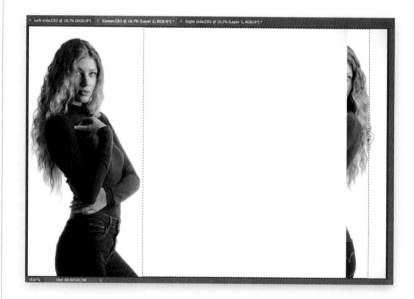

SIDE EFFECTS

I had two really good choices for chapter names for this one: either the 2013 movie *Side Effects* (starring Rooney Mara and Channing Tatum) or 2009's *Personal Effects* (starring Michelle Pfeiffer and Ashton Kutcher), but once I read the brief plot summary on IMDb (the Internet Movie Database), I knew it would have to be *Side Effects*. Here's what it said: "A young woman's world unravels when a drug prescribed by her psychiatrist has unexpected side effects." That movie might just as well have been based on me, because that's my story. When I read it, it sent chills down my spine because (a) I'm a young woman, (b) I live in this world, (c) it's unraveling because… (d) my psychiatrist prescribed the drug trimethoxyphenethylamine, which had the unexpected side effect of me growing a full head of long blonde hair on the small of my back, to the extent that my colleagues refer to me as "Pony Boy" or "Pony Girl" or "Polly Grip." It's not funny. I have to trim that tail at least three times a week using a Black & Decker 12-inch, 18-volt Cordless Electric GrassHog String Trimmer/Edger to this very day. Now, there was another "effects" movie title I could have gone with, which was 2012's *Lake Effects* (starring Jane Seymour and Scottie Thompson), and the fact that one of the stars was named "Scottie" was pretty compelling unto itself, but I couldn't get past the "Lake" part. However, once I read the short plot summary on IMDb, I thought this sounded even more like my life story than *Side Effects*. Here's what they wrote: "Sara and Lily grew up at Smith Mountain Lake. Sara became estranged from the family and without explanation moved to Los Angeles to study law." This is really eerie because I grew up at Smith Mountain Lake. I became estranged from my family and without explanation I moved to L.A. to study law. It was there in Los Angeles that my psychiatrist prescribed the drug trimethoxyphenethylamine, and I bought my first Black & Decker Cordless GrassHog. Every word of this is true.

SWAPPING OUT FOR A BETTER SKY

Nothing kills an image like a cloudless sky, but luckily, replacing your bland sky with a better one is actually remarkably easy, thanks to Photoshop's Blending Options Blend If sliders. They do the work for us and keep us from having to create really intricate masks. It's really just a few seconds and boom—done.

STEP ONE:
We'll start by selecting this image—taken under a dull, cloudless sky—in Lightroom and pressing **Command-E (PC: Ctrl-E)** to open it in Photoshop. I'm amazed I'm letting anyone see this at all, but it's only because I have a feeling it's about to look somewhat better.

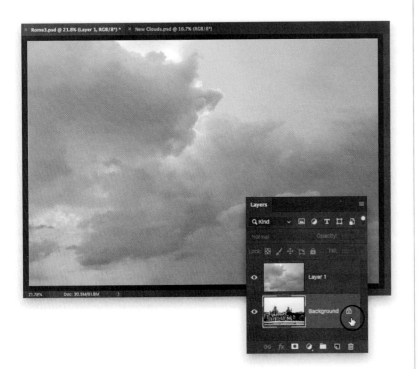

STEP TWO:
Here's an another image of some clouds taken just a couple of days later in the same town. Since it's not a sky that's all "shiny and blue," I think it will look just about right with the rest of the other image. Press **Command-A (PC: Ctrl-A)** to select the entire image, then press **Command-C (PC: Ctrl-C)** to Copy it into memory. Switch back to the image with no clouds and press **Command-V (PC: Ctrl-V)** to Paste it into this document, on its own layer. Next, we're going to need to convert the Background layer into a regular layer, so go to the Layers panel and click once directly on the little Lock icon to the right of the word "Background" (as shown here). This unlocks the Background layer and converts it into a regular layer (and the Lock icon will disappear).

STEP THREE:

Now, in the Layers panel, click-and-drag the no clouds image to the top of the layer stack (as seen below right. The city image is now on top, and the clouds are on the layer below). Double-click directly on the top layer's thumbnail to bring up the Blending Options in the Layer Style dialog (seen here bottom left). At the bottom center are the Blend If sliders (the gradients with triangle-shaped sliders beneath them). By default, the Blend If pop-up menu is set to Gray, but since we're replacing a sky, we'll need to switch to the Blue channel. Now (and this is *very* important), we're going to drag the top right slider to the left, *but before we do*, we're going to press-and-hold the Option (PC: Alt) key because if don't, when we drag that slider, we won't get a smooth blending of the new sky. Instead, we'll get harsh, jaggy results that look pretty awful. So, press-and-hold the Option key, drag the top-right slider to the left, and you'll notice that it splits the slider knob in half, which creates a smooth blend. The farther you drag, the more the blue sky from the bottom layer shows through (as seen here). When you're done, click OK.

STEP FOUR:

It's likely there will be a few areas that have similar tones as the sky that will also have the sky showing through a bit, like the marble railing at the bottom of the image, here (if you look on the right side of it, you can still see some of that sky showing through). To get rid of those areas with unwanted bleed-through, click on the cloud layer in the Layers panel, get the History Brush tool (**Y**; I like to think of this as "undo on a brush") from the Toolbar, then paint over those areas and they return to their normal look, covering up the bleed (that's what you see happening here, where I painted over the left side of the railing). Paint over any areas where some of that sky is showing through—this should only take a few seconds and you're done. Optional: If, after the blending, you feel the sky looks too light in tone, go to the Camera Raw filter (under the Filter menu) and lower the Exposure a bit.

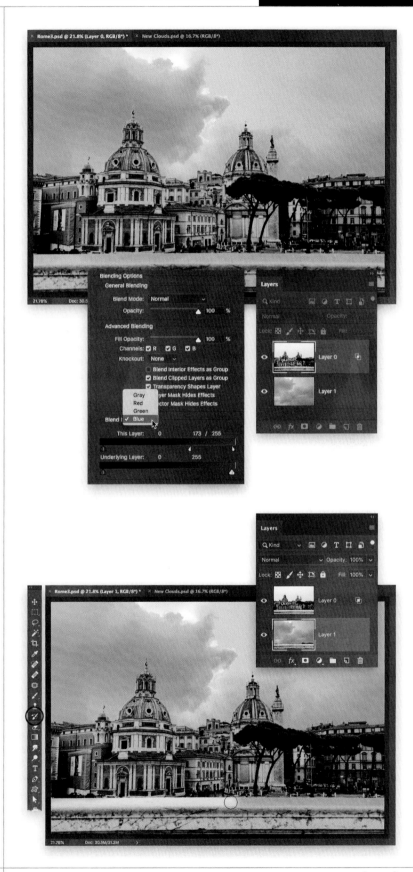

CREATING FALL COLOR (LAB MODE)

This effect has you converting from regular RGB to Lab color mode, but don't worry—it won't mess anything up (in fact, when you do the conversion, your image will look the same, but it allows us to very easily turn green summer leaves into a fall-color autumn scene in 10 seconds flat. 15 tops).

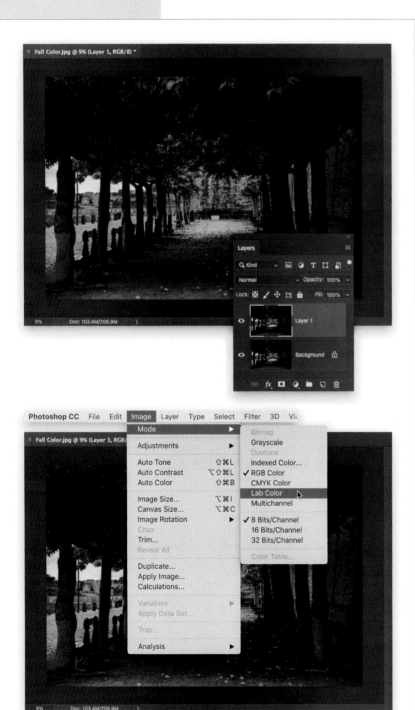

STEP ONE:
In Lightroom, select an image that you want to apply fall color to and press **Command-E (PC: Ctrl-E)** to open it in Photoshop. The first step is to duplicate the Background layer by pressing **Command-J (PC: Ctrl-J)**. This will come in handy later (you'll see why in Step Four).

STEP TWO:
Go under the Image menu, under Mode, and choose **Lab Color**. In the dialog that appears, click Don't Flatten. You won't notice any change at this point—the image will look the same—but if you looked in the Channels panel (found under the Window menu), you'd see that instead of the image being made up of a Red, Green, and Blue channel, the image is separated, so the Lightness (detail) is one channel, and the other two are color channels named "a" and "b." Just an FYI.

STEP THREE:

Next, go under the Image menu and choose **Apply Image**. From the Channel pop-up menu, choose "b," and from the Blending pop-up menu, choose Overlay (as seen here), and you'll immediately see the fall effect appear in your image. If it's too intense, lower the Opacity amount (you'll have to type in a number if you want to change it—there's no slider for it in this dialog) until it looks right to you. Once it does, click OK.

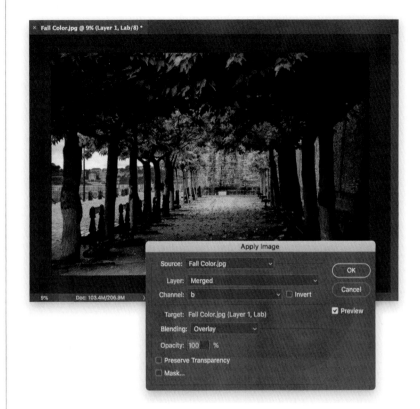

STEP FOUR:

Let's convert back to regular RGB color mode by going back under the Image menu, under Mode, and choosing **RGB Color**. Again, click Don't Flatten in the dialog that appears. Now our image is back to normal mode, but there's a good chance that parts of it either look too orange/yellow or too blue. We knew this was likely, and that's why we created that duplicate layer in the first step. So, go to the bottom of the Layers panel and click on the Add Layer Mask icon (the third icon from the left). Get the Brush tool **(B)** from the Toolbar, press **D**, then **X**, to make sure your Foreground color is set to black, and then paint over any areas that look too blue (or, if you have people in your image, their skin might be too orange), and it brings back the original color in those areas. Here, I painted over the wall on the right to bring back its original color, as well as areas on the left in between the trees. If you didn't want to do the duplicate-the-layer thing, an alternate method to get back to the original color would be to get the History Brush tool **(Y)** from the Toolbar and paint over those areas to bring back their original tones. (*Note:* You can't use this tool until you convert back to regular RGB color mode, though.)

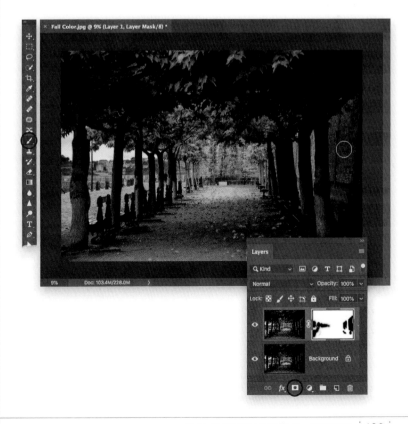

ADDING LIGHT BEAMS

Want to add some dramatic beams of light to your image? There are a half-a-dozen ways to do this, but most of the techniques have you creating a brush stroke that has a bunch of different spots to it, and then adding a radial zoom blur to change those spots into beams. In this version, we're going to use a "spots" brush that's already in Photoshop, so all we have to do is zoom it, mask it, and we're done.

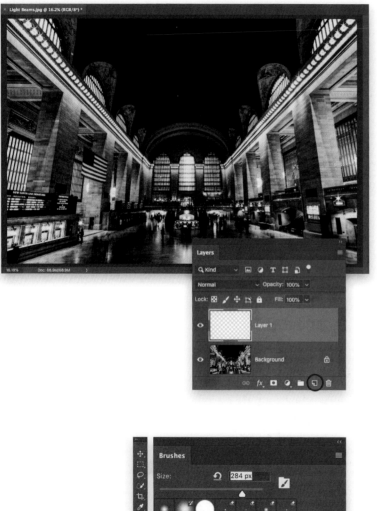

STEP ONE:
Open the image you want to add light beams to (in this case, it's New York City's Grand Central Terminal). Again, we're going to use a preset brush, which we're going to turn into our beams. We'll need to do this on a layer, so go to the bottom of the Layers panel and click on the Create a New Layer icon (the second one from the right) to create a new blank layer. This is where we'll build our beams.

STEP TWO:
Now, get the Brush tool (**B**) from the Toolbar, and then open the Brushes panel (you can open it by choosing it from the Window menu). You'll find a number of different sets of brushes here and the one we're looking for is in the Special Effects Brushes folder. Look inside that folder, and you'll find the "Kyle's Spatter Brushes - Spatter Bot Tilt (Brush Tool)" brush (shown selected here. Look for a special effects brush whose size is 284 pixels and that will help you find it fast). Click on that brush to make it your active brush tip.

STEP THREE:

A size of 284 pixels is going to be pretty small for the high-resolution shots like you get from today's cameras, so go up to the Options Bar, click on the brush thumbnail, and it will bring up the Brush Picker (shown here below). Increase the size of the brush big time (I increased the Size slider to 2100 pixels—nearly 10 times the default size). Press the letter **D** on your keyboard, then **X**, to set your Foreground color to white, and then click on your image, hold your mouse button down for a couple of seconds, and it will paint a spattering of different-sized spots, like you see here. Or, you can click a few times—doesn't matter—we just want a bunch of different-sized spots. That's what we're looking for (and, by the way, this isn't the only brush that will work for this—any brush that has a bunch of spots or shapes will pretty much work).

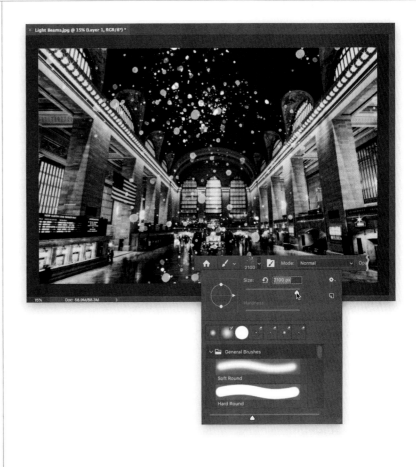

STEP FOUR:

Next, go under the Filter menu, under Blur, and choose **Radial Blur**. When the dialog appears, set your Amount really high (I used 100); for Blur Method, choose Zoom; and for Quality, choose Best. Now, take your cursor, click it in the middle of the zoom Blur Center, and drag the center up toward the top of that little preview square (as shown here). This puts the center of the blur up high and sends most of the zoom effect aiming down, which it what we want— beaming from up high. Click OK to apply the Radial Blur zoom to your white spots layer. *Note:* It can take a while for this particular filter to do its thing, so be patient. If you're running this on a 16-bit version of your photo, this wouldn't be a bad time to grab a cup of coffee. Maybe a sandwich, too. Have you done your tax return yet? You've got time.

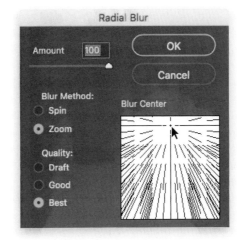

Continued

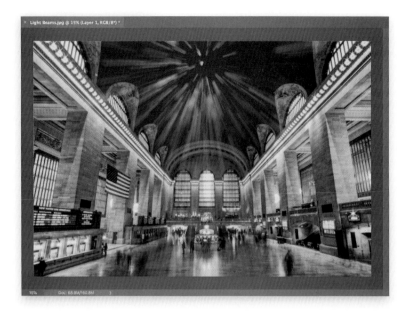

STEP FIVE:
This creates our initial beams, and you're probably thinking, "Scott, this doesn't look all that awesome," and I'd agree, but only because we're not done yet. We've got to make the beams brighter, then position them in the right place, and then remove all the leftover stuff we don't want visible in our image. So, think of this is as the first draft version. It'll get better.

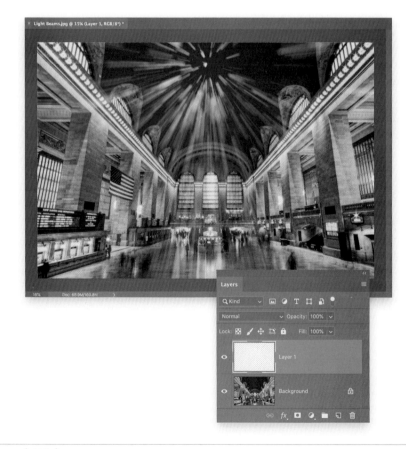

STEP SIX:
To make the beams of light brighter and more defined, simply duplicate the beams layer **(Command-J [PC: Ctrl-J])**. Just duplicating this layer has kind of a "build-up" effect as semi-transparent pixels build up behind one another and it looks better and brighter. Now, let's merge these two layers into one single layer. Click on the top layer in the Layers panel, then press **Command-E (PC: Ctrl-E)** to merge this top beams layer with the original beams layer on the layer below it. Still not done yet.

STEP SEVEN:

Switch to the Move tool (**V**) and click-and-drag the light beams down, positioning them toward the bottom part of the windows at the end of the terminal. Now, go to the bottom of the Layers panel and click on the Add Layer Mask icon (the third one from the left) to add a layer mask to your beams layer. Switch back to the Brush tool, then bring up the Brush Picker again and switch to a round, soft-edged brush, making sure it's a really big brush. Press D, then X to set your Foreground color to black, and then paint over the top of the light beams to hide the parts you don't want seen (the beams above the windows; as shown here), and all that's left are the beams that look like they're coming through the windows. If the beams look too bright, go near the top right of the Layers panel and lower the Opacity of this beams layer (as I did here). Also, if the beams look too sharp or hard-edged, click on the beams layer's thumbnail (not the layer mask, the regular thumbnail), then go under the Filter menu, under Blur, and choose **Gaussian Blur**. Apply a small amount of blur to the beams layer to soften it up—5 pixels or so should do the job, but again, only if they look too sharp or hard.

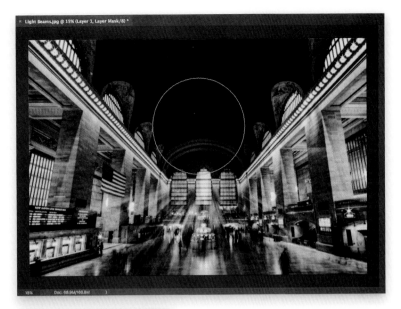

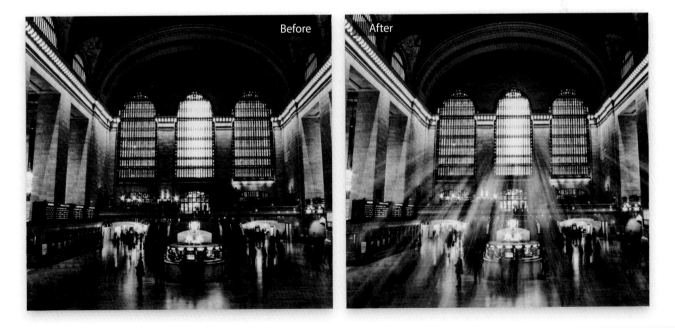

Before

After

TURNING A PHOTO INTO AN OIL PAINTING IN ONE CLICK

This is a really popular effect for photographers who do portraits of babies, brides, pets, or anything really cute and cuddly. It can also look wonderful on landscapes, travel shots, and well...you just have to try it out on whatever image you'd like to see as an oil painting because, since it's so easy, it's worth trying out. *Note:* There's a lot of math going on with this filter, so it's not the fastest when it comes to displaying your changes (you might have to wait a few seconds after a change for the preview to redraw). Luckily, the preview right in the filter dialog updates instantly as you make changes. Just a heads-up.

STEP ONE:
Select an image in Lightroom that you want to turn into an oil painting, then press **Command-E (PC: Ctrl-E)** to open it in Photoshop. Here's a travel shot of Mont-Saint-Michel in northern France that we're going to turn into an oil painting in one click.

STEP TWO:
Go under the Filter menu, under Stylize, and choose **Oil Paint.** This brings up the Oil Paint filter dialog, and it immediately applies its default settings. So, once you choose it—BANG!—you've got an oil painting. To really see the paint effect, you'll probably need to zoom in to 100%, but you'll see it does a pretty amazing job of keeping detail while still looking very painterly. Of course, at this point, you can just click OK and be done with it, but you actually have quite a bit of control over how your oil painting looks. Let's start with the first slider: Stylization. Technically, this controls the style of the brush it paints with, and the farther you drag this slider to the right, the more intense the effect becomes, because the brush strokes get longer and the effect looks smoother (at lower numbers, it paints with small, hard brush strokes). If you drag this slider all the way to the left, the oil paint look pretty much goes away and it just looks like you put a canvas texture over your image. Try dragging the Stylization slider over to 9.0 and you'll get a smoother Van Gogh-esque look.

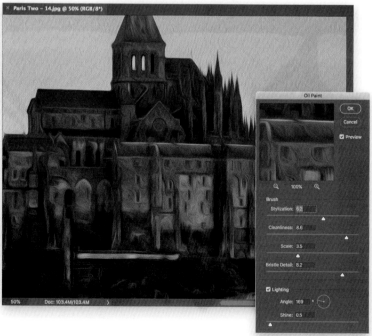

STEP THREE:
The next slider down, Cleanliness, controls the detail (in fact, they could have named it the Detail slider and saved us a lot of grief). If you want the brush to paint your image with a cleaner, more detailed look (more realistic), keep this slider closer to the left, and for a softer, more painterly look (seen here), drag it to the right (I dragged it over to 8.2).

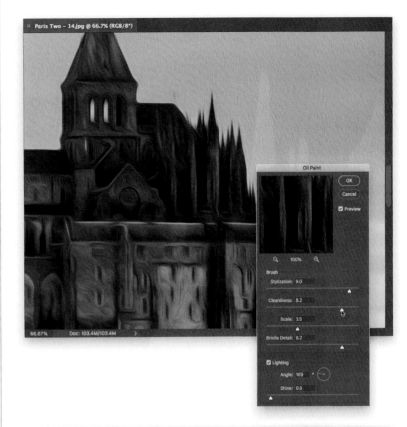

STEP FOUR:
The Scale slider controls the size of your brush, so dragging it way over to the left paints your image with a very thin brush and dragging it all the way over to the right paints it with very thick strokes, which definitely creates a different look. In short, want the look of bigger brush strokes? Drag the Scale slider to the right (compare the sky in this image with the image in Step Three, and you'll see the difference in stroke size).

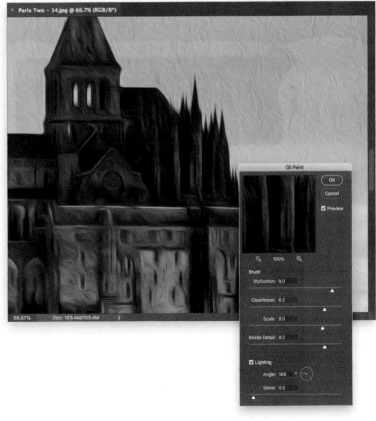

Continued

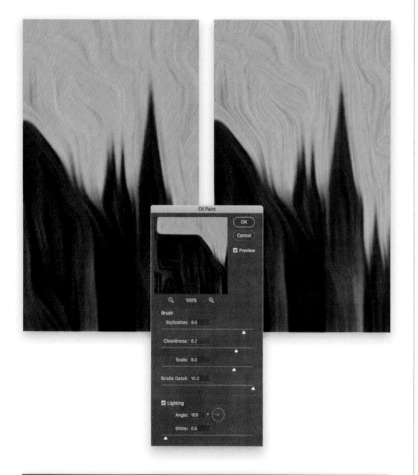

STEP FIVE:
Okay, a better name for the next slider, the Bristle Detail slider, would be the Sharpness slider. It makes the overall image look sharper or softer with how it affects the brush. Dragging it to the left takes away the detail of the brush bristles, so it's very soft, smooth, and undefined. Dragging it to the right gives it a harder, more detailed look that makes the image look sharper, as you really see the bristles in the stroke now. Compare the sky on the left (with the Bristle Detail set at 1.0) to the one on the right (with it set at 10.0). It's sharper, with more detail in the strokes.

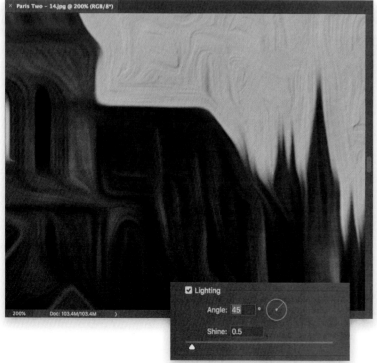

STEP SIX:
In the Lighting section, below the Brush controls, the Angle setting controls the angle of the light hitting your painting, and the light changes as you drag from 0 to 360 degrees.

TIP: GETTING GOOD RESULTS
I hate to be the guy that says, "Just drag the sliders around until it looks good to you." But, I can tell you that I've used this filter enough to know that it looks so different depending on the subject, that if you just drag each slider back and forth a couple of times, you'll find a sweet spot where it looks good for that particular photo, and you just stop there. It sounds like a cop-out, but honestly, that's how I use it.

STEP SEVEN:

The last control in this dialog is the Shine amount, and it controls how the light reflects: dragging its slider to the left makes your image very flat-looking, and dragging it over to the right adds contrast to the highlights and shadows and kind of makes the paint look thicker, almost like it's embossed. Here on the left is the Shine set at 0.5, and on the right it's raised to 3.5 (you can just imagine what it would be like if you raised it to 10, right?). Down below, you'll see a before and after with the original image on the left and then after applying the Oil Paint filter.

TIP: PRINT IT ON CANVAS

If you really want to "sell" the effect that this image was painted with oil paint, do two things: (1) sign it, and then (2) print it on canvas.

F/1.2 BOKEH BACKGROUND EFFECT

This is a really cool filter effect because it lets you add a super-shallow depth of field to your image and lets you place the focus point, and the blur, right where you want it. This is kind of designed to emulate the soft-focus, shallow depth-of-field from shooting a telephoto lens with a wide aperture (creating a bokeh effect when you have bright areas in the background).

STEP ONE:

Open your image in Photoshop, then go under the Filter menu, under Blur Gallery, and chose **Field Blur**. This brings up the Blur Gallery workspace and places a blur pin on the image. What we're going to do is use pins to keep parts of the image sharp (like the parts of our subject that are closest to the camera), and then add a mega-blur to other areas, including parts of our subject that would be a little out of focus, like her ear and the back part of her hair.

STEP TWO:

First, drag the blur pin the filter added over her eye that's closest to the camera, then go to Blur Tools panel in the top right and, in the Field Blur section, drag the Blur slider down to zero. This protects that area from being blurred. Click on the image to add another pin and do the same thing anywhere part of your subject is on the same plane as their front eye. In this case, I felt that part of her jacket needed to be in focus, as well, since it would be pretty much on the same plane. So, I added a pin there, and set the Blur amount to zero to remove the blur in that area. I then did the same thing on her hand. Now to add the blurs.

STEP THREE:
Click on the image to add another pin to the right of our subject and set the Blur amount very high (in this case, I went up to 227 pixels) to make that area very soft. What I like about using these Field Blur pins is that you can reposition them. You can even get very close to your subject's face and that first pin we moved over her eye will protect that area. So, it offers you a lot of control when trying to get her ear a little bit out of focus, along with the back of her hair. You'll see what I mean when you try it yourself.

STEP FOUR:
Keep clicking on the image to add more pins. Once I had a few more in place, I felt the background looked too blurry, so I clicked on each of those pins and lowered the Blur amounts to around 175. I also moved the pin on her jacket over to the right a little (as shown here), so that there was less blur on her arm and shoulder. Another thing I love about using Field Blur is that you can move a pin outside the image area, out onto the canvas area, so you can get just the edge of the effect in the image (as I've done here, bottom right). By the way, we've been using the Blur slider here, but you can also control the amount of blur by clicking on that ring around an active pin and dragging around the ring. As you drag, the ring turns gray to show you how far you've gone, and the actual amount of blur appears in a little pop-up display at the top of the ring.

CREATING MIRROR-LIKE REFLECTIONS

Nothing kills a shot like choppy water. I include it in my "Seven Deadly Sins of Landscape Photography" talk, and it's pretty deadly for travel shots, as well. Here's a quick technique that gives you nice, still water, with a glassy reflection. You can end the technique right there, or you can take it a couple of steps further and bring a little more realism into the look. The choice is yours (and it does depend on the image. Sometimes the straight-up mirror look is best).

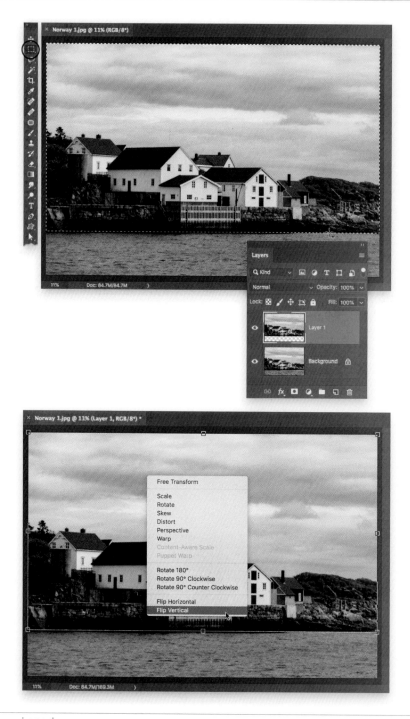

STEP ONE:
We'll start by opening the image in Photoshop. In this case, we have a photo from Norway's Lofoten Islands and the water is kinda choppy. Get the Rectangular Marquee tool **(M)** from the Toolbar and make a selection from the top of the water (where the land meets the water at the seawall) and go all the way up to the top of the image (as shown here). Now, press **Command-J (PC: Ctrl-J)** to copy that selected buildings-and-sky area up onto its own separate layer.

STEP TWO:
Next, let's flip this layer upside down. Press **Command-T (PC: Ctrl-T)** to bring up Free Transform, then Right-click anywhere inside the Free Transform bounding box. From the pop-up menu of transformations that appears, choose **Flip Vertical** (as shown here) to flip this layer upside down, and then just click anywhere outside the bounding box to lock in your transformation.

STEP THREE:

Now your image on this layer is flipped upside down. That's what we're going to use to make our reflection.

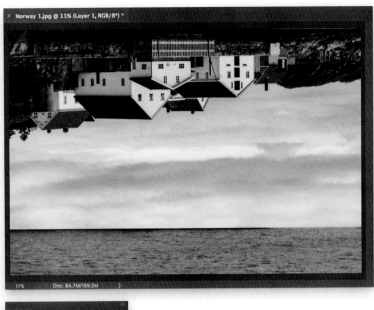

STEP FOUR:

Get the Move tool **(V)** from the top of the Toolbar, then press-and-hold the Shift key, and drag this flipped layer straight downward until the bottom of the flipped image touches the bottom of the seawall (as seen here). The reason we hold the Shift key as we drag is that it keeps the image lined up as you drag—it keeps it from sliding over to the right or the left—so it goes straight down, which is what we need to make everything perfectly match up. This creates the mirror reflection and you certainly could end right here, and it would look good. However, I do take it another couple of moves further and whether you do (just for the sake of realism) is up to you.

Continued

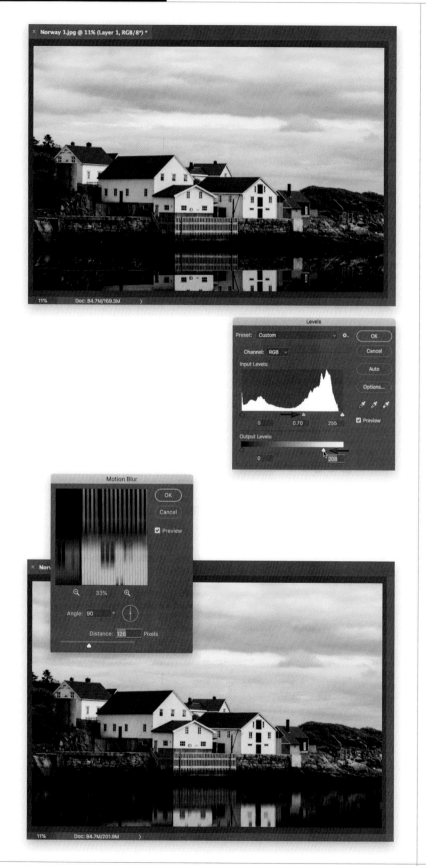

STEP FIVE:

The first thing I do is darken the flipped reflection so it doesn't stand out from the original image, and I do this using Levels (press **Command-L [PC: Ctrl-L]**). When the Levels dialog appears, I drag the light gray Input Levels slider (below the center of the histogram) over to the right a bit to darken the overall flipped reflection (as seen here where I dragged it over to 0.70). That darkens the midtones (kind of like what Lighroom's Exposure slider does), but if it stills looks a little too bright, you can also drag the white Output Levels slider (under the gradient bar) to the left a bit (as shown here), and that should do the trick. That way the reflection doesn't draw too much attention to itself, and with it darkened, the viewer's eye will be drawn to the brighter houses on shore.

STEP SIX:

The next thing I do (again, this is totally optional, but I almost always do this extra step) is to apply a bit of motion blur. That way, the water still reflects, but it's not that absolute mirror reflection, and looks more like what a real reflection looks like in many cases (although it is totally possible to get a true mirror-like reflection in real life, depending on the water's location, like at a lake, a river, or at sea—you just have to get up really early in the morning before the winds start messing everything up). To add this blur, go under the Filter menu, under Blur, and choose **Motion Blur**. When the dialog appears (shown here), set the Angle to 90° (straight up and down), and then drag the Distance slider over to the right until it looks good to you (in other words, it looks imperfect).

STEP SEVEN:

My final step is to go near the top of the Layers panel and lower the layer's Opacity for this reflection by about 15% (here, I lowered it to 80%) to let just a tiny bit of the original water peek through, again to help it look more realistic. The final before and after is below.

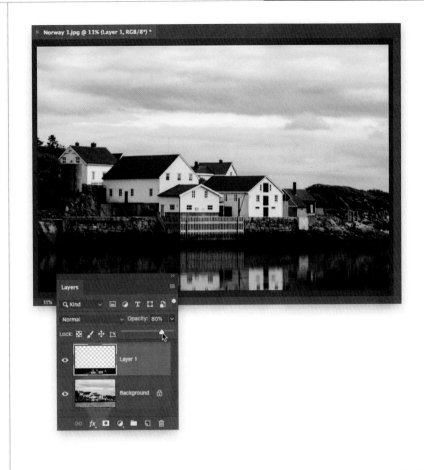

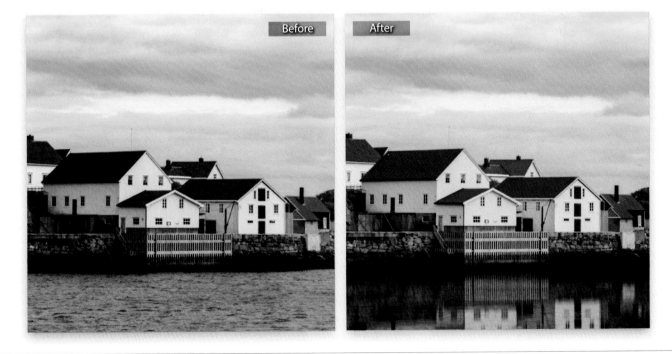

ADDING LENS FLARE

This is one of those effects that you either love or you hate, and if you hate it, it's probably because you've (we've) spent years doing your best to avoid lens flare appearing in your outdoor portraits. We've purchased special nano-coated lenses and bulky lens hoods to avoid lens flare, and now here we are learning how to actually add it too our images. I know, I know, but this "look" is really popular right now, so…don't shoot the messenger (especially the messenger who is about to teach you how to trash…errr…I mean "enhance and embellish" your image).

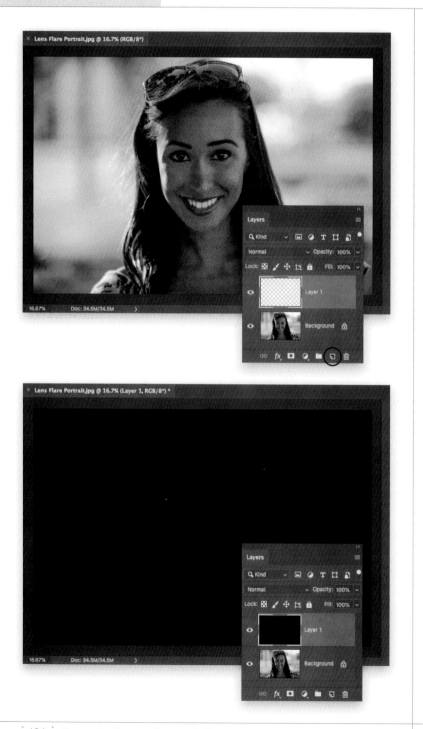

STEP ONE:
It helps if you have the right kind of image to start with—one where your subject is backlit (like you see here) on a bright, sunny day. This is a hard one to pull off under the shade of a giant oak, or on a gray overcast day, so part of the technique is to shoot with this in mind. Start by selecting the image in Lightroom, and then pressing **Command-E (PC: Ctrl-E)** to open it in Photoshop. Go to the bottom of the Layers panel and click on the Create a New Layer icon (the second one from the right) to add a new layer, so now you have a blank layer above your image.

STEP TWO:
Press the letter **D** on your keyboard to set your Foreground color to black. Then, fill this empty layer with black by pressing **Option-Delete (PC: Alt-Backspace).**

STEP THREE:

Now, go under the Filter menu, under Render, and choose **Lens Flare**. When the Lens Flare dialog appears, crank up the Brightness, and then to reposition the lens flare, click inside the filter's preview window and drag it where you want it. It took me a couple of tries to get it to start at the edge of her hair, on the right side where the sun is coming from. I had to apply it, undo it, and try again. What you can do to see how close you are is to click OK in the filter dialog, then go near the top right of Layers panel and lower the Opacity of this black lens flare layer a bit, so you can see your subject on the layer below it. That way you can see what you need to do to get your lens flare in just the right spot. It'll take you a couple of tries, but it won't take long. Just try it—apply the filter, lower the opacity, and if you see you need to redo it, hit **Command-Z (PC: Ctrl-Z)** to Undo, then go under the Filter menu and try it again. Once you've got it where you want it, bring the lens flare layer's Opacity back up to 100%.

STEP FOUR:

Now, to fully see the effect on your image, go near the top left the Layers panel and change the layer's blend mode from Normal to **Screen** (as shown here bottom right). If you need to reposition it, get the Move tool **(V)** from the Toolbar and drag it where you want it. If you do this, though, you most likely will see the edge of the lens flare layer, so you might need to add a layer mask to it, then get the Brush tool **(B)** with a large, soft-edged brush, and paint over the edge to hide it (we looked at layer masks earlier in this chapter). If you think the image needs more yellow/orange to sell the look, go to the bottom of the Layers panel, click on the Create New Adjustment Layer icon (the fourth one from the left), and choose Photo Filter from the pop-up menu. Then, in the Properties panel, choose **Warming Filter (81)** from the Filter pop-up menu (as seen here on the left) and crank up the Density (amount) a bunch to finish off the effect.

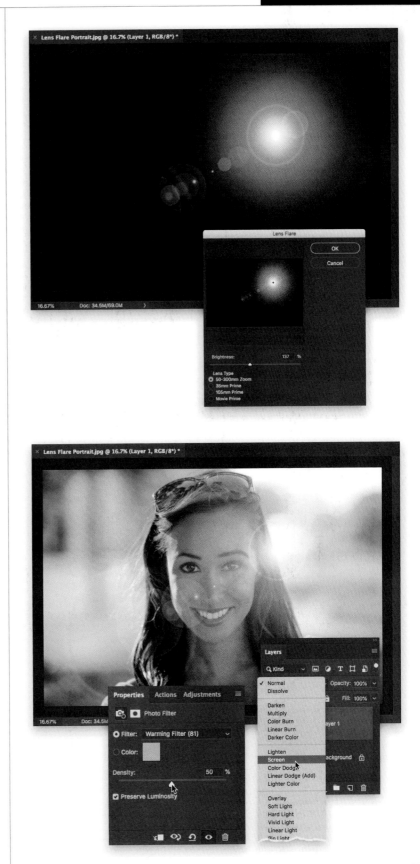

FINE ART COLLAGE USING THE BLEND IF SLIDERS

Another popular use of the Layer Style Blend If sliders is to experiment while creating fine art collages. While you're doing this, you'll totally have your artist vibe on because there's no telling what you're going to come up with when you drag these sliders using multiple images—it's only limited by your creativity. You see this look a lot in posters, in fine art, and things created just for fun.

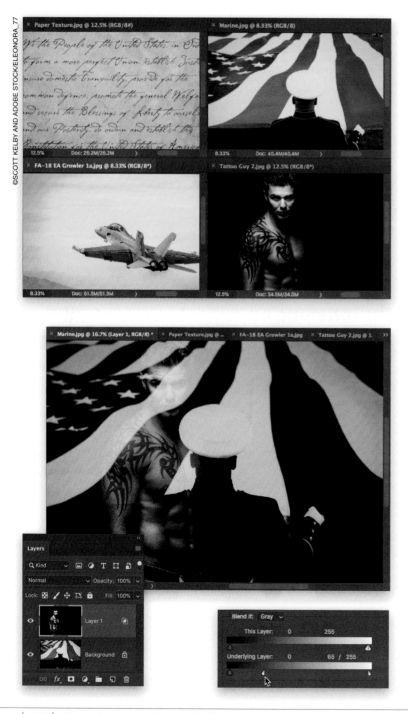

STEP ONE:

The first step is picking the images you want to combine into a fine art collage. Here, I chose four images and opened them in Photoshop (in case you're wondering how I got them into this 4-up look, it's actually a Photoshop feature. Just go under the Window menu, under Arrange, and choose **4-Up**). We'll use the image of the Marine holding the flag (shot during the pre-game ceremony at an Atlanta Falcon's football game) as the first image in the collage.

STEP TWO:

Click on the black-and-white portrait of the guy with the tattoo, press **Command-A (PC: Ctrl-A)** to select it, and then press **Command-C (PC: Ctrl-C)** to Copy it into memory. Switch over to the marine and flag image, and then press **Command-V (PC: Ctrl-V)** to Paste it onto its own layer in this document. Now, double-click on the tattoo guy's layer thumbnail to bring up the Blending Options in the Layer Style dialog, where we access the Blend If sliders (seen here below right—you'll find them at the bottom center of the dialog). You learned earlier in this chapter that dragging these sliders blends the layers together based on their tones, and how they overlap and intersect. If you just click-and-drag them, the blends will look harsh and jaggy, but if you press-and-hold the Option (PC: Alt) key while you drag, the slider knob will split into two, and the blend will be smooth. Here, I pressed-and-held the Option key, dragged the bottom-right slider to the left, and you can see how this affected the two images (it's not just lowering the opacity, these blends are dependant on the content of the two images).

STEP THREE:

All right, we're on our way—let's keep messing with it. Now, click-and-drag the bottom-left slider way over to the right, and you can see how that affects the image (you're seeing the green field starting to show through different parts of the image, and the red is coming back into the flag, where it was kind of desaturated in Step Two). Remember to always press-and-hold the Option (PC: Alt) key as you drag (you'll know if you did, if the triangle splits in half). Also, once you've split a slider, you'll see that you can drag it right over the half of the other slider (like I did here).

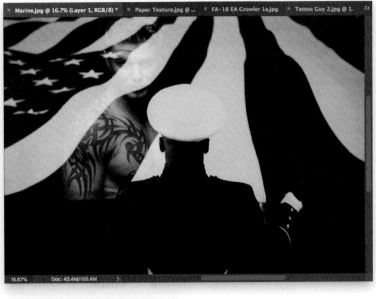

STEP FOUR:

Click OK in the Layer Style dialog, and let's add a third image—the one of the jet (an EA-18G Growler, shot out at Naval Air Facility El Centro during touch and goes). Select it, and then copy-and-paste it into our collage document, onto its own layer. Double-click on its layer thumbnail to bring up the Layer Style dialog again, and then try clicking-and-dragging each of the Blend If sliders (while pressing-and-holding the Option [PC: Alt] key). Here, I wound up liking how it looked when I split the top-right slider and dragged it to the left, and then split the top-left slider and dragged it almost all the way over to the right. Again, we're just experimenting here—dragging sliders and seeing what works and what doesn't. Let's keep going.

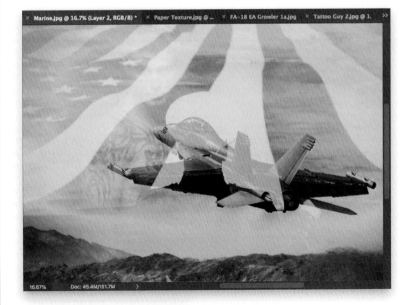

Continued

STEP FIVE:
Click OK and let's add another image. This one is a stock paper texture I downloaded from Adobe Stock where I added text from the US Constitution, using the P22 Cezanne font (one of my favorites—I love it in all lowercase, but here it looked "right" in uppercase and lowercase). With this copied-and-pasted into our collage image document, we now have four layers. By the way, if you look in the Layers panel, to the right of each layer's name, you'll see two overlapping squares. That icon lets you know that you've used the Blend If sliders on those layers.

STEP SIX:
Now that we've got this text image, let's blend it in with our other images. Double-click on its layer thumbnail and, well, you know what to do now. Here, I split the bottom-left slider and dragged it all the way to the right (it's hidden under that bottom-right slider below). Then, I split the top-right slider and dragged it nearly all the way to the left (as shown here). This pretty much got rid of the paper texture and only left the text showing.

STEP SEVEN:

Since we now have four different image layers that we can work with, let's see what happens when we tweak the sliders. With the top layer still active, I dragged the half of the bottom-left slider that I had dragged to the right back to the left a bit (as shown here), then I dragged the half of the top-right slider back over to the right, and then I split-and-dragged the top-left slider way over to the right—just experimenting and seeing what looks good. In this case, tweaking the sliders brought back some of the yellow paper texture.

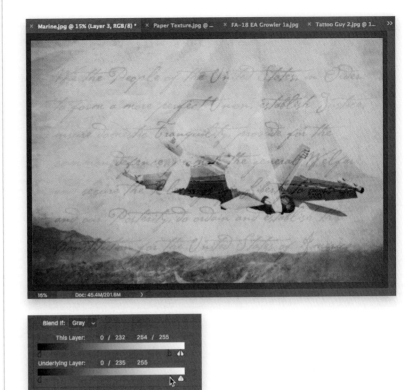

STEP EIGHT:

Changing the order of the layers in the Layers panel will also change how things look. And, if you choose different channels (Red, Green, Blue, instead of the default Gray) from the Blend If pop-up menu, things will blend differently, yet. Here, I chose **Red**, and then dragged the sliders to get another look, where the paper and the texture fade gently into the rest of the image. Again, remember that this is all about experimenting, getting creative, and trying new things.

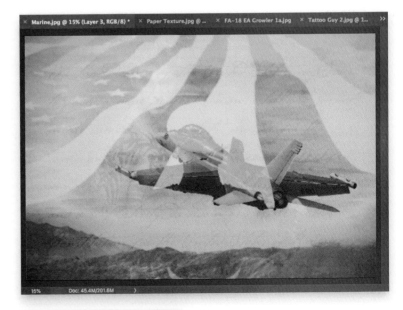

LONG-EXPOSURE ARCHITECTURAL LOOK

This is normally a technique that can take many painstaking hours to achieve, but I've come up with a dramatically quicker way to get that popular long-exposure, daylight, architectural look that looks like night with a hint of light coming in. This won't take the place of the long method that the top architectural photography pros use, but maybe it will get you "in the ballpark" to the extent that you start to get some decent results, which will make you want to dig in deeper and learn those advanced techniques.

STEP ONE:

Here's the original image, taken in London's financial district (this shooting location is included in my online course at KelbyOne.com called, "A Photographer's Guide to London"—one in a series of courses on travel photography shooting locations around the world). I converted the image to black and white (using the B&W profiles in Camera Raw—also in Lightroom). It was a gray, dreary day, so I let the sky blow out to nearly pure white, and then I increased the Whites slider and Highlights slider in Camera Raw until it blew out to white.

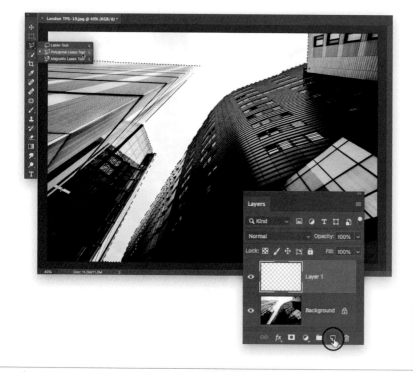

STEP TWO:

First, let's select the sky in the image. I used the Polygonal Lasso tool (select it in the Toolbar or press **Shift-L** until you have it) here, because it makes straight-line selections and there are a lot of fairly straight ones in this image. When it came to that curve in the building to the right of center, I just made a lot of little lines, so I could bend right around it pretty well. If you miss an area, you can add it by pressing-and-holding the Shift key. If you select an area you didn't mean to, press-and-hold the Option (PC: Alt) key and remove it. Once you have the sky selected, go to the Layers panel and add a new blank layer by clicking on the Create a New Layer icon (the second one from the right) at the bottom of the panel.

PHOTOSHOP FOR LIGHTROOM USERS

STEP THREE:

Press the letter **D** on your keyboard to set your Foreground color to black, and then press **Option-Delete (PC: Alt-Backspace)** to fill your selected sky with solid black (as seen here). Press **Command-D (PC: Ctrl-D)** to Deselect, and then press **Command-E (Ctrl-E)** to merge this layer with the Background layer, so they become just one layer (the Background layer).

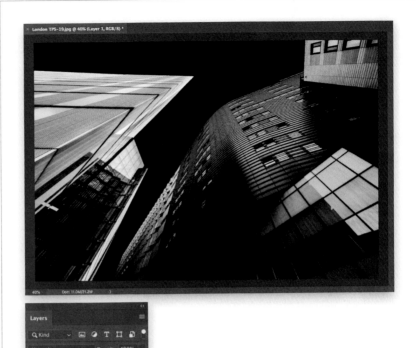

STEP FOUR:

Go to the Layers panel again, and add another blank layer. Fill this new blank layer with black by pressing Option-Delete (PC: Alt-Backspace) again.

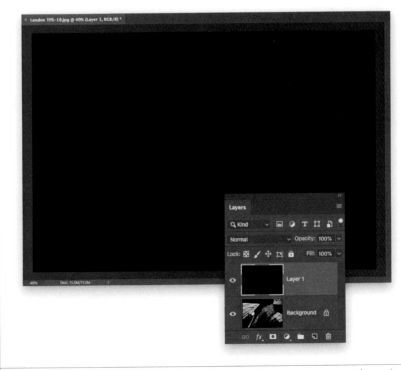

Continued

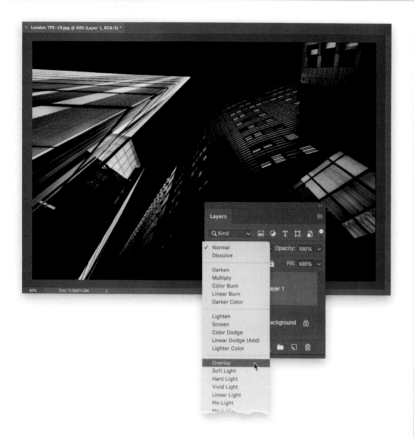

STEP FIVE:

We're going to change the layer blend mode of this all-black layer to a mode that looks good with our image, and makes it look dark and dramatic, but with a little bit of light still falling on the buildings. In this case (and in most cases I've seen), it's Overlay. You'll know which one looks best by going near the top left of the Layers panel, clicking on the layer blend mode pop-up menu, and moving your cursor down the menu of blend modes. As you move over each one, you'll see a live preview onscreen. Here's how the image looks when changed to **Overlay**. We're starting to get "the look" we're after. Now, merge this layer with the Background layer by pressing Command-E (PC: Ctrl-E) again.

STEP SIX:

Next, we'll darken the edges all the way around the image, using Camera Raw. So, go under the Filter menu and choose **Camera Raw Filter**. When the dialog opens, click on the Effects tab (the fx beneath the histogram, near the top right), and then click-and-drag the Post Crop Vignetting Amount slider nearly all the way to the left. I also lowered the Midpoint slider a bunch, too, which makes the darkening on the edges extend farther into the image. Click OK.

STEP SEVEN:

For this next step, where we're softening the image a bunch, we'll need to duplicate the Background layer (so we can change its blend mode later). So, press **Command-J (PC: Ctrl-J)** to duplicate it. Then, go under the Filter menu, under Blur, and choose **Gaussian Blur**. When the dialog appears, enter 50 pixels for the Radius (so your image is nice and blurry, like this one), and then click OK.

STEP EIGHT:

Now, we're just going to change the blend mode of this blurry layer from Normal to **Soft Light** (or Overlay—your call, since it depends on the image), and it darkens the image some more, and makes the remaining light a bit more dramatic. When you look at the original image (shown in the inset here), you can see how far we've come. Again, this is kind of the "cheating" version of this effect, but it's a whole lot quicker, and gets you a lot of the way there.

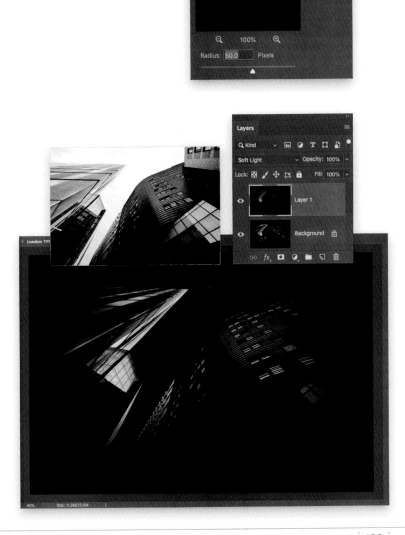

SHARPEN
SHARPENING TECHNIQUES

How cool is this?! I found a 2011 movie short named *Sharpen*, so—BAM—that's the title. Done. Boom. It's too perfect. Now, I must admit, it doesn't sound incredibly compelling, as IMDb simply describes it like this: "A boy talks about his family and recounts a traumatic event." Snore! Every boy has a traumatic family story and, while I didn't see the movie short, I'll bet my traumatic childhood story is much more traumatic than this kid's, so I thought I'd share it here: When I was a young boy, I always dreamed of taking a jet plane flight. I didn't even care where the plane was going. The whole idea was just so amazing, and being a passenger on a commercial flight was about the best thing this little boy could imagine. My older brother Jeff got to take a number of flights, but I was always left behind. But one year, on my birthday, my mother and father surprised me—the three of us would fly on a big jet to the "Big Apple." Finally, my dream would come true. The night before the flight, I couldn't sleep. I kept picturing the free snacks, and the soft drinks, and how polite I would be to the flight attendants (more polite than any little kid on any jet had ever been). I'd ask if I could go up front and take a peek inside the cockpit at all those instruments and dials, and if they gave me a pin-on pair of wings, I would probably just black out and be in the fetal position on the floor of the plane—I was that excited. But when we got to the airport, and they started to board the flight, I noticed we didn't board right away. So, I asked my mother if everything was okay since we weren't boarding, and she got down on one knee, looked me in the eyes, and said, "Honey, we're flying Southwest Airlines. There is no First Class." I started to tear up, but I stayed strong, I looked over at my dad and said, "Dad, we're at least in Business Class with lie-flat sleeper seats, right? We're at least in Business Class, right Daddy?" They chuckled and my mom said, "Dear, there is no Business Class on Southwest. We're in coach like everybody else." Well, I burst into tears, and I started screaming and cussing, and began kicking her in the shins, and she was sobbing and her shins were bleeding, and right then a TSA agent came up and Tasered us both. Coach class. Really?! I haven't spoken with either of them since. Take that, *Sharpen* kid with the "traumatic event."

THE UNSHARP MASK FILTER (THE SHARPENING WORKHORSE)

Seeing as Lightroom has its own sharpening available in the Develop module's Detail panel, why do people love to sharpen in Photoshop so much? Well, the main reason is we can see the sharpening in Photoshop much better than we can in Lightroom. I'm sure there's some techie reason why you have to view your image at 100% to really see the sharpening in Lightroom, but whatever it is, it's just easier to see in Photoshop (at all magnifications). Plus, you have more ways to sharpen (from subtle to over-the-top). We'll start with probably the most-used sharpening filter in the world today: the Unsharp Mask filter.

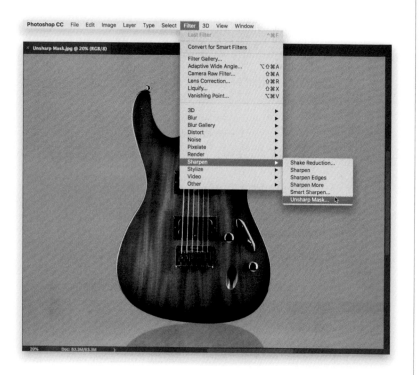

STEP ONE:

In Lightroom, choose the image you want to sharpen and press **Command-E (PC: Ctrl-E)** to open it in Photoshop. Then, go under the Filter menu, under Sharpen, and choose **Unsharp Mask** (as shown here). Don't let the name throw you—it's a holdover from the traditional darkroom days. *Note:* I add this sharpening on top of any sharpening already applied to a RAW image in Lightroom, or to a JPEG image in-camera. That's called "capture sharpening" and is designed to bring back the loss of sharpness that occurs during the capture stage (in other words, in-camera). This extra sharpening we add here is more of a "discretionary sharpening" we add to make our images look tack sharp. In fact, all the sharpening we would add here in Photoshop would fall under discretionary or "creative sharpening."

STEP TWO:

In the Unsharp Mask dialog, Amount determines the amount of sharpening applied to the photo, Radius determines how many pixels out from the edge the sharpening will affect, and Threshold determines how different a pixel must be from the surrounding area before it's considered an edge pixel and sharpened by the filter (by the way, Threshold works the opposite way of how you might think—the lower the number, the more intense the effect). So, what numbers do you enter? I'll share five settings I use most these days. The first one (shown here) produces a nice, crisp sharpening and, of the five, it's probably the one I use most—Amount: 120, Radius: 1, Threshold: 3. It's like porridge—it's not too much, it's not too little. If you're using a super-high resolution camera (50-megapixel range), you might have to increase the Radius to 1.1 or 1.2.

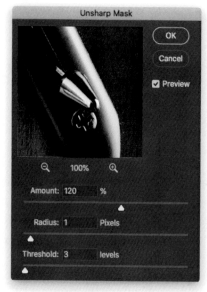

(#1) General sharpening

STEP THREE:
Here are the four other settings I use:

#2: Amount: 100, Radius: 1.1, Threshold: 10. Sharpens detail areas, like eyes, lips, eyebrows, etc., while going easy on skin.

#3: Amount: 150, Radius: 0.7, Threshold: 4. The higher Amount and lower Radius works well for landscapes.

#4: Amount: 65, Radius: 3, Threshold: 2. If your subject has lots of detail and you really want to bring it out, try this one.

#5: Amount: 50, Radius: 0.8, Threshold: 4. I only use this one if I resize an image down for posting to the web and I can tell it doesn't look as sharp. This is a subtle amount of sharpening, but it will snap back a lot of that sharpness lost in the resize.

TIP: SHARPENING PREVIEWS
When you use the Unsharp Mask filter, you get two previews of your sharpening: (1) you see the effects in your image right onscreen as you drag the sliders, and (2) you see a zoomed-in preview of how the sharpening is affecting your image in the small preview window inside the dialog itself. Click-and-hold inside this window to get a before (unsharpened) view of your image; release the mouse button to see the after.

(#2) Portrait sharpening

(#3) Landscape sharpening

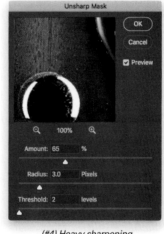

(#4) Heavy sharpening

(#5) Web sharpening (after resizing)

Before

After

SMARTER SHARPENING (WITH SMART SHARPEN)

This one is aptly named—it's a sharpening filter that uses a better mathematical algorithm than Unsharp Mask (which, by the way, has been in Photoshop since version 1.0), which lets you apply more sharpening with less of the bad stuff associated with it (increased noise, halos that appear around the edges of objects, or little specks or artifacts in the sharpened image). So why does anyone even use Unsharp Mask? Because it's the classic sharpening, it has been around forever, people know how to use it, and people don't like change (even if better sharpening, with more control, is just one spot up in the Sharpen menu).

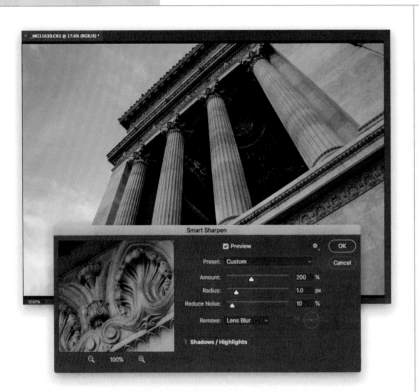

STEP ONE:
You find Smart Sharpen right near where you find the Unsharp Mask filter—go under the Filter menu, under Sharpen, and choose **Smart Sharpen** to bring up the dialog you see here.

TIP: SAVE YOUR SETTINGS AS A PRESET
If you find settings you really like, you can save them as a preset by going to the Preset pop-up menu, at the top of the dialog, and choosing **Save Preset**. Give it a name, click Save, and now your preset, with those settings, will appear in that pop-up menu. Pretty handy.

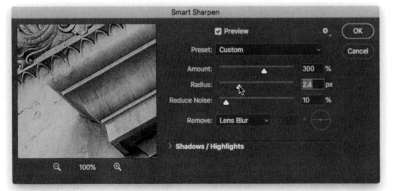

STEP TWO:
One of the downsides of sharpening has always been that if you apply a lot of it, the edges start to get "halos" (those bright lines) around them, but Smart Sharpen's algorithm lets you apply a higher amount of sharpening before halos start to appear. So, how do you know how far you can push the sharpening? Adobe recommends that you start by increasing the Amount slider to at least 300%, then start dragging the Radius slider to the right until you start to see halos appear around edges. When they appear, back the slider off by just a bit (until the halos go away). By the way, did I mention that the Smart Sharpen dialog is resizable? Yup, just click-and-drag the bottom-right corner out as large as you'd like (as I did in the next step).

STEP THREE:

With your Radius amount set, go back to the Amount slider and start dragging it to the right (above 300%), until the sharpening looks good to you (or haloing appears, but you'd have to crank it quite a bit before that happens). I ended up leaving mine at 300%. Also, do you see that Remove pop-up menu? Make sure it's set to **Lens Blur** (it's the only good option here). The top choice (Gaussian Blur) basically gives you the same math as Unsharp Mask, so you're not getting the advantage of the "better math." The bottom choice (Motion Blur) is for those one-in-a-million times where you can determine the exact angle of the motion blur and try to counteract it by entering the angle of the blur in degrees.

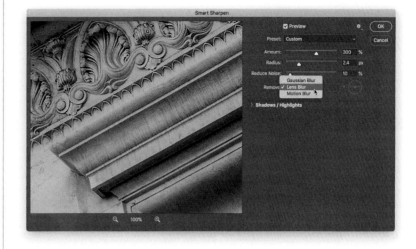

STEP FOUR:

Sharpening tends to make any noise more visible, which is why it's nice that there's a Reduce Noise slider here. The goal with this slider is not to decrease noise; it's to let you add a lot of sharpening without increasing the noise. After you apply your sharpening, you'll drag this slider to the right until the noise in the photo looks about like it did before you sharpened. Lastly, once you become a shark at this filter, click on Shadows/Highlights to reveal Fade sliders—drag them to the right to reduce sharpening in either the highlight or shadow areas.

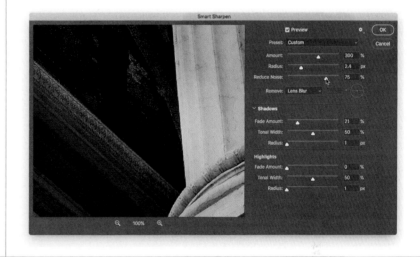

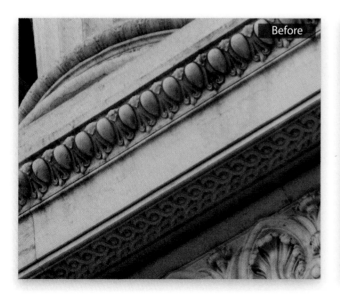

Before

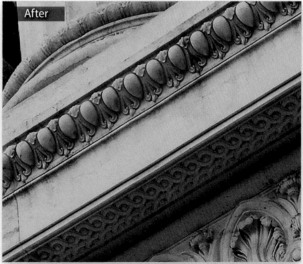

After

HIGH PASS SHARPENING

This is a very high level of sharpening that's really popular with landscape photographers, cityscape photographers, HDR photographers, and folks who shoot images with lots of fine detail, because it accentuates all the edges in the photo, and making those edges stand out can really give the impression of mega-sharpening.

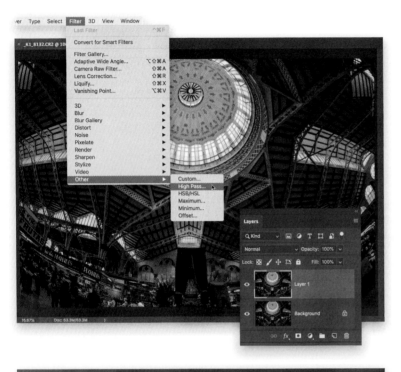

STEP ONE:
Open the image you want super-sharp in Photoshop (this is a food market in Valencia, Spain, shot with a super-wide-angle lens). Start by duplicating the Background layer by pressing **Command-J (PC: Ctrl-J)**, then go under the Filter menu, under Other, and choose **High Pass** (as shown here).

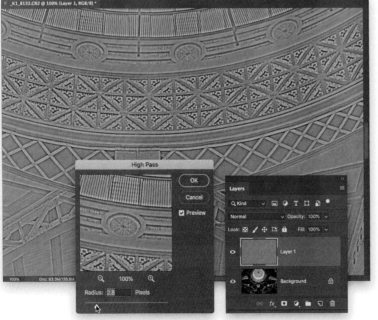

STEP TWO:
In the High Pass dialog, start by dragging the Radius slider all the way to the left (everything turns gray onscreen), then drag it over to the right until you start seeing the edges of objects in the image clearly appear. The farther you drag, the more intense the sharpening will be, but if you drag too far, you start to get these huge glows and the effect starts to fall apart, so don't get carried away. I usually end up between 1 and 3 pixels, but if you have a really high-megapixel camera, you might have to raise it to 4 pixels or higher to get the edges clearly visible.

STEP THREE:

To bring the sharpening into the image, I use one of three layer blend modes, and they are: (1) Hard Light. This gives you the most intense amount of sharpening. (2) Overlay. This is for really punchy sharpening, and it's usually my first choice. If I try it, and want more sharpening, I just switch to Hard Light. (3) Soft Light. This one is the most subtle of these three high-powered choices. To choose one of these three blend modes (which makes the gray fill on the layer go away), go near the top left of the Layers panel, and change the blend mode of this layer from Normal to whichever one you want. We'll try **Hard Light** here, so you can see how this one looks—it applies some serious sharpening. Try changing the blend mode to Overlay, then Soft Light, so you can see the differences in sharpening amounts. Also, if the sharpening with any of these seems too intense, you can lower the amount by lowering the duplicate layer's Opacity near the top right of the Layers panel. Or, just try changing the blend mode to Overlay (which makes the sharpening less intense) or Soft Light (even more so).

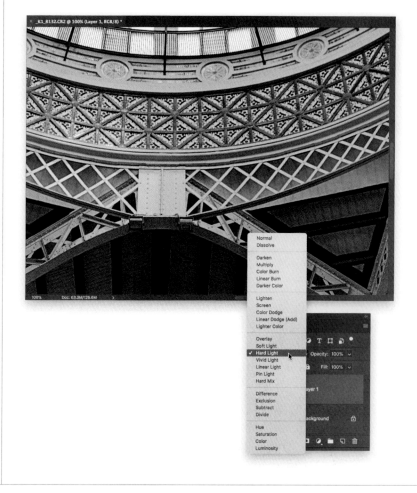

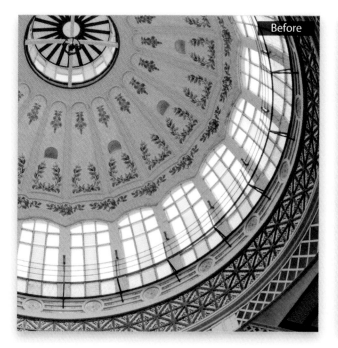

FIXING PHOTOS BLURRY FROM CAMERA SHAKE

If you have an image that is blurry because of camera shake (any sort of movement while your shutter was open, usually while shooting hand-held and made worse in lower-light situations with longer exposure times), there's a Photoshop filter that can help save it. This filter doesn't fix images that are blurred because your subject was moving; it fixes those that are blurred because you were moving. Also, this filter works best on images that don't have a lot of noise, have a pretty decent overall exposure, and where you didn't use flash. So, while it doesn't work on every image, when it does work, it's definitely a shot-saver.

STEP ONE:
Open an image that was blurred from camera movement when you took the shot (read the intro above for which types of blur this reduces). I was walking down a street in Venice when I saw this beautiful arrangement of flowers in an open window, but it was kinda shady and I didn't hold the camera steady enough to get a nice, crisp shot. The shot looks okay here, but when you zoom in (like I've done in the next step), you'll see the blurring problem pretty clearly.

STEP TWO:
Here's the zoomed-in view, and you can really see the camera shake big time. Since the flowers aren't moving, it's pretty clear it was my fault—I didn't keep the camera steady enough for the lighting conditions. But, we can fix that. Go under the Filter menu, under Sharpen, and choose **Shake Reduction** (as shown here).

STEP THREE:

When the dialog opens, it immediately begins analyzing the image, starting in the middle (where most blurring occurs) and searching outward. You'll see a little progress bar appear near the bottom of the small preview in the right side of the dialog (it's called the Detail loupe). Once it's done doing the math, it shows you its automated blur correction and, as you can see here, it did a pretty amazing job of saving the shot. It's not perfectly 100% sharp, but the original was pretty much unusable. For most of us, this is all you'll need to do: open the filter, let it do its thing, and you're done.

STEP FOUR:

If there are specific areas that the default reduction didn't fix, you can add additional Blur Estimation Regions (the rectangular areas it uses to determine the repair). Click on the Blur Estimation tool in the top left (it's selected by default), then drag it over areas where there's a decent amount of contrast (here, I dragged out two more—one in the top left and one on the lantern). You can also move any region by clicking on its center point, repositioning it where you want, and it will reanalyze that area automatically. When you're done, click OK. One more thing: after this filter gets it looking sharper, I still usually apply an Unsharp Mask to finish things off.

SHARPEN TOOL FOR CREATIVE SHARPENING

This is another method for applying creative sharpening (discretionary sharpening you do to draw the viewer's attention, or sharpening particular areas without over-sharpening the rest of the image). The best thing about this technique is that it uses some of the most sophisticated sharpening in all of Photoshop, and the über-math for this kind of sharpening is found in Photoshop's Sharpen tool.

STEP ONE:
Open the image you want to add creative sharpening to in Photoshop (here, we're sharpening a shot of the back of a custom chopper), and then get the Sharpen tool from the Toolbar (seen circled here in red—its icon looks like a tall triangle).

STEP TWO:
Start by pressing **Command-+** (plus sign; **PC: Ctrl-+**) to zoom in (this will help you see the sharpening better as you apply it). Also, glance up in the Options Bar and make sure the Protect Detail checkbox is turned on (otherwise, you'll be using the "old math"—it was updated years ago and now gives vastly better results, as long as you have that checkbox turned on). Now, take the brush and paint over the areas you want sharpened (in the example shown here, I painted a few strokes over the chrome logo on the side of the bike—you can see the outline of my brush tip going over the top half of the letters "d" and "o," but I painted over that enter flat section, including the bolts on each side). You have to use some care when using this tool because it is so powerful, and it's easy to over-sharpen and introduce noise into your image. This is why it's important to zoom in to at least 50%, so you can see the effects of the tool, and see if things are getting too sharp or noisy.

STEP THREE:

The idea here is to paint over small areas of interest to pull them out. This makes the entire image look sharper because these important details are now sharper. In particular, I paint over any text. Also, on a motorcycle shot like this, I would probably paint over any nice looking chrome lug nuts—like I'm doing here, top center. There's no rule on exactly what should get sharpened because it will be different from image to image. But, I do think it's important to choose interesting parts to sharpen, since sharp areas grab the viewer's eye. Of course, knowing that helps you to direct their eye using this spot sharpening technique. I put a before/after below, so you can see the difference spot sharpening makes. Also, if you want to see a quick before and after, go to Photoshop's History panel (shown here; it's found under the Window menu) and click Open, at the top, to see the image as it looked when you first opened it. Then, scroll down and click the last history state (it should read Sharpen Tool—you'll see a bunch of them, so click the bottom one) to see the after again.

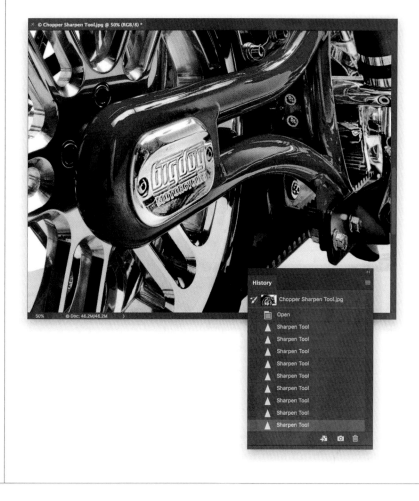

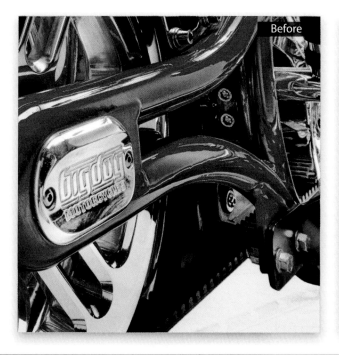

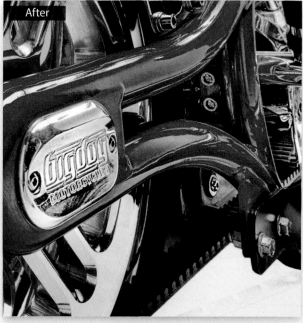

DON'T MOVE

HOW TO REMOVE DISTRACTING STUFF

This may well be the first time I've used a line from a movie, rather than a movie, TV, or song title. Now that I think about it, there may well be a movie or show with that title. I guess I should check. Hang on for a sec (I'll be right back). Ah, ha! I just checked on IMDb (the Irrrefutable Maultaschen Deustch Bundesbahn official website) and there is not only one movie named *Don't Move*, there are three (well, one is a movie short, and one just says the word "video" after it, so I'm not so sure about that one), but I do know this about the one actual movie: *Don't Move* is not its real name. Its original release title was *Non ti muovere*, and according to IMDb, the story is about "A destitute woman (Cruz) becomes involved with an upper-crust physician (Castellitto)." It sounds riveting. I'd love to know why the studio green-lighted this one. Well, once I saw the movie poster (you can find it by Googling it under either name, but of course that could be said about pretty much anything), I saw why it was so popular. It's pretty racy. Why is it pretty racy? I'll tell you why. It's because it's Italian, and let me tell you, they are a hot-blooded people. How do I know this? Well, I'm about to reveal something about myself, something few people know, but may forever change the way you feel about me and my hot-blooded, racy, Italian sub ancestry. I know I'm risking a great deal by revealing this part of my past, but by revealing my past, well, it's the only way I can move into the future. You see, when I was younger, so much younger than today, I never needed anybody's help in any way. But now these days are gone and I'm not so self-assured. Now I find, I've changed my mind, I've opened up the doors. Well, there you have it—my story, in my own personal, original words, and I have to admit, now that I've shared it, I'm not feeling down. And I do appreciate you being 'round, and for helping me to get my feet back on the ground. Why, why do I play these games? Okay, I admit it—those aren't my own words, after all. That was taken word-for-word from the final dramatic scene of *Don't Move*, where Dr. Castellitto and Captain Renault watch as Castellitto's girlfiend's plane lifts off the runway into the rainy night, and the camera slowly pulls back as the two are walking toward the tarmac, stepping through the rain puddles, and Dr. Castellitto looks at Captain Renault and says, "Louie (which is odd, because his name is Captain Renault), I think this is the beginning of a great chapter intro for one of Scott's books," and then the credits roll. Fade to black. True story. You can Google it.

HAVE PHOTOSHOP REMOVE TOURISTS FOR YOU

This is more of that "Photoshop magic," and if you do the camera part right, Photoshop will take care of the rest, removing all the tourists in your scene in just seconds. Luckily, the camera part is easy: stay very still (or better yet, be on a tripod) and take a shot every 10 to 15 seconds. Take maybe 10 or 12 photos total. That's it. There is one "gotcha" with this technique: What Photoshop does is analyzes the scene, and if it sees something move from frame to frame, it gets rid of it. So, if someone happens to just stand there in the same place in all your photos, and they don't move, Photoshop doesn't get rid of them. My fix for this? I have a friend walk over and nicely ask them to move for the photo.

STEP ONE:
In Lightroom, select the images you want to remove tourists from (read the camera technique you need to use for this to work above), and press **Command-E (PC: Ctrl-E)** to bring them over to Photoshop. They'll all open as separate tabs across the top of the window (if you still have this default preference set), with just one image showing. But, I wanted you to see more than just that one, so here, I went under the Window menu, under Arrange, and chose **6-up**, which automatically tiles six of your tabbed images in rows (I shot and opened a total of 12 images, though. Unfortunately, there is no 12-up).

STEP TWO:
Once all your images are open in Photoshop, you're going to go to an unlikely place: go under the File menu, under Scripts, and choose **Statistics** (as shown here). This is where, with one minor tweak, you change this feature from a nerdy math dialog into a travel photographer's best friend. By the way, you can kinda see in this larger image the type of foot and auto traffic I encountered while shooting between two parked cars, on a tripod, along Ocean Avenue on Miami's South Beach. The reason this house always draws a crowd is because it's actually the famous Villa Casa Casuarina (better known as the Versace mansion).

STEP THREE:

When the Image Statistics dialog appears (seen here), first click the Add Open Files button (shown circled here in red). That way, it uses the images you just brought over from Lightroom. Then, up at the top, from the Choose Stack Mode pop-up menu, choose **Median** (as shown here). There is one more checkbox you might need, but you would only turn on Attempt to Automatically Align Source Images if you hand-held the shots. If you did this, the images would all be off in their alignment to one another, so turning this checkbox on would automatically align them for you—it just adds some extra time to do its thing. In this case, I shot on a tripod, so there's no need to turn this checkbox on (and wait while it goes through its alignment phase).

STEP FOUR:

Click OK, and after just a few seconds (or more than a few seconds for really high-megapixel images), a new document appears with your image, but without the tourists. It usually works amazingly well, but again, there's the "gotcha" that I mentioned earlier in the intro. One more thing: if it left a little bit of some-one behind (as it sometimes can), you can remove those small areas using the Healing Brush tool (press **Shift-J** until you have it) or the Clone Stamp tool (**S**; more on these tools coming up in this chapter). But, before it lets you do that, you have to go to the Layers panel's flyout menu (in the top-right corner of the panel) and choose **Flatten Image**. Now you can clone or heal or whatever.

CLONING OVER DISTRACTING STUFF

Photoshop's Clone Stamp tool is a workhorse of a tool—it fixes, covers up, copies, and removes all sorts of distracting things like magic. Have a photo of a building with a broken window? You can clone a nearby window right over that broken one at a quality where no one would ever know it was fixed. Have two light fixtures on a wall and wish there were three? Clone Stamp tool time. Want to patch a hole in a wall, or repair a torn edge of a photo, or pretty much want to fix anything? There are few things this powerful little tool can't do. It's hard to believe it has been in Photoshop since version 1.0 (over 25 years ago), yet we still use the heck out of it.

STEP ONE:

First, it helps if you really understand what the idea of "cloning" is all about. Once you've got that, then you can also use this tool for not just duplicating stuff (to add more of something), but to fix, cover, and repair stuff. So, we'll start with regular ol' cloning. In the image here, let's copy—I mean, clone—our guard on the right over into the guard shack on the left. It's easier than it sounds. Start by getting the Clone Stamp tool **(S)** from the Toolbar (its icon looks like a rubber stamp), then press-and-hold the Option (PC: Alt) key and click on the guard's elbow (as shown here). That sets what's called the sample point, which is where we're cloning *from*. So, if you now paint anywhere in this image, it starts painting from that guy's elbow (or whatever that part of your arm that's on the opposite side of your elbow is called). If you moved your brush up to that top-right window and started painting, it would start painting the guard up there, starting at that elbow thingy.

STEP TWO:

To get him to appear in the other guard shack, you're going to paint over there, at the same approximate height and location as he is on the right. Move your cursor over to the right side of the other guard shack, and you'll notice that inside your round brush tip cursor, you see a preview of what you're about to paint. This is more helpful than it sounds, because you can really line his arm up in just about the exact same spot thanks to this brush tip live preview.

STEP THREE:

Once it looks to be pretty much the same height as the other guard's elbow, start painting and it clones in the rest of the guard. Look over at the original guard, and you'll see a little + (plus sign) cursor (called a "crosshair" cursor; it's circled here in red). That shows you the area you sampled when you Option-clicked (PC: Alt-clicked) earlier and where you're cloning *from*. The circular brush shows where you're cloning *to*. Here, I painted in the guard in just a few seconds. You don't want to paint too much outside the shape of the guard because you're cloning whatever that crosshair cursor on the right crosses over onto. Okay, so that's the basics of how this works: Option-click (PC: Alt-click) on the thing you want to clone, then use your brush in the area of your image where you want this clone to appear. Now, let's put the Clone Stamp tool to use for what you'll be using it for in a real world situation (I know, it's hard to believe that cloning guards is not on the top of the list. Well, it actually is in North Korea).

STEP FOUR:

In our natural-light portrait here, we want to get rid of the building on the right. The quickest way to do that is to put a Lasso selection around the entire building (railings and all) and then use Photoshop's Content-Aware Fill feature to remove it. We're going to look at how to use Content-Aware Fill on page 160, but for now, get the Lasso tool **(L)** from the Toolbar and make that selection, then go under the Edit menu, choose **Fill**, and from the Fill dialog's Contents pop-up menu, choose **Content-Aware** (as seen here).

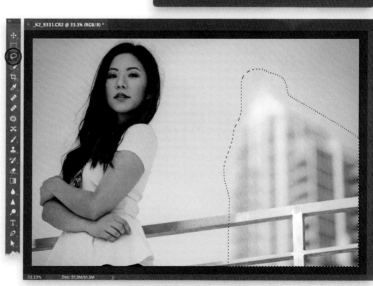

STEP FIVE:
Click OK in the Fill dialog, and when it's done filling the selection, press **Command-D (PC: Ctrl-D)** to Deselect. So, that pretty much got rid of the entire building, but it kind of trashed the railing in the process. What's weird is Content-Aware Fill usually does a pretty decent job replacing things like railings, but I think because the building behind it was so blurry, it kind of gave it fits. No problem—the Clone Stamp tool is perfect for fixes like this.

STEP SIX:
Get the Clone Stamp tool, and then make your brush kinda small (as shown here; you can change the brush size by pressing the **Left Bracket key** to make it smaller or the **Right Bracket key** to make it larger). Now, press-and-hold the Option (PC: Alt) key and click right along the edge of the railing where it still looks nice and straight, and then start painting (cloning) that part of the railing right over the missing parts. What makes this so easy is that preview that appears inside your brush cursor. You can line the railing right up inside that preview before you start cloning—works like a charm. Also, take a look at the crosshair cursor on the left here—that's showing where it's cloning from—and the circular brush tip cursor on the right is what's being cloned in. You're literally painting the railing from the left over the gap in the railing on the right. That bottom railing is still a mess, and worse yet there's no straight area there to clone from. But, no worries—we've got an easy workaround for stuff like this.

STEP SEVEN:
Since there's no area to clone from on that bottom railing (see Step Six), we'll just clone from the edge of the top railing, right down to where the bottom railing should be (as shown here). Not only can we easily clone from one area to another like this, you can even clone from one document to another. So, if you had another image where the railing was intact, you could open that image (and leave it open during this process), Option-click (PC: Alt-click) on its railing, then switch to this document and clone in the railing from that document into this document. Crazy, right? I love the Clone Stamp tool.

STEP EIGHT:
Let's just finish things up by cloning that top railing to the bottom railing, until it reaches the edge of the image (like you see here). One more thing: If you're cloning in a line like this, and suddenly it starts looking funky or stops cloning, it's quite possible (actually, it's pretty likely) that your crosshair cursor has reached the end of what it can clone, and it's starting to double-over the area where you started cloning. It's kind of an *Inception* thing—you can't clone over things that don't exist yet. So stop cloning for a second, move farther back on the left on the railing, resample that area, and then start cloning again. Here's the final image with the building gone and our railings repaired. This is typical of the type of stuff we do with the Clone Stamp tool.

REMOVING LARGER OBJECTS WITH THE PATCH TOOL

The Spot Healing Brush and the regular Healing Brush tools are awesome for fixing small problems—anything from removing blemishes to power lines, and sometimes you can get away with removing larger objects with them. But, you can save yourself some time and trouble by using a tool that's designed for larger types of chores: the Patch tool. It works remarkably well for larger clean-up jobs, and it has an option to help you deal with one of the Healing Brush's and Spot Healing Brush's biggest weaknesses, which is smearing when part of what you want to remove is along an edge in your image.

STEP ONE:

When the object you want to remove is large, that's when we reach for the Patch tool. It's kind of like Lightroom's Spot Removal tool, if it was combined with Photoshop's Lasso tool. Here's how it works: In this instance, we want to remove that small boat and floating dock along the left edge of the image. So, get the Patch tool (press **Shift-J** until you have it; its icon looks like a patch) from the Toolbar. Now take the tool, and draw a loose selection around the entire object you want to remove (as shown here), just like you'd do with the Lasso tool. Make sure you pick up any reflections or shadows—you don't want to leave behind any telltale signs that something was removed.

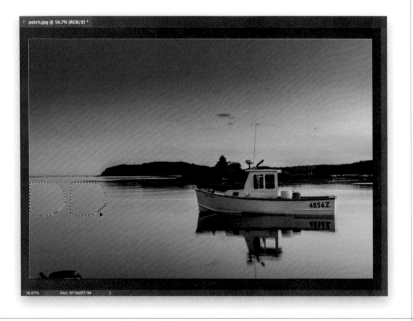

STEP TWO:

Once your selection is in place, click inside the selected area and drag it to a clean area nearby (like you see here, where I've dragged the selection over to the right—you can see the original selection on the left and a copy of that selection I'm dragging on the right). One of the best things about the Patch tool is that, as you drag that selection, you see a live preview back in the originally selected area of what the "patch job" would look like if you released your mouse button. This live preview makes it easy to pick a spot in your photo that would make a perfect fix. Try dragging it over to the bigger boat on the right, and you'll see what I mean—letting go of the mouse button when you have it over the boat would make a mess of your patch. By using that preview, you'll have no problem finding a great spot for your patch.

STEP THREE:

When you look back at the preview in the originally selected area and it looks good to you, just let go of your mouse button and the selection snaps back to its original location and removes the boat and dock, all based on the texture, tone, and color from where you dragged the selection to (as seen here, where the boat and dock are gone without a trace). Now, press **Command-D (PC: Ctrl-D)** to Deselect. If it doesn't do a perfect job (it leaves a little something behind, or a visible line or something), just put a new Patch tool selection around what's left, then drag it somewhere else, and that will probably do the trick. While we're here, look back in the bottom-left corner of the image in Step Two. See that boat engine? Let's make it go away. Put a Patch tool selection around it, click inside the selection, then drag it to a clean, nearby area (as shown here) and release your mouse button

TIP: WHAT TO DO IF IT SMEARS

If the object you want to remove is near an edge in the image, there's a chance the Patch tool will leave a large smear on the edge as it patches the area. If that happens, press **Command-Z (PC: Ctrl-Z)** to Undo, then go up to the Options Bar and, from the Patch pop-up menu, choose **Content-Aware**, and try again. That will usually do the trick. Also, another trick to try is to use the Clone Stamp tool **(S)** to clone over the part that's right along the edge, then once there's a gap between the edge and the rest of the thing you want to remove, you can use the Patch tool again, set to Normal patch in the Options Bar.

STEP FOUR:

There was one more little area right under the reflection near the front of the bigger boat, so I just put a selection around it, dragged it to a clean, nearby area, released the mouse button, and it's gone. This tool works so well, so often, that I predict it will become one of your go-to tools, especially when the thing you want to remove is a little larger than what you'd use the Spot Healing Brush or regular Healing Brush to remove.

ANOTHER WAY TO REMOVE LARGE DISTRACTING THINGS

If I have a large distracting object in my image, the first thing I go looking for is another part of the image that I can copy-and-drag to cover that distracting object right up. In this example, I want to use the clean, yellow wall on the right side of the image to cover over the green vines on the wall on the left. So, the plan is the same as always: find another part of the image we can copy to cover the bad part.

STEP ONE:
We'll start by opening the image in Photoshop, so select it in Lightroom, and then press **Command-E (PC: Ctrl-E)** to take it over to Photoshop. See those vines covering the wall on the left side of the image? That's what we're going to need to cover with the clean, yellow wall on the right side.

STEP TWO:
Get the Rectangular Marquee tool **(M)** from the Toolbar and drag it out over the wall on the right side (as seen here). Make sure you drag all the way from the top, down to the bottom.

STEP THREE:

Press **Command-J (PC: Ctrl-J)** to put this selected area up on its own separate layer (you can see it here in the Layers panel). Once it's on its own layer, we're going to need to "flip it" horizontally so we can use it to cover the other side, and that means going to Free Transform. So, press **Command-T (PC: Ctrl-T)** to bring up the Free Transform bounding box. Once it appears, Right-click anywhere inside the bounding box and, from the pop-up menu that appears, choose **Flip Horizontal** (as shown here).

STEP FOUR:

Move your cursor inside the Free Transform bounding box and it'll change into a black arrow. Now, click-and-drag this flipped wall over to the left side, so it covers the vine wall completely.

TIP: HOW TO LINE THINGS UP PERFECTLY

It's not really necessary for this particular image, but if you're dragging one piece of your photo to cover another, sometimes it's helpful to lower the Opacity amount of the layer you're moving so you can see the original layer below it. It just helps when you're trying to line things up (and yes, you can go over to the Layers panel and change the opacity of this layer even while the Free Transform bounding box is in place).

STEP FIVE:

If you look back at the image in Step Four, you'll notice that the steps at the bottom of the image don't quite match up, which will be a dead giveaway of a bad retouch. So, we'll have to fix this. You already have Free Transform in place, so this is an easy fix—just grab the bottom-center control point and drag straight downward, stretching the image a bit until the steps line up (as shown here). When you're done, just click anywhere outside the bounding box to lock in your transformation.

STEP SIX:

Of course, you can see a hard edge on our flipped wall layer, so we're going to softly paint that edge away so you don't see where the new wall starts and the old one begins—we'll create a smooth transition between the two. For erasing edges like this, we don't get the Eraser tool (it's too unforgiving and uses a hard-edged brush by default). For stuff like this (hiding edges), we go to the bottom of the Layers panel and click the Add Layer Mask icon (the third icon from the left) to add a layer mask. That way, if we make a mistake while we're painting away that edge, we can just switch our Foreground color to white and paint over our mistake. Press **D**, then **X** to make sure your Foreground color is set to black, get the Brush tool **(B)** from the Toolbar, choose a large, soft-edged brush from the Brush Picker up in the Options Bar, and then paint right over that hard edge to mask it away (as seen here).

STEP SEVEN:

The last two steps are just to help make our fix look more realistic. The first is to paint over the steps on the bottom left to reveal the original steps. That way, the steps on the left side don't wind up looking like an exact duplicate of the steps on the right side—so, you're using the wall from the right, but leaving the original steps on the left side visible. That's what you're seeing me do here— I'm painting in black over those steps to reveal the original steps from the Background layer.

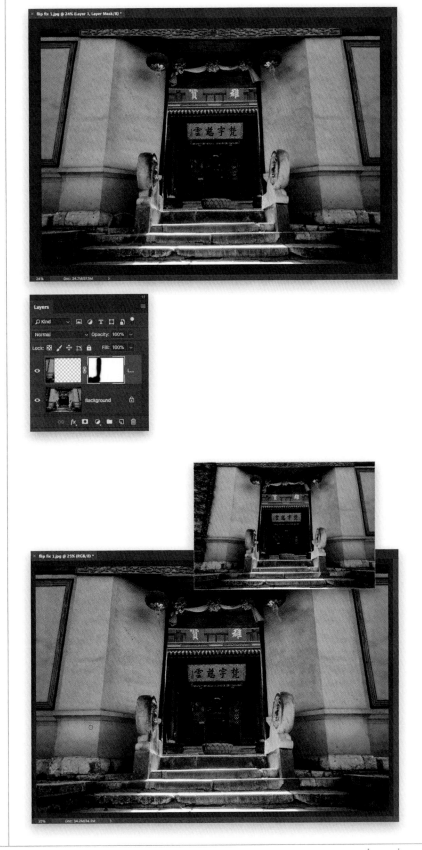

STEP EIGHT:

The last step uses the same idea of making this flipped wall look less like an exact duplicate of the wall on the right. First, go to the Layers panel and, from the flyout menu at the top right, choose **Flatten Image** to combine that layer mask layer and the Background layer into one single flattened layer. Now, get the Spot Healing Brush (**J**) from the Toolbar and get rid of some of the spots and specks on the wall on the left side (that are also in the exact same locations as the spots and specks on the wall on the right side), just so they look a bit different. Make your brush size a little larger than the spots themselves, move it over a spot, then just click once to remove it (that's what you see me doing here on that wall on the left), and that finishes up our "cover up" job. I put the original here in the inset, so you can see how well the cover-up worked.

REMOVING STUFF USING CONTENT-AWARE FILL

The Healing Brush is great for removing spots, wrinkles, etc., and the Patch tool is great for removing larger objects. But, the mack daddy of all cover, remove, fix, and hide tools is Content-Aware Fill—it uses some amazing technology, and is simple to use. Unless it's just a spot or speck, I come here first (even before the Patch tool). It's particularly handy for filling gaps on the corners or edges of an image that are sometimes left after a major lens correction, or when you've stitched together a pano. Content-Aware Fill is perfect for these because it's faster, easier, and cleaner. Here, we'll just do a simple Content-Aware Fill, and then we'll look at a more advanced technique, which lets you tweak the results before you commit, so the result is really clean.

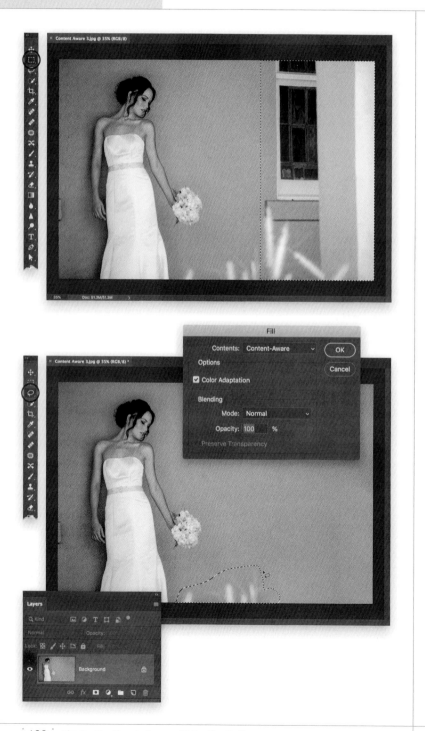

STEP ONE:

Here, we want to remove the window and column on the far right, the weeds popping up into the photo from the bottom, and the small edge of the window ledge along the left side. This feature is called "Content-Aware" Fill because it is aware of what is around the object you're trying to remove and it analyzes that surrounding area and does its best to intelligently fill it in. So, start by getting the Rectangular Marquee tool **(M)** from the Toolbar and make a selection around the window and column—from top to bottom (as seen here).

STEP TWO:

If your image is on the Background layer (as this one is), this is easy—just press the **Delete (PC: Backspace) key**, it brings up the Fill dialog, and, by default, Content-Aware is selected in the Contents pop-up menu (if it's not, just choose it). Now, just click OK, Content-Aware Fill does its thing, and all that distracting stuff on the right is gone (as seen here). If the thing you want to remove is on a layer above the Background layer, no big deal—instead of hitting the Delete key, there's only one difference: go under the Edit menu and choose **Fill**. It still brings up the Fill dialog you see here; it's just an extra step. Go ahead and press **Command-D (PC: Ctrl-D)** to Deselect. Then, let's remove those weeds by getting the Lasso tool **(L)** from the Toolbar and making a loose selection around them at the bottom of the image (as seen here).

STEP THREE:

Once you've got those weeds selected, hit Delete (PC: Backspace) to bring up the Fill dialog (again, if you're working on the Background layer, like we are here). Hit OK and those weeds are gone! Deselect and move on to the small window ledge on the left—put a Lasso selection around it, bring up Fill, hit OK, and boom, it's gone. By the way, I leave the Color Adaptation checkbox turned on because it helps blend in the fix with the surrounding colors.

TIP: WHEN CONTENT-AWARE FILL DOESN'T WORK LIKE IT SHOULD

If you select an area, apply Content-Aware Fill, and it either doesn't work at all or it does kind of a lame job, just press **Command-Z (PC: Ctrl-Z)** to Undo, and then try applying it again. It'll randomize the areas it picks from, and you might get much better results the second time you try it.

STEP FOUR:

As you can see here, Content-Aware Fill did a great job of not only getting rid of the window on the right, it also got rid of all the other distracting stuff really well. This is the type of stuff Content-Aware Fill does best—fixing skies, walls, trees, backgrounds, and stuff like that. Compare this image to our original back in Step One. It took all of 30 seconds. It constantly surprises me how brilliantly it works more times than not, but in some cases, depending on the image and what you're trying to remove or fill, it doesn't remove the whole thing. If it doesn't look great, ask yourself this: "Did it at least fix part of it, or even most of it?" If it even fixes some of the problem, then you have that much less work to do with the Healing Brush and Clone Stamp tools. Also, another route might be to use some of the advanced Content-Aware Fill stuff that you'll learn next. It can help by showing you a preview of the areas it's sampling its "fix" from, so you can influence where it chooses from to get better results. It's really helpful, but I don't go to that step until I can't get this method to work.

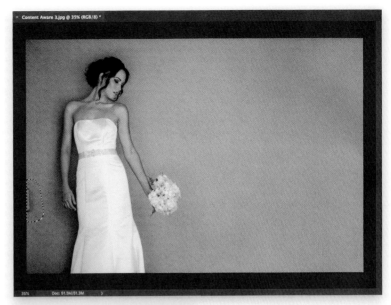

ADVANCED CONTENT-AWARE FILL

In the last project, you learned the simple, straightforward way to remove stuff using Content-Aware Fill. But, since this is such important technology, Adobe created an entire workspace for it, with more advanced features to help you get even better results. Its main advantage is that you can tweak where Content-Aware Fill pulls its "fix" from within your image. So, it not only makes a smarter choice about where to sample, but it also gives you features like flipping, rotating, and such that make Content-Aware Fill even more powerful. Don't use this until you've tried the simple method in the previous project first, but then head back here if you do this stuff as much as I do.

STEP ONE:

First, in this image, we want to remove the pipes and reddish and white wall on the left side of the photo to give us a cleaner look. So, we'll start by using regular ol' Content-Aware Fill, like you learned in the previous project. Get the Rectangular Marquee tool **(M)** from the Toolbar and drag it over the pipes and reddish and white wall we want to remove on the left side of the image (as seen here).

STEP TWO:

Since this image is on the Background layer, you can just press the **Delete (PC: Backspace) key** to bring up the Fill dialog. Make sure **Content-Aware Fill** is selected in the Contents pop-up menu, and click OK. Now, you can see here what the problem is—Content-Aware Fill is pulling its "fix" area from the white wooden frame around that window. So, instead of seeing solid blue, we're getting a bunch of repeating white frame areas. This is simply a case of Content-Aware Fill sampling from a bad area (well, it's not bad, it just makes for a bad fix). So, to help Content-Aware Fill pick a better spot, press **Command-Z (PC: Ctrl-Z)** to Undo the fill (make sure your selection is still in place), and then we'll go under the Edit menu and choose **Content-Aware Fill** (as shown here) to enter the full editing workspace for this feature.

STEP THREE:

When you choose Content-Aware Fill from the Edit menu (like we just did), it brings up this new workspace: there's a Toolbar on the left, then your image window (with the area outside your selection tinted in green), then a preview of Content-Aware Fill's fix in its own Preview panel (use the slider at the bottom of the panel to change the size of your preview), and then the Content-Aware Fill panel on the right (seen here, below). At this point, we haven't done anything other than open this new workspace, so it doesn't look any different than it did before—it's still pulling its patch from that white window frame, and it still looks bad. One thing that I do before I start working in this workspace is I go to the Sampling Options section in the Content-Aware Fill panel and, from the Indicates pop-up menu, I choose **Excluded Area** (as shown here, and seen in the next step). That way, I can paint over any areas I don't want Content-Aware Fill to use, and see those areas in the green tint (by the way, if you don't like green as the color that displays the areas you want excluded, click on the Color swatch and choose a different one. You can also change the Opacity of the tint using the Opacity slider).

STEP FOUR:

Since we can see it's pulling the fix from the white frame, we need to exclude that window area from where Content-Aware Fill samples. So, get the Sampling Brush tool **(B)** from the Toolbar, switch to the add brush by either clicking on the Add icon (the plus sign) up in the Options Bar, or by just pressing-and-holding the **Option (PC: Alt) key**, and paint over that side of the window (as shown here). As you paint, it updates the Content-Aware Fill fix in the Preview panel. You can see that it's now no longer pulling from that white frame because we've excluded it as a choice for its fix. This instant feedback is what makes this workspace so powerful. If you paint over an area and it makes things worse, switch back to the erase brush (up in the Options Bar), and then erase the area.

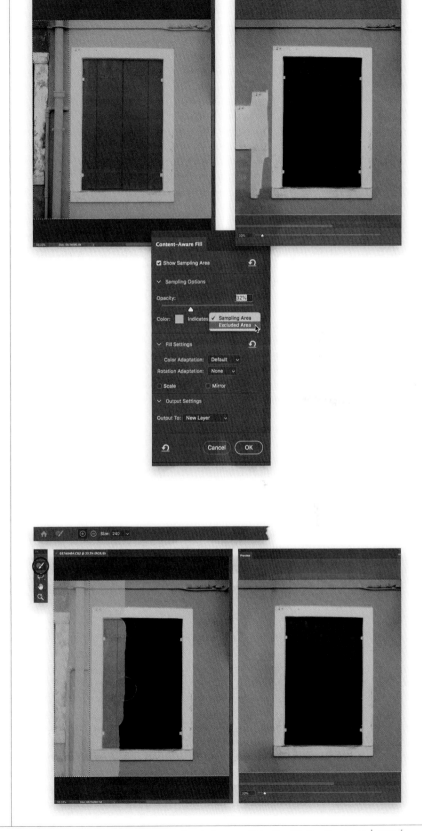

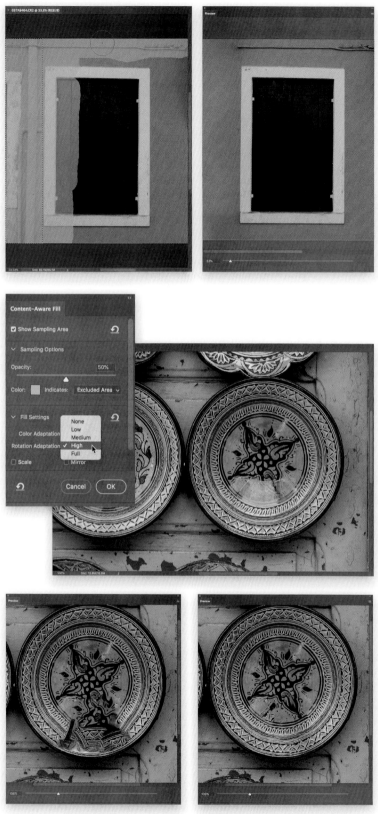

The default fix *With Rotation Adaptation set to High*

STEP FIVE:

If you look at the image back in Step Four, you'll see that when it did its fix, it actually extended the wire above the window on the top left, rather than removing it. That's because we didn't tell it to exclude that area. So, take the Sampling Brush tool, paint over that wire above the window, and now Content-Aware Fill knows not to use that to make its fix—you can see in the Preview panel, here, it no longer extends that wire. Okay, let's switch to a different image to check out some of the other options in this new Content-Aware Fill workspace.

STEP SIX:

Here's a different image, with a different problem (and a different solution). In the Content-Aware Fill panel's Fill Settings section, there's an option called Rotation Adaptation and it's used when you need to influence how Content-Aware Fill picks its patch area from a round object. Here, at the top, the green plate on the right has a bright highlight that's messing up the detail in the bottom of the plate. So, I selected it with Lasso tool **(L)**, and then brought up the Content-Aware Fill workspace. Below left, you can see the result of the default Content-Aware Fill repair (which is a mess). After choosing **High** from the Rotation Adaptation pop-up menu (which is precisely for problems like this), you get the far better result you see below right. You should try out each of the rotations to see which one you like best, because they all worked pretty well, but the results here were just a bit different (I thought Full looked really good for this image, as well, but I went with High).

STEP SEVEN:

Here's a different problem. In this case, I want to remove the celery from our plate of boneless wings (apparently, it doesn't have enough fat, sodium, or calories to be in this image). You can see I've selected the celery with the Lasso tool, so that area appears in a green tint. When Content-Aware Fill did its thing, you can see the results (below left) were less than awesome. To see if you can coax some better results, head over to the Fill Settings section and try turning on the Mirror checkbox, which lets Content-Aware Fill flip the patch if it thinks it will do a better job. While turning on the Mirror checkbox here didn't make it perfect, it sure made it a lot better. Another option in this section is Color Adaptation, which I mentioned in the last project, but here you can choose different levels of it (from None to Very High). It didn't help with our wings picture, but you'll want to know it's there as an option. The Scale checkbox lets it change the size of the patch if it thinks it'll give you better results (particularly helpful if there's a repeating pattern on a floor or a background).

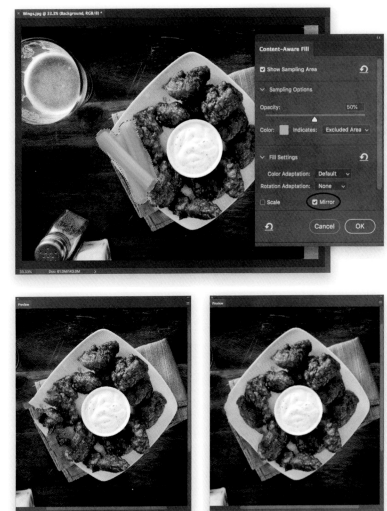

The default fix

With the Mirror checkbox turned on.
Not perfect, but better

STEP EIGHT:

Below the Fill Settings section are the Output Settings. Here, you simply decide what you want to happen when you're done. Do you want this fix applied directly to the image layer we've been working on (you'd choose Current Layer from the Output To pop-up menu); do you want these changes to appear on their own separate layer above the image (choose New Layer); or do you want to create a new duplicate of your layer, but with the changes applied directly to this duplicate (choose Duplicate Layer)? Which one is the right choice? There isn't a "right choice." It's totally up to you (I just apply mine directly to the current layer, just like you would using regular Content-Aware Fill, but that's just me).

New Layer Duplicate Layer

PROBLEMSKI

DEALING WITH COMMON IMAGE PROBLEMS

I can't imagine a better name for a chapter on dealing with problem photos than one borrowed from the title of the 2015 Belgian comedy/drama *Problemski Hotel*, featuring Jean-Claude Soetens as Garde de sécurité, and Evgenia Brendes as Lidia, the Russian girl. Sure, I could have used any one of the more obvious names, like the TV short *Problems (II)*, or 2012's TV miniseries *Problems*, or even the 1998 TV miniseries *Problems* (I guess, after 14 years, you're allowed to make another miniseries with the exact same name), but using any one of those is the work of a lazy writer, and I am not a lazy writer. I'm a sleepy writer. That's different. You see, I'm willing to go the extra mile for my readers because you deserve more than a hacky *Problems* title for your chapter, and I want to deliver for you. It's not that I don't want to put the time in, it's that I can't stay awake long enough to dig a little deeper to see if maybe there was actually a movie or TV show named *Common Image Problems*. It's not that far-fetched, ya know? That's why, in previous versions of this book (by the way, there was only one previous version, but all copies were rounded up and burned by the Huns. Well, they said they were Huns and they looked very hunny to me. You might say they were "hunny-looking"), you can imagine my surprise when I was able to find movies, TV show titles, or song names that were so descriptive that even I was surprised. For example, who would have ever dreamed that there would be a film named *Advanced Masking and Selections in Photoshop*, and that in 2006, it would win the much-coveted Outstanding European Achievement in World Cinema award presented that year in Copenhagen by Crown Prince Akeem Joffer of the African nation of Zamunda. As a side note, the film narrowly beat out *My Life as a Zucchini* and *Camera Raw Tips and Tricks* (the story of a small boy whose dreams of becoming a point guard for the NBA's Portland Trailblazer's are crushed by the fact that he's a small boy), both of which were up for the prestigious Prix Fripsci award for unintelligible sound design in a documentary or cruel musical. So, as you can tell, this one was pretty much up for grabs, and in my fiduciary role for the reader, I think I made the right call. Oh well, it's like that Russian line they say in the closing scene of *Problemski Hotel*, "Рад познакомиться с вами," which roughly translates to "Oh, dear! I've forgotten the combination to the safe in my hotel room." Who saw that coming, right? You have to love a cliffhanger like that.

SCALE PARTS OF YOUR IMAGE WITHOUT DESTROYING IT

We haven't used film cameras for sooooo many years now, but just to check, I went to Target .com, looked at picture frames and, sure enough, they're still available in the old 35mm film sizes (8x10", 11x14", and so on). It kinda blows my mind that they're so incredibly behind the times (not just Target, but the framing industry as a whole). Luckily, Photoshop has a way to make your images fit in these traditional sizes without having to crop in on them, or destroying them because you scaled part of it to fill in the white gaps left from the resize.

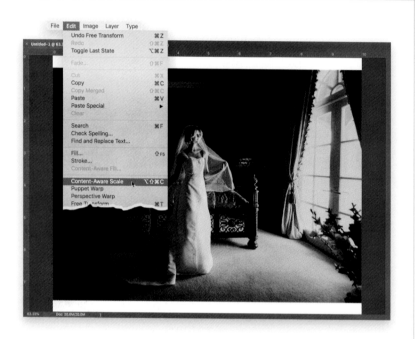

STEP ONE:
Here, I dragged a digital camera image into a traditional 8x10" document (so it'll fit in a frame I buy at Target or Walmart or wherever). When you resize it down, so it fits in the document without cropping off parts of your image, you can see it leaves white gaps at the top and bottom of the image (as seen here). So, to combat this, we're going to use Content-Aware Scale, which lets you expand the image area without stretching your subject like they were made of taffy and totally destroying your image. Because it's aware of the main subject in the image, it does a "smart stretch" (my own term—not official), only moving parts that don't contain your main subject. So, start by going under the Edit menu and choosing **Content-Aware Scale** (as shown here).

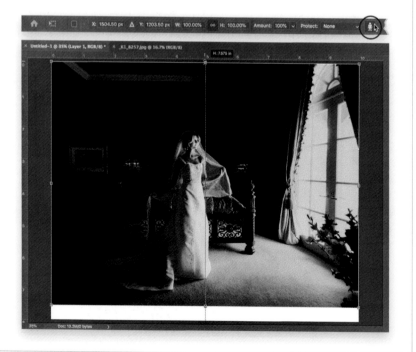

STEP TWO:
This brings up what looks like the Free Transform control points around your image. Before you just start dragging, though, you can get better results by letting Photoshop know there's a person in this image, so it knows how to stretch them. You do that up in the Options Bar by just clicking on the Protect Skin Tones icon (it's shown circled here in red; it looks like a little person). Once that's done, click on the top-center control point and drag straight upward to fill that empty space. You'll notice, here, that it only stretched the ceiling and wall above her head—it did not stretch or distort our bride at all, which is part of the wonder and magic that is Content-Aware Scale.

STEP THREE:

Now do the same thing at the bottom of the image—grab the bottom-center point and drag downward until it fills that white gap intelligently, without stretching our bride at all. When you're done, press the **Return (PC: Enter) key** to lock in your scaling. You've now covered the gaps and your bride (and overall image) still looks awesome. This is just one way to use Content-Aware Scale (it helps here and there for Instagram images for me), but there are probably half-a-dozen ways you'll find to use this feature. Now, it's important to note that this won't work on every image (I'm not sure I know of any effect that works perfectly on every single image), and there's a limit to how far you can drag before it just can't help itself and it starts stretching your subject. But, I have another tip in the next step that might help, if it does start to stretch something (or someone) when you don't want it to.

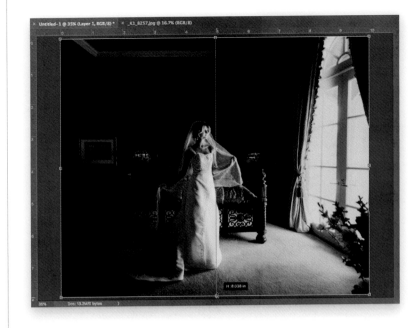

STEP FOUR:

If you realize it's stretching something it's not supposed to, press **Command-Z (PC: Ctrl-Z)** to Undo, then get the Lasso tool **(L)** from the Toolbar, and draw a loose selection around the area you don't want to move when you're scaling (as shown here, where I put a loose selection around the bride and the bed area. These are the areas that really can't afford to get messed up). Then, go under the Select menu and choose **Save Selection.** The Save Selection dialog will appear, but you don't need to do anything there other than just click OK, and it saves this selection as what's called an "Alpha channel." Now, go under the Edit menu and choose Content-Aware Scale, but before you start scaling, up in the Options Bar, choose **Alpha 1** from the Protect pop-up menu (as shown here, above). That tells Photoshop that the area you selected earlier with the Lasso tool is to be protected and can only be stretched in cases of dire emergency (either then, or anytime you stretch the thing too darn far!). Again, this is to give Photoshop a heads-up before you start stretching, so you get better results.

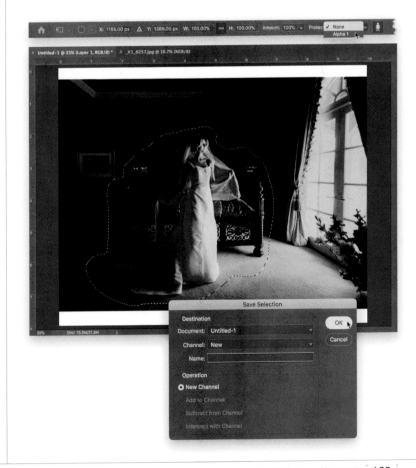

GETTING RID OF "HALOS" ALONG EDGES

Halos, bright lines that appear right along the edges of things in your image, are the bane of image editors everywhere. They sometimes appear naturally in nature, but most of the time they're a by-product of our post-processing. These awful telltale glows can appear more pronounced when you apply a lot of tonal contrast, a lot of clarity, or just push things a bit when processing HDR images. While there's no good way to get rid of these within Lightroom, this is easy work for Photoshop thanks to two tools that work great together.

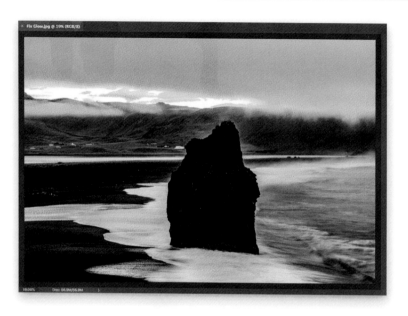

STEP ONE:

Here's our processed image, and you can see that there's a wide, soft glow around the outside of the rock formation in the foreground. When we zoom in (in the next step), you'll see a brighter, thin, hard white glow right along the edges. Both are pretty bad, but actually fairly easy to fix.

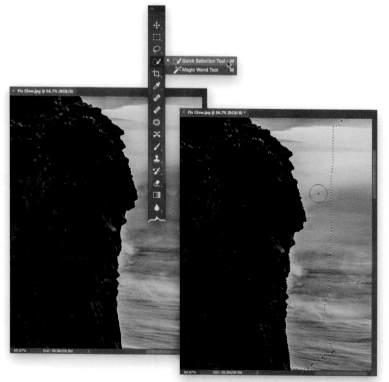

STEP TWO:

Here, I zoomed-in close, so you can really see that hard glow along the edges. Now, we want to make sure that when we get rid of this glow, we don't accidentally mess with the edges of the rock. To do that, we'll put a selection around the area we're going to work on—right up to the edge—and once that selection is in place, we won't be able to accidentally paint outside that selected area. It's like we put a fence around it to keep our repairs inside. The easiest tool to use to put up this selection "fence" is the Quick Selection tool (**W**). Just paint with it along the outside of that edge area and it snaps to the edge of the rock as you paint (as shown here at right, where I'm painting along the right side of the rock). You can change the size of your selection brush just like you would any other brush—the **Left Bracket key** on your keyboard makes it smaller; the **Right Bracket key** makes it larger.

STEP THREE:
Now switch to the Clone Stamp tool (**S**; see page 150 for more on this tool) and make your brush nice and small. Go up to the Options Bar and lower your Flow amount to 25% (that way, your strokes will build up as you paint. So, if you paint over an edge and it doesn't remove enough, you can paint over it again and it will build up). Now, press-and-hold the Option (PC: Alt) key and click just a 1/4" or so to the right of the rock to sample that area that doesn't have a glow, then move your brush right along the edge (as shown here) and start cloning over it. If you look closely here, you'll see a little + (plus sign) crosshair cursor just to the right of my brush cursor. That's the area I sampled from (Option-clicked [PC: Alt-clicked] on) to clone over my glow. If your glow is wider than just along the edge, you'll use this same technique, but with a larger brush, and you won't sample as close to the edge as I did here—you'll need to sample outside the area where you see the glow. That's it.

FIXING REFLECTIONS IN GLASSES

I get more requests for how to fix this problem than probably all the rest combined. The reason is, it's so darn hard to fix. If you're lucky, you get to spend an hour or more desperately cloning, and in many cases, you're just stuck with it. However, if you're smart, you'll invest an extra 30 seconds while shooting to take one shot with the glasses off (or ideally, one "glasses off" shot for each new pose). Do that, and Photoshop will make this fix absolutely simple. If this sounds like a pain, then you've never spent an hour desperately cloning away a reflection.

STEP ONE:

Before we get into this, be sure to read the short intro above first, or you'll wonder what's going on in Step Two. Okay, here's a photo of our subject with her glasses on and you can see the reflections in them (pretty bad on the right side, not quite as bad on the left, but they definitely need fixing). The ideal situation is to tell your subject that after you take a shot, they need to freeze for just a moment while you (or a friend, assistant, etc.) walk over and remove the glasses (that way, they don't change their pose, which they absolutely will if they take them off themselves), and then take a second shot. That's what I did here (I took the first shot, an assistant took off her glasses, and I took the second shot. Took all of 10 seconds).

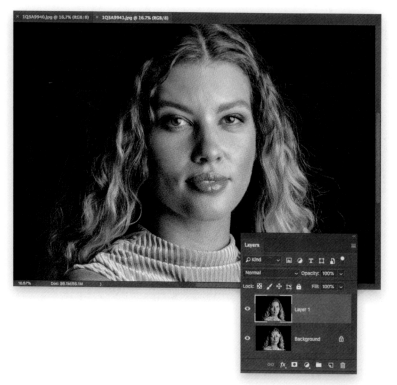

STEP TWO:

Her head moved slightly when I took this second shot (believe it or not, no matter how still their head appears, there's almost always a bit of movement), but we'll be able to line the two shots up pretty easily. We'll do a simple copy-and-paste to get this no-glasses image over into our reflections image document. So, press **Command-A (PC: Ctrl-A)** to select the entire no-glasses image, then press **Command-C (PC: Ctrl-C)** to Copy it into memory, switch to the reflections image, and press **Command-V (PC: Ctrl-V)** to Paste the no-glasses image into this document. It'll appear on its own separate layer above the Background layer (as seen here). Now, one thing you can try is lowering the Opacity of the top layer to around 60%, so you can see through to her eyes on the Background layer. Then, get the Move tool **(V)** from the Toolbar and try lining up her eyes. It's usually fairly easy, but Photoshop can do this for you.

STEP THREE:

To automatically align them, make sure your top layer is back at 100% opacity (if you tried that whole "lower the opacity" trick), and then we'll let Photoshop do the work for us. Start by going to the Layers panel, pressing-and-holding the Command (PC: Ctrl) key, and then clicking on each layer to select them both. Once they're both selected (as shown here), go under the Edit menu and choose **Auto-Align Layers**. When the dialog appears (seen here), leave the Projection set to Auto and click OK. Once it's done aligning the layers, you'll usually end up with some gaps around the edges of your image. So, if you want to crop those away, just grab the Crop tool **(C)** from the Toolbar and click-and-drag the outside edges of the cropping border inward until the gaps fall outside that border. Click anywhere outside the cropping border (or hit **Return [PC: Enter]**) to lock in your crop (and, yes, it keeps your two layers still intact).

STEP FOUR:

Now, click on the top layer to make just that layer active, and then press-and-hold the **Option (PC: Alt) key** and click on the Add Layer Mask icon at the bottom of the Layers panel (it's the third icon from the left, circled here in red). This hides the top layer (the layer where she has no glasses on) behind a black layer mask—that layer is still there, but it's like it's hidden behind a black wall. So, all you should now see is the glasses on with reflections image (as seen here), and in the Layers panel, you'll see that a black layer mask has been added to that top layer (that's the black wall I was talking about).

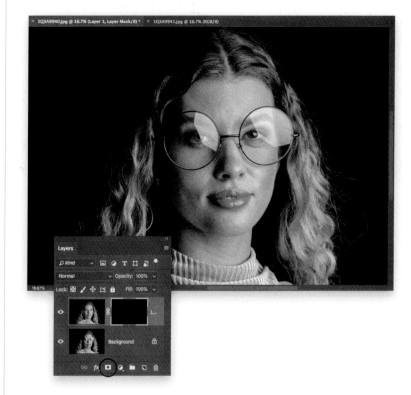

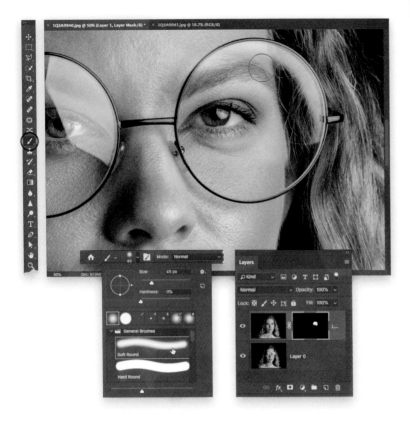

STEP FIVE:
Use the Zoom tool **(Z)** to zoom in on her eyes, and then press **D** to make sure your Foreground color is set to white. Get the Brush tool **(B)** from the Toolbar, then choose a small-to-medium-sized, soft, round brush from the Brush Picker up in the Options Bar (as shown here). Now, simply start painting over the inside of the frame on the right, and it reveals the version of her eye without the glasses on (as seen here). What you're doing is revealing the top layer, but just where you want it. Don't erase all the way to the edges—we'll need a hard-edged brush for that, so stop short of the edges for now (like you see here). The reason we're using a soft-edged brush to start with is because we want to smoothly blend the edges near her eyes from the no-glasses image with the rest of her face from the glasses image. That soft edge works wonderfully for that, creating a nice, smooth blend.

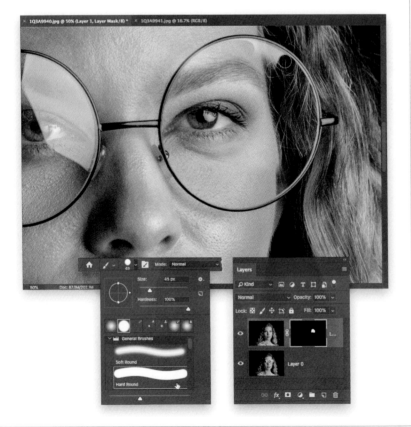

STEP SIX:
When all that's left of the reflection is near the edges of the frame, head back up to the Brush Picker in the Options Bar and choose a hard, round brush, and then paint right along the edges of the frame, and of course, try not to accidentally erase any of it (duh). If you do make a mistake, no biggie—just press **X** to switch your Foreground color to black and paint the frame back in. That's why we use layer masks instead of just using the Eraser tool, because if we make a mistake, we can just switch to black and paint away our mistake. Nothing we did is permanent—we can always throw away our layer mask (just drag it on top of the Trash icon at the bottom of the Layers panel) and start over. In short, layer masks rock (and I'm pretty sure Elvis did a song once about them called "Layer Mask Rock").

STEP SEVEN:

When you're almost done, zoom in tight to make sure you haven't missed anything. You can make your hard, round brush as small as you want (like I did here) by using the **Left Bracket key** on your keyboard (this saves you a trip up to the Options Bar). Once you're finished on this side, do the same thing to the reflection on the other side. There wasn't as much reflection on that side, so it shouldn't take much to get it fixed. You can see the before/after below.

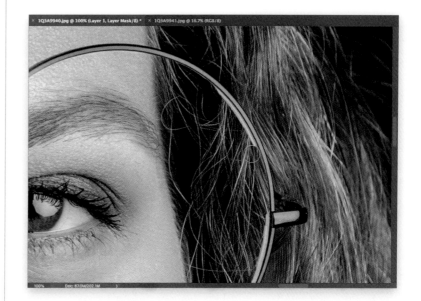

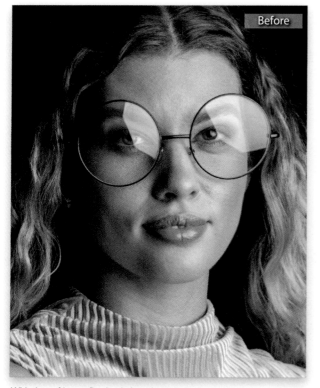

With the softbox reflecting in her glasses

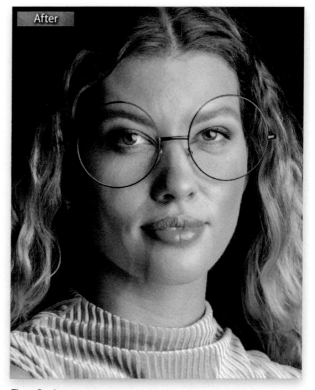

The reflections are now gone

FIXING GROUP SHOTS

Group shots are always a challenge because, without a doubt, somebody in the group will be totally hammered (at least, that's been the experience with my family. You know I'm kidding, right?). Okay, the real problem is that in group photos there's always one or more people who blinked at just the wrong time, or forgot to smile, or wasn't looking at the camera, etc. We're going to look at two ways to fix this really easily—the first one is the easiest, which is when you use a tripod to take the shot, and the second is when you shoot your group shots hand-held (don't worry, still easy).

STEP ONE:
Here's a group shot I took on a tripod (hand-held version coming shortly) with some of the crew after a shoot in the studio (L to R: Steve, Jason "J-Bone," Christina, Viktor, and Erik). Erik (in the red shirt, with his arms crossed, on the far right) was caught in mid-blink, but that's why we always take a number of group shots, one right after the other, because the more people in the shot, the more likely it is that someone was blinking, or was caught looking the other way, or wasn't smiling. So we'll need to find another shot from that same shoot where Erik wasn't blinking.

STEP TWO:
Here's another shot taken just a few moments later. Erik looks great in this shot, but I don't want to use this one as the final image because everyone else's expressions are much better in the other shot. So, we have one shot with four people with great expressions, and this photo where Erik has a great expression. The idea is to take Erik's expression from this shot and add it to the shot you see in Step One. That way, everybody looks great.

STEP THREE:

First, get the Lasso tool **(L)** from the Toolbar and make a selection around Erik's face (as shown here). You don't need to select the whole head, unless you feel it's absolutely necessary—this technique is easier when you just swap faces rather than heads (by the way, in this case, you could actually just select the area around his eyes. But, since people tend to move their heads a little between shots, I usually take the whole face just to save time). Once you have his face selected, press **Command-C (PC: Ctrl-C)** to Copy it into memory.

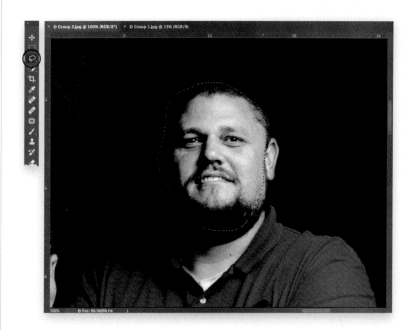

STEP FOUR:

Now, switch to the original image document (the one where everybody, but Erik, had their eyes open), then go under the Edit menu, under Paste Special, and choose **Paste in Place**. This is a special version of Paste that works perfectly for situations like this (as you'll see in the next step).

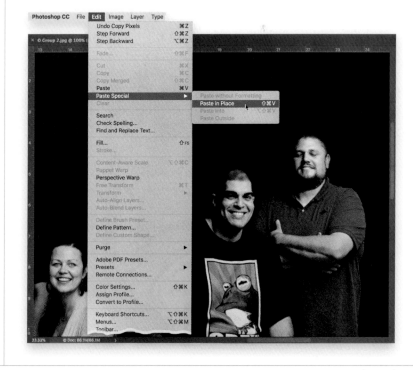

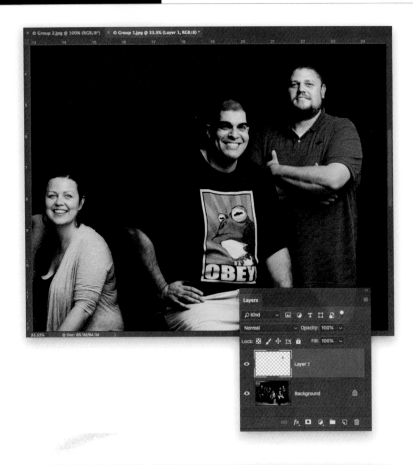

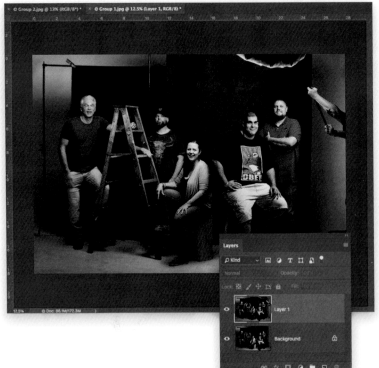

STEP FIVE:

When you choose Paste in Place, it pastes his head in the exact same spot in this image document that it was in the original (adding two words would've helped to make it easier to understand—they could have named it "Paste in the Same Place"). Anyway, because I shot on a tripod, it pasted his face in the exact same spot, and boom—you're done. If he had moved his head a little, and it looked a little off when it pasted in place, we could've just switched to the Move tool **(V)** and clicked-and-dragged it into the right spot.

TIP: IF IT'S NOT RIGHT ON THE MONEY

When you choose Paste in Place, if it doesn't place it right on the money (his head moved), I mentioned above you could use the Move tool to nudge it into place. But, that's not the tip. The tip is to go to the Layers panel and lower the Opacity of this pasted layer, so you can see his eyes from the Background layer and that helps you line up his eyes on the two layers perfectly.

STEP SIX:

This all worked so perfectly because I shot on a tripod (they are awesome for group shots, even if you're not in the group—some people think tripods are only needed if you're going to use a self-timer and run around and get in the shot). But, what if you hand-held your shot? Then, I use a slightly different technique. First, we need to get the two photos into the same document. So, bring up the image where Erik's expression looks good, press **Command-A (PC: Ctrl-A)** to put a selection around the entire image, then press **Command-C (PC: Ctrl-C)** to Copy it into memory. Now, switch to the other photo and press **Command-V (PC: Ctrl-V)** to Paste the image in memory right on top of it. The pasted image will appear on its own separate layer (as seen in the Layers panel here), but if any of our subjects moved even a tiny bit between frames (and someone usually does), the two photos won't be perfectly aligned. Luckily, Photoshop can do the layer alignment for us.

STEP SEVEN:

Start by going to the Layers panel and, with the top layer already selected, Command-click (PC: Ctrl-click) on the Background layer, so both layers are selected (as seen here, on the top right). Now, go under the Edit menu and choose **Auto-Align Layers** (as shown here, on the top left). When the Auto-Align Layers dialog appears, click on the Auto radio button (if it's not already selected), and then click OK to have Photoshop align the two layers for you (and it usually does a pretty darn amazing job at it, too!). Doing this sometimes causes you to have to do a slight crop at the end of this process, using the Crop tool **(C)** to get rid of any little corner gaps left around the outside of your image.

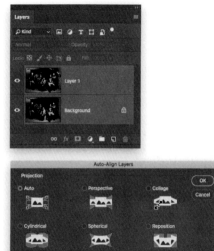

STEP EIGHT:

Whether you used Paste in Place, or you had to use the Auto-Align Layers feature to get both layers perfectly aligned, at this point, they're aligned. So, click on the top layer to make just that layer active, then press-and-hold the **Option (PC: Alt) key** and click on the Add Layer Mask icon (the third icon from the left, circled here in red) at the bottom of the Layers panel to hide the top layer (the one with Erik's eyes fully open) behind a black layer mask. Now, get the Brush tool **(B)** from the Toolbar, choose a small, soft-edged brush from the Brush Picker up in the Options Bar and, with your Foreground color set to white, paint over Erik's face (well, that general area). As you do, it reveals the "eyes open" version of him on the top layer (as shown here), and your group shot has everybody looking good.

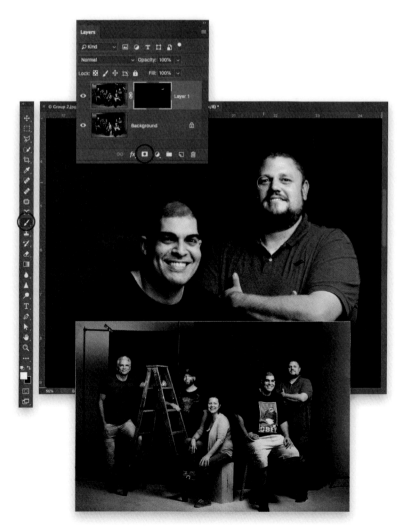

Index

layers, 2
auto-aligning, 46, 173, 179
blank, 11
blend modes for, 29, 30
cheat sheet, 30–31
creating new, 11, 30
deleting, 5, 30
duplicating, 18, 20, 31, 89, 112
explained, 4
flattening, 48
hiding, 9, 31, 59
how they work, 4–5
merging, 48, 89, 112, 131, 132
opacity setting for, 11
outputting selections to, 88
renaming, 31, 60
reordering, 8, 30
resizing things on, 6, 8
selecting multiple, 31
smart object, 42–43
stacking order of, 5
Layers panel, 4–5
Lens Blur removal option, 139
lens flare effect, 124–125
Lens Flare filter, 125
Levels dialog, 122
light beams, 110–113
Lighting sliders, 116–117
Lightroom
External Editing preferences for, 36–39
jumping between Photoshop and, 34–35
Linear Light blend mode, 69
Liquify filter
body part retouching with, 72–73
facial feature retouching with, 56–57
fixing teeth with, 74–75
long-exposure architectural look, 130–133

M

Magic Wand tool, 27
masking hair, 86–93
Merge to HDR Pro dialog, 44, 52
merging layers, 48, 89, 112, 131, 132
Mirror checkbox, 165
mirror-like reflections, 120–123

Motion Blur filter, 122
Motion Blur removal option, 139
Mouth Width slider, 57
Move tool
aligning images with, 172
blended images and, 95, 96, 97
composite images and, 101, 102
group portrait fixes and, 178
portrait retouching and, 59, 63
positioning elements with, 5, 20, 22, 26
special effects and, 113, 121, 125
Multiply blend mode, 29, 99

N

naming/renaming
layers, 31, 60
photos, 39
Navigator panel, 16
noise
adding, 65
reducing, 139
Normal blend mode, 29
nose size adjustments, 57

O

Oil Paint filter, 114–117
opacity settings
blank layers and, 11
blended images and, 97
Brush tool and, 65
color matching and, 92
composite images and, 101, 102
drop shadows and, 21
eyeglass reflection fixes and, 172
glassy reflections and, 123
HDR image creation and, 47
lens flare effect and, 125
portrait retouching and, 65
type layer and, 13
opening panels, 17
Options Bar, 4, 15
ordering/reordering
layers, 8, 30
panels, 17